AfterBurn

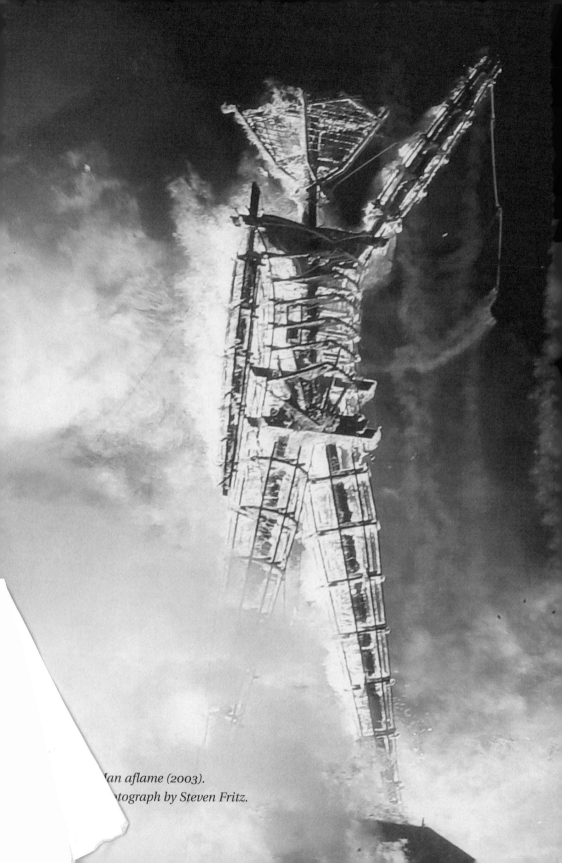

Man aflame (2003).
Photograph by Steven Fritz.

AfterBurn

Reflections on Burning Man

Edited by Lee Gilmore

and

Mark Van Proyen

THE UNIVERSITY OF NEW MEXICO PRESS

ALBUQUERQUE

11 10 09 08 07 06 2 3 4 5 6 7

ISBN 13: 978-0-8263-3399-5
ISBN 10: 0-8263-3399-0

LIBRARY OF CONGRESS CATALOGING-IN-PUBLICATION DATA
Gilmore, Lee, 1969–
AfterBurn : reflections on burning man /
Lee Gilmore and Mark Van Proyen.
p. cm. — (Counterculture series)
Includes index.
ISBN 0-8263-3399-0 (pbk. : alk. paper)
1. Burning Man (Festival)
2. Performance art—Nevada—Black Rock Desert.
3. Counterculture—Nevada—Black Rock Desert.
4. Black Rock Desert (Nev.)—Social life and customs.
I. Title: After burn. II. Van Proyen, Mark.
III. Title. IV. Series.
NX510.N48G55 2005
394.25'09793'54—dc22

2005007285

Book design and composition:
Kathleen Sparkes
Book is typeset in
Utopia 9.5/14; 26P6
Display type is Berthold
Akzindenz Grotesk

 A volume in the
CounterCulture Series

Also available:

Rebel Music: The Harvey Kubernik InnerViews
 by Harvey Kubernik

New Buffalo: Journals from a Taos Commune
 by Arthur Kopecky

Lost and Found: My Life in a Group Marriage Commune
 by Margaret Hollenbach

Seema's Show: A Life on the Left
 by Sara Halprin

Editors: David Farber, History, Temple University

Beth L. Bailey, American Studies, Temple University

CONTENTS

LIST OF FIGURES

ACKNOWLEDGMENTS

It has been said that it is as absurd for any one individual to take credit for Burning Man as it would be for a surfer to take credit for a wave, so in that spirit we would like to start by expressing our profound gratitude to the many thousands of Burning Man participants who have embraced the event's ethos of participation, self-expression, and radical self-reliance. They provide the remarkable social substance that brings the canvas of a dry desert event to life with their blood, breath, and vision.

Special thanks are due to Burning Man organizers and staffers Larry Harvey, Michael Michael, Crimson Rose, Marian Goodell, Harley Dubois, Will Roger, Andie Grace, and Jess Bobier for their enthusiasm and encouragement for this project, and to CounterCulture series editor David Farber for his early faith in its value and his patient shepherding of it through the publication process. We should also thank the contributors to this volume for their keen insights on the event and their tireless commitment to this project, without which this volume would quite literally not exist.

Lastly, we would like to thank all of our theme-campmates in the Bleu Light District, Daguerrodrome, and Low Expectations Camp (especially Eric Pouyoul and Pat "Chef Juke" Mackey, who routinely go above and beyond all expectations) for their support and good humor over our periodic use of the camp as a research station in the desert. And a very special thank you goes to Ron Meiners, husband, friend, critic, and inspiration for doing so well at being all wonderful things to a great many people.

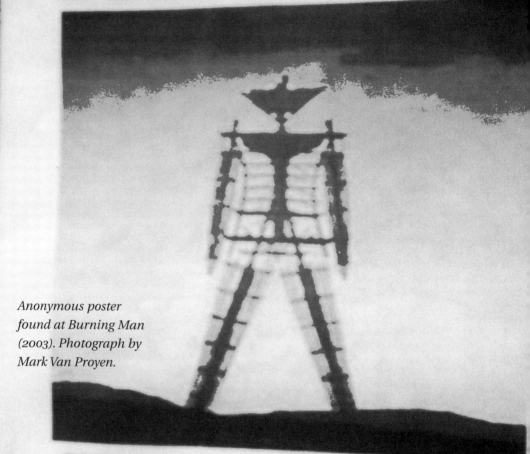

Anonymous poster found at Burning Man (2003). Photograph by Mark Van Proyen.

Introduction

Lee Gilmore and Mark Van Proyen

*Precisely because it is hard to pin down, "experience" has
served as an effective guarantee of ethnographic authority. . . .
Experience evokes a participatory presence, a sensitive contact
with the world to be understood, a rapport with its people,
a concreteness of perception. It also suggests a cumulative
deepening knowledge. . . . Experiences become narratives,
meaningful occurrences or examples.*
　　　—James Clifford, *The Predicament of Culture*, 1988

*So I'll tell you what I would like. I would like some bad acting
and wrong thinking. I would like to see some art that is
courageously silly and frivolous, that cannot be construed
as anything else. I would like a bunch of twenty-three-year-
old troublemakers to become so enthusiastic, so noisy, and
so involved in some stupid, seductive, destructive brand of
visual culture that as a critic I would feel called upon to rise
up in righteous indignation, spewing vitriol, to bemoan the
arrogance and self-indulgence of the younger generation and
all its artifacts. Then, rather than simply confirming public
policy, I would be really working, really doing my thing. And
it will happen. It is already beginning to happen.*
　　　—Dave Hickey, *Frivolity and Unction*, 1997

At about half-past nine on a Saturday night near the
end of summer, a throng of over thirty thousand revelers will enthusiastical-
ly shout "Burn it!" in a remote corner of northwestern Nevada's Black Rock

Desert. "It" is a towering effigy made of intricately latticed wood and glowing neon, and it stands atop an elaborate wooden pedestal the size of a two-story house. Although devoid of overt dogmatic significance, this figure is laden with many allusions inviting an incalculable number of associations. For example, it has a primitive, fetishistic quality, albeit one that is writ absurdly large, while its exacting geometric proportions also suggest the cybernetic models that are made possible by computer-assisted drafting, making it resemble an avatar from a 1980s video game. Part pre-technological idol and part post-technological puppet, this anonymous effigy exudes an enigmatic solemnity as it towers over its viewers.

Although the dominant tone of this gathering is one of obstreperous celebration, one can also detect a giddy bloodlust in the air as the figure is prepared to meet its doom. The arms of the figure are raised high above its head, creating a crisp X shape set against the darkening night, a gesture that is at once submissive and triumphant. As the disorganized chanting melts into a defining cheer, a long moment passes and the figure finally ignites, exploding in a choreographed succession of impressive pyrotechnics. Unable to sustain its own weight in the engulfing conflagration, it soon collapses into a pile of sparks and a pillar of smoke, transforming the desert and its inhabitants into a chthonic dreamscape where most of the socially ordained rules of so-called normalcy are suspended until dawn.

Clearly, some kind of sacrifice has occurred, but what exactly has been sacrificed can only be a matter of inconclusive speculation. Perhaps it was only a spectacular simulation of sacrifice, a confused (yet highly theatrical) rendition of the cathartic rapture invoked by ancient ceremony. Or maybe it was the real thing, begging only for the leap of faith that could allow for such a recognition. Some will see in it the announcement of a fleeting moment of absolute permission, and follow suit by engaging in imaginative feats of debauchery. Others may read the pyro-symbolic rite as a dramatic prophecy heralding an end of a reviled "patriarchal corporate hegemony" (commonly dubbed "the man"). Many will simply see it as a clarion announcing the end of a playful summer previous to a return to the corporate (or academic) vineyard. At the end of the long night after the burn, all of those in attendance will eventually steady themselves and greet the sun. Then they will pack up and return to the yoke and blinders of their daily lives, biding time and exchanging E-mail until they are able to return the following year to the event called *Burning Man*.

Those who have gathered together on this occasion, known collectively as "Burners," refer to the aforementioned figure as "The Man," and the occasion of its demise as "The Burn." But these simple monikers understate the affectionate reverence that almost all of them feel for the event. Since the first Burn in 1986, the Man has gradually become the central icon of a widespread community to whom it implies an unstated, albeit deeply felt, cosmology. For a full week, thousands hailing from all over the world (but mostly from the San Francisco Bay area) have camped in a two-mile-wide semicircular civic space arrayed around the Man. Here, they have created a temporary town or "ephemeropolis"[1] called Black Rock City, named after the four-hundred-square mile alkali desert upon which it rises and falls each year. The cracked surface of this dry and utterly flat prehistoric lake bed—known as "the playa"—is completely devoid of any vegetation or animal habitat. Temperatures can range from 40° at night to well over 100° during the day, while fierce dust storms with winds of 75 mph are common occurrences.

When viewed from above, the city might be said to resemble a giant sundial, the schematic imprint of a crop circle, or perhaps a Tibetan sand mandala etched like a gargantuan tattoo on a vast extraterrestrial plain. Black Rock City's typical ground plan consists of well-marked curvilinear roads forming three-quarters of a full circle, which are in turn bisected by radial cross streets, including a long central causeway that forms a gauntlet through a succession of large-scale artworks. And at the center of it all stands the Man itself, an imposing locus of physical and perceptual centrality.

Imaginatively designed temporary shelters proliferate in Black Rock City, as do festive decorations and colorful costumes. Its citizens circulate on foot, on bicycles, or in elaborately modified vehicles known as "art cars," licensed by the DMV ("Department of Mutant Vehicles") as artistic exceptions to a policy of prohibiting individuals from driving their own cars. Black Rock City maintains basic civic amenities such as an internal peacekeeping force of specially trained "Rangers"; a "Department of Public Works" (a.k.a. the DPW), who begin building the city's infrastructure over a month before the festival commences; emergency medical services; a functional post office; an official daily newspaper called *The Black Rock Gazette* (and at least two other "alternative" publications); dozens of pirate radio stations; and a central café called the Center Camp Café, which is the city's single largest structure.[2] Last, but certainly not least, the city's sanitation needs are met by

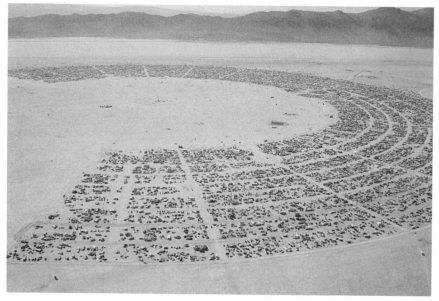

Desde Arriba: *shot from the air at the Burning Man Festival,*
Black Rock City, Nevada, August 2002, by Keyer Photography
(http://www.kyerphotography.com).

several hundred regularly serviced chemical toilets placed at key junctures
amidst its highways and byways.

A particularly significant feature of this city is the fact that there are no
advertisements anywhere to be seen—even the signage on rented trucks is
often creatively altered or otherwise masked from view. Because vending is
also forbidden, the inhabitants of the city enact what is idealistically referred
to as a "gift economy," freely sharing what they have brought, just as they
share the many other burdens of surviving the harsh and daunting desert.
Oftentimes, Burners organize themselves into groups that create "theme
camps," usually presented as whimsical places dedicated to a particular motif
or affinity, each functioning as a hub for its own extended community. Num-
bering in the hundreds, these camps form themselves into a mythomaniacal
arcade that semipublicly and semisatirically displays the human exempli-
fications of a staggering variety of subcultural lifestyles, each resplendent
with appropriate code words, identifying artifacts, and fanciful totems.

Interactivity is a key feature of most theme camps, as their creators invite and entice other Burners to participate in their theme or project. A typical theme camp might be devoted to a particular preference in music or erotic identity (such as *The Church of Funk* or *Bianca's Smut Shack*), or it might feature regularly scheduled performances or theatrical contests of some type, as is the case with the *Death Guild*'s "Thunderdome" (faithfully adapted from a scene in the *Mad Max* movie of the same name). Oftentimes they feature sardonic parodies of well-known popular figures or corporations, such as the *Spock Mountain Research Labs* or *Motel 666*. Always, these camps present themselves as an eccentric outpost for some form of cultural commentary, a place where identity is interactively negotiated as individuals exchange displays and postures before receding back into the anonymous and undulate crowd. Burning Man organizers promote this kind of interactivity as a form of "radical self-expression," keynoted by an effacement of rigid boundaries between private and public in favor of unscripted enactments of surreal alter egos and fantastic psycho-geographies. Oftentimes, these enactments (and their fanciful accouterments) are inspired by Burning Man's annual theme, while in other instances they remain oblivious to said theme, contenting themselves to engage Black Rock City's noncommercial marketplace of do-it-yourself spectacle with a thematics of their own oftentimes obscure device.

Burning Man organizers have invoked a variety of broadly inclusive annual themes to shape each iteration of the event, beginning in 1996 with *The Inferno* (a.k.a. *HelCo*), which was intended to evoke an iconoclastic conjunction of the rise of multinational corporations with Satanism. Subsequent years were devoted to themes that were less tinged with satire or negativity. These included *Fertility* (1997), which vaguely nodded to notions of neo-pagan goddess worship, love, and sexuality; *Nebulous Entity* (a.k.a. *The Great Beyond*, 1998), hinting at beliefs in extraterrestrial intelligence; and *The Wheel of Time* (1999), a loosely millennial theme in which the Black Rock City layout became a monumental clock face. These were followed by *The Body* (2000), featuring artistic representations of body parts arranged as kundalini chakras along the city's central causeway; *The Seven Ages* (2001), celebrating the human life cycle from birth to death; *The Floating World* (2002), which transformed the desert into an oceanic spectacle of boats, fantastical marine life, and pirates; *Beyond Belief* (2003), intended as an exploration of the boundaries of world religions, rituals, and faiths; and *The Vault of Heaven* (2004), which paid homage to cosmic grandeur, alien worlds, and scientific discovery.

During the week-long event, the denizens of Black Rock City improvise themselves into a tightly knit community of kindred spirits and shared priorities, even though no one actually can state with confident certainty what those priorities might be beyond the prohibition of vending and corporate advertising, and that no trace of their inhabitation of this space should be left behind. Another dictum that remains a popular ideal is the injunction to *participate* in some way, with the corollary that there should be *no spectators*. Simply put, this means that everyone in attendance is accountable for making some kind of positive contribution to the collective experience. Larger crowds have made the interpretation of this edict less clear, but its ethos lives on as an invitation and an opportunity, for in the community gathered around the Man, participation remains the only currency with which status and recognition can be purchased.

Given the size and cultural reach that Burning Man has attained, it is perhaps surprising to note its humble beginnings. As the well-circulated legend has it, the event started in 1986 when Larry Harvey and Jerry James built an eight-foot effigy and incinerated it at sundown on summer solstice at San Francisco's Baker Beach (James withdrew his interest in Burning Man early on and Harvey has remained the director of Burning Man in all of its subsequent manifestations). Although the event was intended as an intimate ceremony of personal catharsis and simple enjoyment for a handful of friends, it drew a crowd of passers-by who were attracted to the flame and who spontaneously joined in the merriment. An agreement was made to repeat the same act the following year, which was attended by a larger and more boisterous crowd of approximately eighty individuals. The Man was also larger, having grown to fifteen feet. Subsequent years were marked by even taller effigies and ever larger crowds, until June of 1990, when federal park police were called by neighboring homeowners to intervene in an event that had attracted around eight hundred boisterous revelers. It was determined at that time that the effigy could not be burned, suggesting that the event had clearly outgrown this particular location. At that point, Harvey and his compatriots teamed up with *The San Francisco Cacophony Society*, a loose-knit confederation of self-proclaimed free spirits dedicated to exploring "experiences beyond the pale of mainstream society through subversion, pranks, art, fringe explorations and meaningless madness."[3] Through the organizational efforts of Cacophonists Michael Michael and John Law, an event called a *Zone Trip* was organized

for the following Labor Day weekend, and the components of the then forty-foot Burning Man were loaded into the back of a rented truck and carted off to the Black Rock desert to be torched.[4]

Around eighty for the most part unprepared participants made that first trek to the desert. The following year, the population of what was soon to be known as Black Rock City doubled, and it continued to roughly double annually, until eight thousand arrived for the 1996 event, which proved to be the watershed year for Burning Man. It was that year that the city's characteristic ground plan took its initial form, and it was also the first year that the event had an official theme, featuring close to a dozen major artworks that were intended to be burned in a variety of ritualistic settings. It would also be the last year that Black Rock City would have porous boundaries (meaning by default that paying the then $50.00 admission charge was optional), and the last year that cars were allowed to come and go as they pleased, owing to increased safety considerations prompted by a tragic vehicular fatality. The following year, the event relocated to private land on nearby Hualapie Playa, pending a protracted environmental impact review conducted by the Bureau of Land Management—the federal agency responsible for the oversight of the Black Rock desert.

The 1997 event was the first iteration of Burning Man in its current organizational form. At that time, Harvey formed the Black Rock City Limited Liability Corporation with Michael Michael (lead ranger), Crimson Rose (administration), Marian Goodell (communications), Harley Dubois ([née Bierman] community services), Will Roger (DPW), and Joegh Bullock (special projects). Later, attorney Carole Morrell and businessman Andy Pector joined as partners. (Law dropped out after the 1996 event, while Pector, followed by Morrell, left the LLC in 1998. Bullock is also no longer on the LLC board, but continues to produce Burning Man parties and events in the San Francisco Bay area.) With a more tightly controlled gate, admission charges became enforceable, and with that, realistic budgets and plans could be established. But this change of venue and organizational structure also allowed the agencies of Nevada's Washoe County to become involved, and they did so by seizing the event's proceeds at the gate. This forced the LLC to engage in several protracted legal battles that set the stage for the event's return to the Black Rock playa in 1998. The event has continued to take place at that location ever since, in part by paying the Bureau of Land Management upwards of a half million dollars a year in various fees since 2000. At that

time, Burning Man's annual population stabilized itself at approximately 25,000–30,000, achieving a peak attendance of 35,664 in 2004.

There are many things that can be said about Burning Man, many ways of connecting it to the world from which it presumes to escape. The nine essays contained in this volume were selected for their power to initiate and frame such a conversation, which is hoped to be an ongoing one. Each seeks to map and elaborate a specific aspect of the event from the twin vantages of participant recollection and academic analysis, and it should be noted that all of their authors are repeat Burning Man participants. This means that each essay is an exercise in bridging the chasm that exists between two very different worlds. None is a simple "report to the academy," laying the labor of fieldwork onto the table of a tenure review committee. Rather, they all have something more personal at stake in that they are as much a confession of an alternative life lived (for however short a period of time) as they are the forwarding of conclusions and speculations based on the formalized gathering and weighing of evidence. In short, our claim is that these essays should be understood as contributions to Burning Man's ethic of participation, as much so as the building of a sculpture or the construction of a theme camp. At the same time, they are also honest attempts to locate the event amid a respectable variety of sensitizing frameworks that extend far beyond its temporary desert home.

The organization of the book represents an attempt to roughly mirror the actual experience of discovery that is attendant on participating in and then reflecting upon Burning Man, while also echoing the physical rise and fall of Black Rock City in any given year. Erik Davis's essay begins by exploring both the personal and cultural ramifications of Burning Man's "spirituality" by way of what he terms the "cults" of experience: intoxicants, juxtaposition, flicker, and chaos, each of which is inexorably grounded within a particularly Californian historical milieu that has set the subcultural stage for the inevitable arrival of Burning Man. Lee Gilmore's essay picks up at this point with a meditation on the ritual practice and transformative symbolism of pilgrimage as it applies to Burning Man. Working with the model developed by Victor Turner, she explores Burning Man's capacity to profoundly transform the lives of participants long after they vacate the desert.

Jeremy Hockett's contribution addresses itself to the idea of ethnographic reflexivity, which of necessity will undergird any subsequent analysis of the event. Comparing portrayals of the event from mainstream media with those authored by individual participants, he argues that Burning Man provides an opportunity for participants to reflexively engage in an "ethnographic" experience of their own culture. The event's skewing and reframing of postmodern marketing paradigms is the subject of the essay by Robert V. Kozinets and John. F. Sherry Jr. Casting Burning Man as an alternative theater of consumption, they argue that it represents "an attempt to ameliorate some of the social deficiencies of markets." Katherine Chen offers a kindred analysis of the motives and circumstances of the many volunteers who contribute long hours to the construction and maintenance of the event's infrastructure. Based on extensive interviews with numerous volunteers, she surmises that they are in large part motivated by the opportunity to interact with a congenial community, and that this opportunity carries with it a valuable reward that can have the same weight as financial compensation.

A historicist note is sounded by JoAnne Northrup, who focuses on the scores of "art cars" that are such a visible part of Burning Man. Tracing the irreverent and iconoclastic origins of art car culture in North America, she finds that the proliferation of creativity fostered by Burning Man has had a significant impact on the rest of the art car world. Allegra Fortunati's essay sees a utopian enactment in Burning Man that echoes Joseph Beuys's early 1970s notion of "social sculpture." Working with Carl Mannheim's description of four types of utopia, she examines how each operates amid Burning Man's reverence and tolerance for disparate forms of individual and collective creativity. Mark Van Proyen's essay represents an effort to compare and contrast the differing aesthetic moieties that are inherent in a presumed antagonism between an academically nullified "artworld surrealism" and various sculptural installations exhibited at Burning Man, which he contends are more in keeping with the original Surrealists' anarchic aspirations of "seeking out the miraculous." The book concludes with Sarah Pike's essay on two incarnations of one such work, known as *The Temple of Tears* (a.k.a. *The Mausoleum*) in 2001 and *The Temple of Joy* in 2002, created by David Best. In exploring the many meanings of ritual action in and around these Temples, Pike speculates about the significance of rites of mourning taking place in a temporary community rather than in the hometown churches, synagogues, temples, and living rooms of Burning Man participants.

Burning Man flourishes at the dawn of the twenty-first century in an America that is the putative victor in the fifty-year conflict called the Cold War. This era of metastasizing corporate power has been euphemistically dubbed "The New Globalism," and one of its chief characteristics is a programmatic scorn for any public space and public dialog set apart from the realm of corporate control. Thus, it becomes exceedingly easy to talk about "life-styles" and "demographic groups" just as it becomes ever more awkward to invoke the terms "community" and "way-of-life." Much of the interest that Burning Man has thus far generated lies in how it can be perceived as challenging and satirizing this trend. And yet, even as the event facilitates mimetic responses to these invidious aspects of our "postmodern" world, mass media accounts of Burning Man often elide this fact by echoing the earliest nineteenth-century exercises in ethnographic narrative, replete with exoticized and sensationalized references to a regressive "tribal primitivism." Such accounts remain firmly in the grip of a rationalistic modernity via their idealizations and/or demonizations of "primitive" or "original" culture, and they miss what may well be the event's most important point: in its pluralistic emphasis on radical inclusivity and psychic nomadism, in its imaginative deployment of advanced information technologies, and in its irony-laced encouragement of fluid, boundary-effacing identities, Burning Man is a quintessentially *postmodern* event. It is no article of hyperbole to suggest that Burning Man represents an attempt to create a distinctive form of postmodernity taking the guise of modernity's repressed shadow of premodernity; but it is also fair to say that the event enacts a high-speed exponentialization of postmodern decadence so as to allow a fleeting glimpse of the possibility of a new archaicism.

There is much more about Burning Man that remains unspoken. Some of those things will be illustrated in the essays that follow. But it is important to remember that Burning Man will always be best understood by way of various "educations of desire" conveyed by vivid example rather than vicarious description. Styles of Burning Man participation may vary, but it seems that their common point of agreement is that such a community can and should flourish without any agreement about explicit doctrine, in effect claiming that a heterotopian ideal of maximized elective affinities *is* the doctrine. While it is true that many Burners have simply come to find a good party, perhaps going so far as to exert much effort to provide said party for others, we need to recognize that megaparties are available in much less daunting locales, suggesting that there is a special significance to this particular

celebration. At the very least, it allows for a momentary stealing back of everyday sanity, facilitating a special and urgent resistance against the demoralizing reign of cultural complacency that comprises quotidian existence in our twenty-first-century society of spectacles.

Clearly, there are risks involved in bringing out this anthology, or any other that might take Burning Man as a subject of analysis. Perhaps the greatest of these is that Burning Man is deeply resistant to all but the most cursory of descriptions. Keynoted by the aspiration to a heterotopian ideal, it is an event that is rich in paradox and parody, oftentimes providing dangerous temptations to the process of free association that aspires to offer an analysis. For just as one might seize on some aspect of the event that might promise to represent its "essence," another aspect comes to the fore and pulls the proverbial rug out from under any such interpretation. In practice, this means that any attempt at analysis runs the risk of falling into a vortex of self-satire when compared to a multifarious subject that is inclined to be quick and fearless in satirizing itself. But just as any writing about Burning Man hazards an element of risk, so too does it labor under an almost irresistible enticement, for, given the extremes of effort and dedication evidenced by Burning Man participants, and in recognition of the growing cultural reach of the event, the question of "why this, and why now?" seems unavoidable, even as answers to it remain delightfully elusive.

NOTES

The first epigraph is from James Clifford, *The Predicament of Culture* (Cambridge: Harvard University Press, 1988), 37, 39. The second is from Dave Hickey, "Frivolity and Unction," in *Air Guitar: Essays in Art and Democracy* (Los Angeles: Art Issues Press, 1997), 78.

1. Thanks to D. S. Black for coining this term.

2. The Center Camp Café has been a prominent feature at Black Rock City since 1993. Originally the project of longtime Burner (and Marcel Proust scholar) P. Segal, the Café was originally called the *Café Temps Perdu*. In issue 5 (June 1996) of her journal entitled *Proust Said That*, Segal outlined her motives for developing the café:

 All my adult life I have known that my true calling, the one way that I would make my fortune, so I might some day sit down at ease and

simply write, would be to own the greatest café on earth, or the greatest cafés, as I plan to open them in all my favorite cities in the world. My café would be as much a salon as anything else, not filled with a decor chosen by some cutting edge designer, but filled with fine art, with books, great music, the thousands of extraordinary people I have met, the thousands I have yet to meet and, of course, the HQ of the Marcel Proust Support Group. (See http://www.chick.net/proust/cafe5.html, accessed June 13, 2004).

When Segal withdrew from managing the café in 1999, it was renamed *The Center Camp Café*. In 2000, architect Rod Garrett designed a thirty-eight-thousand-square-foot circular tent structure to house a significantly expanded café, containing several small stages for performances and exhibition spaces for small-scale artworks. At that time, the café's decor (coordinated by Marcia Crosby) became more flamboyant and thematic.

3. See http://www.cacophony.org (accessed May 20, 2004).

4. For a detailed account of the early years of Burning Man based on extensive interviews with many of the event's most colorful participants, see Brian Doherty, *This Is Burning Man* (New York: Little Brown and Company, 2004).

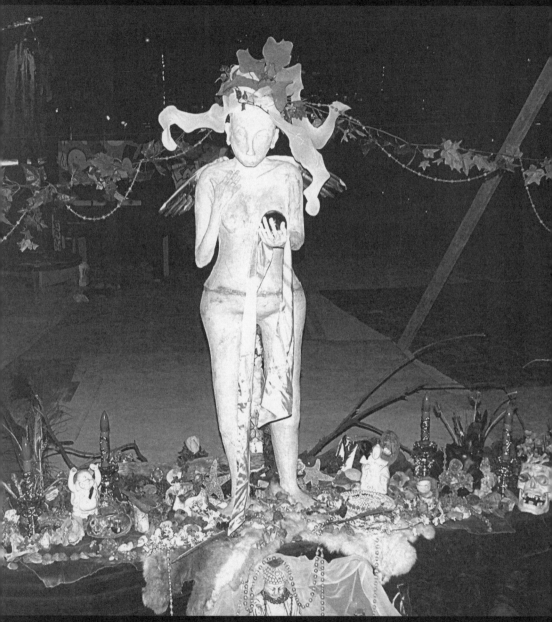

Gaia Altar *by Charity Romero in the Center Camp Café (2003).*
Photograph by Heather Gallagher.

Beyond Belief

The Cults of Burning Man

Erik Davis

For without corruption, there can no Generation consist.
—Corpus Hermeticum

I tell you: one must still have chaos in one to give birth to a dancing star!
—Nietzsche, "Thus Spoke Zarathustra"

Black Rock cliché has it that you can't say anything very penetrating about Burning Man because its diversity and contradictions undermine any generalization you might be tempted to make. This truism is solid enough, and should be mulled over by any Burner foolish enough, like me, to venture into a written analysis of the yearly festival. Yet behind this notion of impossible generalizations lurks a higher and more important injunction: to keep the event free from the prison of interpretation, explanation, and the insidious net of Meaning. This refusal is prophylactic. By setting our bullshit detectors on high alert, Burners ward off pretension, self-consciousness, and all of the prepackaged "experiences" that have come to define late capitalist subjectivity. On the playa, we are united in our evasion of significance.

Thus it is with some trepidation that I turn to one of the more vexing questions that one might ask about Burning Man: can or should we speak of the event as a sacred gathering? Even if we acknowledge the vagueness of terms like *sacred*, *spiritual*, and *religious*, it is still safe to say that, from the

outside at least, Burning Man comes off as exceptionally profane. Ironic and blasphemous, intoxicated and lewd, Burning Man's ADD theater of the absurd might even be said to embody the slaphappy nihilism of postmodern culture itself.[1] Moreover, according to my own anecdotal inquiries and observations, a good portion of committed attendees would deny that spirituality or sacred emotions have any bearing on their rollicking good times.

In matters of the spirit, however, you cannot always believe what people say. Sometimes you have to look at what they do, and what they do at Burning Man features clear parallels to some mystic fetes of yore. Take the Eleusinian Mysteries, the greatest public cult of ancient Greece. The mysteries took place annually at harvest time a day's journey from Athens and continued for almost two thousand years. Initiates came from all walks of life, and made their way to Eleusis only after weeks of preparation. The days leading up to the core rite featured torchbearers, pig-roasts, and Dionysian pageants, and peaked with the witness of a "great light" by initiates.[2] Though we know little about it, the experience, which some believe was mediated by psychoactive drugs, seemed to provide direct insight into matters of life and death. The similarities between the mysteries and Burning Man are notable, and were certainly not lost on Burning Man founder Larry Harvey. Writing under the pseudonym Darryl Van Rhey in a 1995 issue of *Gnosis* magazine, Harvey noted that, like Burning Man, the mysteries attracted a largely urban and sophisticated crowd. "Intense, ecstatic, and immediate, the rites did not stress doctrinal belief, but valued outward show and inward feeling."[3] Though this historical resonance might sound like wishful thinking on Harvey's part, no less august a figure than Aristotle basically concurred: "the initiated do not learn anything but they suffer and feel, experience impressions and moods."[4]

More immediate than such classical resonances are Burners' regular use of religious frameworks and sacred symbols. Whatever their degree of implied irony or seriousness, participants regularly cannibalize Christianity, Satanism, Buddhism, shamanism, Western occultism, Tantra, Judaism, Wicca, and other theme parks of the spirit for their costumes, camps, sculptures, and performances. Since 1994, I have participated in or observed Vodou invocations, Balinese monkey chants, shabbat prayers, Santeria drum circles, sunrise yoga, spiral dances, and group zazen, and once got shushed for a play-by-play commentary of a ponderous Ordo Templi Orientis (OTO) Gnostic Mass. While some of these appropriations are sarcastic or even

blasphemous (especially in the case of Christianity), many are serious attempts to squeeze the juice from more or less traditional rites and images.

But how far does the distinction between serious and sarcastic get us? It's far too literalistic to characterize the spirituality of Burning Man by cataloging its samples of religious traditions or by isolating pockets of "authentic" practice. At its best, Burning Man twists authenticity and irony into a Möbius strip that never lets you know what side you're on but always keeps you going. This productive ambivalence is fundamental to the event's power, deriving, paradoxically, from a circular *coniunctio* of sacred and profane. The specifically religious elements of the Burn are important not in themselves, but in relation to one another and to the less ethereal aspects of the festival: the carnality, the trash, the desert dust. This wider field of relations is not holistic but multiple: a promiscuous carnival of souls, a metaphysical flea-market, a demolition derby of reality constructs colliding in a parched void.

So how can we say anything meaningful about Burning Man's spirituality? My approach here is to tease out some cultural patterns within the festival—patterns I am calling "cults"—and hold them up against the light provided by my own ongoing research into the history of countercultural spirituality on the West Coast, and especially in California. Many core aspects of the Burning Man experience stand out when viewed against the historical context of these spiritual experiments, which have exploited all manner of media, drugs, and hedonic techniques. Of course, tracing such roots and influences is a curious game when you are dealing with an event that wants to scramble historical traces and turn all traditions upside down. In successfully constructing a pocket universe where radically different rules temporarily apply, the festival disguises its connections—historical, economic, and cultural—to the "real" world. This allows for enormous joy, especially as the real world takes on the lineaments of a cruddy Sci-Fi dystopia, but it is nonetheless crucial to remember the ancestors as well.

The essential cult is the Cult of Experience, a cult to which all Burners in some sense belong. I'll follow my brief overview of that cult with four more specific formulations: the Cult of Intoxicants, the Cult of Flicker, the Cult of Juxtapose, and the Cult of Meaningless Chaos. I have called these patterns *cults* partly because the word suggests a pocket of intense and esoteric social practice that passes through time in a marginal or secret fashion. I certainly don't intend to invoke the authoritarian specters of Jim Jones or Marshall "Heaven's Gate" Applewhite, who preside over the media's vision of *cult*.

I prefer popular culture's sense of the term, which denotes a passionate obsession with pop stars or comic books; we may come and go from such cults as we please.

My list is not at all definitive. It could easily be extended to include such crucial Black Rock cults as the Cult of Flesh and the Cult of Sleeplessness. I have chosen these five cults because of their deep connections to particular features of California's spiritual counterculture. But though my comments are rooted in my research into California's cultural history, I also draw, inevitably, from my personal experience of the Black Rock gatherings I have attended (not quite continuously) since 1994. By *experience* I don't simply mean my firsthand observations and reflections, but also the moments of cosmic wonder and insight that have occasionally flared up in my nervous system, at times with a disarming incandescence.

One particularly vivid moment occurred during the 2002 *Floating World* incarnation of the event. Given the year's aquatic theme, I finally got around to performing a solo shtick I had been planning to do for years, but somehow could never pull off in the face of sloth and distraction. I donned a bathing suit, snorkel, mask, and flippers, and plopped down on a touristy Brazilian beach towel near the main drag. I twisted my legs into *padmasana* (full lotus position) and settled down to meditate for forty-five minutes or so.

As a statement, I guess you could say I was performing my critique of Freud's dismissal of the mystic's "oceanic" consciousness as an infantile resubmersion into the womb.[5] Whatever. What really made the act work were the flippers: huge yellow duck feet that I picked up at a second-hand sporting goods store in San Francisco. Enhancing my already somewhat freakish meditation posture with these Donald Duck jobbies was, simply stated, a hoot—amusing enough, in any case, to wind up featured on a Burning Man Web site for a spell.[6] As a bonus, the gag also allowed an internal experiment: what happens when you juxtapose costumed absurdity with serious meditation?

My snorkel-sit began auspiciously. As soon as I settled into the posture and relaxed my gaze, I inhaled a distant whiff of sage, which grew in strength until I sensed that some unseen person was smudging me. Gradually I opened my mind to the wide space of sounds encircling me. Though I was trying to avoid focusing on particular noises, I soon became aware of a moving cluster of guttural barks and impassioned "Arrgghs." I could not resist categorical identification: pirates. Given the year's theme, I had expected to see many such crews: loud, obnoxious young men walking a dangerous line between

honoring the anarchist sodomites of yore and using a tired Hollywood cartoon to float stupid frat-boy antics. But this was my first encounter.

Within moments, I heard, or rather sensed, a large animal hurtling my way, and in an instant I was tackled by a pirate. He slapped and rolled me around, slobbered curses down my snorkel, and mimed my decapitation by pressing a red plastic sword against my neck, none too gently sliding it across my Adam's apple. I remained perfectly still throughout this commotion, registering but not reacting to it, and because padmasana is an extremely stable posture, I kept my shape even as I was rolled around in the dust like a human pretzel. After capering around for a minute or so, the pirate politely set me back on my haunches and ran off to enjoy further escapades. I immediately recommitted to the posture and my breath, and sat for another half hour or so.

For all of Burning Man's rhetoric of participation, such spontaneous interminglings of theme are relatively infrequent. One often enters into another's "trip," but *two* trips don't often collide with such intensity, and rarely pass into physical contact without consent. To this day, I blaze with admiration for my pirate's aggressive lack of restraint, his perfectly Zen instinct for the performative possibilities of the moment—possibilities that were not only comic, but cosmic. I flashed on the Tibetan practice of *chöd*, wherein the yogi offers his body to bloodthirsty, blade-wielding demons in order to separate himself from self-clinging.

I suspect my pirate had no idea of chöd, nor of the *mahavidya* Chinnamasta, a Tantric goddess pictured with her own decapitated head in her hand, as blood spurts from her neck into her own mouth. But no matter: the fellow had split me open. I was facing the hot sun, and the glow behind my eyelids began to intensify, slowly swallowing me into a sad ecstasy. Inhaling and exhaling the light, I felt my heart open to the massive, glorious pain of being in this world. There I sat, with a serene broken heart, the bands of my Donald Duck flippers cutting into my ankles and my magenta Toys-R-Us facemask slowly filling with tears. Gradually the trance passed. I could hear people stopping to take snapshots, and felt the stirrings of pride. But these feelings and sensations just melted into the red ball of yearning absurdity that the moment had become.

This experience galvanized my interest in the spiritual back story of Burning Man, and you can imagine my delight upon receiving the flier for the 2003 event, announcing its theme as *Beyond Belief*. It appeared that Burning Man was finally going to foreground what, to my mind, had always been its

McBuddha *(2003). Photograph by Jason Silverio.*

most powerful and unspoken undercurrent. The ambivalence implied by the theme's name, which disavows the religious beliefs whose materials it wants to appropriate, was marvelously captured in the illustration by Hugh D'Andrade that graced the 2003 flier. Beneath a mutant cherub blasting the good news, a multiarmed androgynous imp meditates in the center of a labyrinth, flanked by a Lilith-like devil girl and a Ganesha on a skateboard, a lotus flower blooming at his/her lap, and a yin/yang symbol emerging from his/her third eye. We recognize this bizarre and mutant assemblage: its mix-and-match iconography, its humor and faint perversity, its own mischievous refusal to admit whether or not it is "serious." And we recognize it because, like all living icons, it encodes patterns of knowledge and experience burned deep into contemporary consciousness.

The Cult of Experience

At the core of Burning Man's spiritual wager is the commanding claim of personal experience. "Beyond belief, beyond the dogmas, creeds, and metaphysical ideas of religion, there is immediate experience," wrote Harvey.[7] First-time participants quickly learn that status and fun are not to be gained through familiar modes of consumption or spectatorship. Instead, participation, spontaneity, and immediacy are prized, even (or especially) at the sizable risk of delirium, discomfort, or the sort of excess that your parents might call "making a fool of yourself."

On the most basic level, the cult of experience makes itself known through a continual parade of intense and not altogether pleasant physical sensations: the brain-numbing heat and Porta-potty stink, the crusty snot and the dry, cracked feet. These offer continual reminders that *something is definitely going on here.* The cult also manifests itself in the pervasive mode of seduction: the blinky light or exotic body or hilarious shtick that distracts you from whatever goal or concept you were riding in order to draw you ever more deeply into the wildfire of energetic activity blazing in the Here and Now. Burning Man represents the ultimate attention economy: what participants exchange are the willingness, and the opportunities, to submit to new experience. These experiences in turn create stories, which become the coin of the realm, fetishes traded over the fire, always pointing back to the *mysterium tremendum* of consciousness itself.

The cult of experience demands a Sisyphean struggle. Human beings are habit-breeding machines, and no more so than in our patterns of thought, sensation, and perception. Though the Dalai Lama might taste something like "pure experience" on his meditation pillow now and then, we humans sink and swim along a rather mindless stream of consciousness choked with slogans, beliefs, recurrent memories, contradictory plans, and congealed perceptual maps. Burning Man stirs this stuff up. Moreover, as Burning Man matures, its own "immediacy" becomes routinized and codified—an inevitable process, perhaps, though one that has encouraged many old-school Burners to stop attending. Theme camps and spectacles grow familiar, alternative styles of communication and consumption are established, and participants and planners develop systems—psychological and technical—to manage chaos and fear. Even the injunction to "Participate!" becomes rote, and part of the experiential ethos of the festival now includes the active and creative resistance to this creeping process of calcification.

What's important to recognize here is that Burning Man's ahistorical rhetoric of experience is itself historical, and draws from a deep well of American spirituality. The trope of experience already permeated Yankee Christianity by the mid-nineteenth century, when revivalist passions drew whole crowds into powerful fits and feints, visions and revelations. But it was William James who made this subjective turn fundamental to American religious understanding. In his famous *Varieties of Religious Experience*, James argued that experience rather than belief was, if not the cornerstone, then at least the ground bed of religious life. "The plain truth is that to interpret religion one must in the end look at the immediate content of the religious consciousness."[8] This emphasis on consciousness anticipated the individualistic and subjective turn religion would soon take, a move that implicitly generated interest in mysticism and what have come to be called "altered states of consciousness." James argued that these states had to be taken into account if we were to develop an adequate picture of the universe in its entirety. Forever endearing himself to later psychonauts, James put his own neurons on the line by experimenting with ether, nitrous oxide, and peyote.

James by and large couched the experiences he described in Christian terms, although he discussed movements, like mind cure and New Thought, that we would now recognize as progenitors of the New Age. But the "cultures of consciousness" that came to define the West Coast's spiritual avant-garde significantly detached altered states from well-defined religious forms. At Beat

cafés and Acid Tests, and more formally at retreat centers like Esalen and the Ojai Institute, a variety of "post-religious" experiences began to be explored. Bohemians have always placed a romantic premium on personal experience, and this romanticism flourished in the counterculture's embrace of primitive exotica and psychedelic Orientalism. But California's scene also reflected the West's pragmatic culture of sensation and know-how, an essentially empirical approach to matters of the spirit that made tools more important than beliefs. Consciousness-altering techniques like meditation, biofeedback, yoga, ritual, isolation tanks, Tantric sex, breathwork, martial arts, group dynamics, and drugs were privileged over the claustrophobic structures of authority and belief that were seen to define conventional religion. "Spirituality" emerged as something distinct from religion proper. Even when established traditions like Zen or Sufism were creatively engaged, they were embraced more as practical means for changing consciousness than as arid cosmologies or rules to live by. Experience became the teacher. It's a tricky teacher, of course, and the ephemeral insights and ecstasies of consciousness can easily leave one in deep despair or confusion, high and dry without the raft of creed or belief. Nonetheless, given the sense that an imminent change was coming, either political or spiritual or both, experience became the central countercultural path toward transformation.

Curiously, this attitude reflected contemporary anthropological concerns with liminality and rites of passage; as Victor Turner and others explained, the intense, novel, and destabilizing experiences associated with tribal initiations heralded a new mode of social being.[9] Yet because this new mode lacked a homogeneous cultural matrix in the 1960s and '70s, the field of possibly transformative or meaningful experience was wide open—and certainly not limited to "spirituality." Everything was in potential service to the Happening. Every intense situation or wondrous rush was a potential launching pad of the new—or unraveled—self. This lack of distinction helps explain one of the more curious features of the era's subcultures: the commingling of overt hedonism and spiritual practice. Many people routinely moved between these modes— meditating and fasting one week, gobbling drugs and partying the next. Even more potent and characteristic were the "Dionysian" fusions of these two modes into a powerful *spiritual hedonism* that encompassed sacred sex, psychedelic magic, and dizzyingly imaginative gatherings.

Burning Man aggressively extends this tradition of hedonic ecstasy, especially emphasizing its technical or practical underpinnings. Op-Art

visuals, disorienting sonics, and a self-conscious excess of sensory stimulation and conceptual reference all help undermine the stabilized frames of reference that, so the story goes, frustrate our capacity for a fresher taste of the Here and Now. Indeed, the festival can often seem like a single distributed, full-sensorium brain machine, designed to bring us in tune with our mind's ongoing construction of real-time on the fly.

Burning Man's bawdy blasphemy and hyperactive pace also insulate the festival from the sectarian excesses of California's consciousness culture, which led some spiritual experimentalists into the arms of repressive situations conventionally labeled "cults." It would be silly to insist that there is nothing at all cult-like about Burning Man, either in its organizational structure, its architectonics, or its transformative effects on participants. But it remains an open and rather slapdash cult, one that offers no particularly coherent message or any coercive demands. By multiplying the opportunities for novel perceptions and altered states, but undermining the coherence of individual trips with bacchanalian excess and a strong distaste for sacred cant, Burning Man represents, in comparison with the '60s and '70s spiritual counterculture, a "late" form of the cult of experience, at once an advance and a decline. The event is deeply skeptical about overt claims of power or meaning, but is also optimistic about the regenerative capacities of creative, full-intensity living. Though visibly ridiculous and profane, Burning Man's faith in sensation and the carnival of consciousness is, in the end, rather innocent and pure.

The Cult of Intoxicants

One cannot overestimate the role that psychedelics have played over the last fifty years in giving modern spiritual seekers a real kick in the pants. Although avant-garde spirituality has marked the West Coast since the turn of the century, it remained a small and esoteric path until LSD and other drugs offered people a dependable and immediate access to powerful and compulsively intriguing expanded states of consciousness. Burning Man's most relevant psychedelic ancestors remain Ken Kesey and his Merry Pranksters. Profoundly influential throughout the West Coast, the Pranksters' memorable Acid Tests were improvisatory fetes that deployed low-tech multimedia, a ragged carnival of thrift-store fashions, and fusions of performance, participation, and prank. Kesey's famous bus *Furthur* is about as Burning Man as

the '60s ever got: a gas-guzzling art car driven by a macho meth-head, hurtling down mountain sides with festooned crazies shooting film and barking bull-horn commentary through squealing speakers strapped to the roof.

On the surface, the Pranksters distanced themselves from the explicitly esoteric maps that other psychonauts were using in order to make some sense of psychedelic experience. At Millbrook, the upstate New York mansion that served as the intellectual Mecca of psychedelia in the mid-1960s, Timothy Leary, Richard Alpert (later known as Ram Dass), and others were raiding the vaults of Tantra, Vedanta, and Tibetan Buddhism in their quest to maximize and comprehend their journeys. The Pranksters avoided such pretense, and their brief visit to Millbrook, at least as framed by Tom Wolfe in *The Electric Kool-Aid Acid Test*, was a culture clash. Kesey told Wolfe that, as far as the religious use of LSD goes, "It can be worse to take it as a sacrament."[10] But Wolfe also noticed something deeply religious in the Prankster manner, a religion of unmarked experience that would go, occasionally, by the name of "Now." The Pranksters' tomfoolery and systematic evasion of deep meanings were productive attempts to keep the Now fresh, to keep the scene close to the source.

Giving voice to the same hunch that Harvey expressed in his statements on *Beyond Belief*, Wolfe speculated that all the great religions begin, not with some conceptual or philosophical breakthrough, but with "an overwhelming *new experience*."[11] This gnostic flash radiates through the lives of a small circle of folks, generally hanging around a charismatic leader who seems to have plugged into the hidden sources of life. To his credit, Kesey more or less dodged such a messianic role. As the "non-navigator," he interacted with his crew obliquely or through cryptic slogans like "See with your ears and hear with your eyes" or the famous "You're either on the bus or off the bus." In his role as Mr. Burning Man, Harvey has played an even more humble hand, at least in terms of his quietly intelligent public persona. Though the "inner circle" of Burning Man has definite sectarian qualities, Harvey and crew are betting on an even more democratic model of participation than the Acid Tests: if you get anywhere near the bus, if you even *see* the damn thing glittering along in the distance, then you're going to hop on.

One of the reasons so many have hopped on is that, before Burning Man is an art festival or a postmodern ritual, it is a party, an uncorked hoodoo bash. Burning Man organizers ask participants to abide by the same laws that apply in the "real world," yet many disregard this directive. Indeed, indulgence in

intoxicants is seen by many to be fundamental to the event's celebratory, neo-anarchist ethos. Though serious overdoses and sociopathic levels of drunkenness are relatively rare, the feral aspect of such voluptuary activity should not be denied—I vividly recall one snarling female teen who thrust a grubby hand in my face, demanding that I sell her whatever Ecstasy (MDMA) she presumed—without cause—that I was packing. Nonetheless, despite the idiocy and thuggery that intoxicants can inspire, they cannot be separated from the transformative and potentially sacred effects of cognitive ecstasy. Bacchus is a god of wine, Shiva the lord of *bhang*, and Siberian shamans aficionados of *Amanita muscaria*. In its most essential and archaic form, popular religion may be indistinguishable from psychoactive release.

Fundamentally, Burning Man's cult of intoxicants is a cult of pleasure—Ecstasy rivaling alcohol as one of the most popular substances on the playa. Nonetheless, the more turbulent and mind-bending psychedelics remain a supreme sacrament in this particular cult, and they are pleasurable only in a qualified sense of the term. Psychedelics, or entheogens, as they are now sometimes called, amplify and transform perceptual processes, jacking consciousness out of its usual ruts. At higher doses, they seem to catalyze awesome experiences of cosmic fusion, revelation, synchronicity, and demonic paranoia that often seem impossible to process without invoking sacred frameworks, however provisionally.

Today, the question of psychoactive spirituality remains tied up with the problem of authenticity. Shamanic societies the world over maintain relationships with "plant teachers" in the context of deeply nuanced and relatively homogeneous world views. Modern consumers, on the other hand, are basically flying blind, whatever their self-styled shamanic beliefs. Despite the mystic insights and magical paradigms that entheogens may unveil, they are also, for us, secular and modern: commodity molecules that rather dependably tune the nervous system to particular channels in the spectrum of consciousness. From this perspective, we can only say that entheogens can produce *something like* spiritual or visionary experience. We can look at them as reality-modelers with powerful special effects but weak claims on truth. But by bracketing the "truth" of the experience, psychedelics may paradoxically move spirit beyond the bugaboo of authenticity. People who undergo mystical or visionary states of consciousness "on the natch" often face the overwhelming temptation to reify and cling to their phantasms, realizations, and insights as real—a temptation that often leads to "religion." Psychedelics, on the other hand,

disenchant the very exalted states they also introduce to the psyche. Amazing mind states may follow the swallowing of a pill or the insufflation of a noxious powder, but they also pass away as the compounds are metabolized and flushed from the body. In this way, drugs may encourage us to sap the illusion of essence from all states of consciousness—not just this serotonin trance we take for ordinary reality, but from even the most legitimate mystical experiences. Everything is a construction, an endless mediation of mind and materials.

Such strange loops proliferate at the Burn, which few will be shocked to hear represents the bleeding edge of contemporary American psychedelic culture. Though detailed figures are of course impossible to come by, it seems that a moderately sized but passionate chunk of Burners amplify their playa escapades with compounds such as LSD, psilocybin mushrooms, ketamine, and 2C-B. But the psychedelic intensity of the Man does not depend on the morphology or even presence of the tryptamines saturating the cranial fluid of its more sophisticated drug users. It lies instead in the qualities of playa experience itself, especially at night, when lights and spaces become yawning portals that shuttle your nervous system into a spin cycle of possible worlds. Even those hewing the straight edge launch into their evenings like trippers, packing supplies and opening their psychic gates to a diverse but strangely coherent stream of synchronicities, fractured archetypes, visual phantasmagoria, and unsettling transhistorical implications—the bulk of which will not be recalled the next morning. Wandering the playa in any state, one is simply no longer lord of one's house.

In contrast to the self-consciously "spiritual" frameworks that surround, say, the contemporary use of *ayahuasca*, Burning Man's psychedelia is raw, lusty, and chaotic. Its cult of intoxicants does not isolate "good" visionary compounds from party drugs. This resistance to explicitly sacred metanarratives could well be criticized as a dangerous refusal to inculcate the higher, more integral potential of entheogens. But I suspect that, as with the cult of experience, this refusal simply reflects Burning Man's spirit of cognitive diversity, one that takes psychedelics not so much seriously as aesthetically. As such, its psychotropic landscape disenchants as much as it enchants, and offers playful tricks as antidotes to the cosmic revelations that inevitably come. For even though Burning Man celebrates visionary capacity, it does not deny the peculiar and even garish emptiness of drugs. This void may offer the deepest teaching of all: you can't really see the patterns until you encounter the nothingness that they etch.

The Cult of Flicker

In his 1970 media-freak classic *Expanded Cinema*, the Los Angeles writer Gene Youngblood defined his era as the "Paleocybernetic Age."[12] Pumped up on Marshall McLuhan and the cult of experience, Youngblood sensed a new phase of culture and humanity emerging, one that unleashed the liberating power of archaic consciousness into a technological society whose growing understanding of *systems*—cognitive, technological, anthropological—was laying the groundwork for radical change. Youngblood saw the Paleocybernetic Age reflected in the media experiments he describes in his book, a catalog of underground cinema breakthroughs leading up to and including light shows, installations, and performances. For Youngblood, expanded cinema meant nothing more or less than expanded consciousness, the drive—spiritual as well as technological—to manifest the spectral machinery of mind in the world before our eyes. This is the cult of flicker.

However you dub the vibe—paleocybernetic, future primitive, or technopagan—West Coast artists have long deployed new visual technologies in the service of trance states well outside (and antecedent to) the official boundaries of modern consciousness. Well before the Prankster Acid Tests and Avalon ballroom light shows of the '60s, San Francisco was home to a nuanced and esoteric tradition of expanded cinema that included Harry Smith's Bop City jazz projections and the profoundly immersive Vortex Concerts staged by Henry Jacobs and Jordan Belson at the San Francisco Morrison Planetarium in the late 1950s. During these concerts, Belson, who went on to make sublimely cosmic experimental films like *Samadhi* and *Re-Entry*, projected largely abstract images through hundreds of projectors, some of which rotated or flickered or zoomed, against the sixty-foot dome of the planetarium. Belson called it "a pure theater appealing directly to the senses."[13]

Less visible (but nonetheless present) during the punk era, the Paleocybernetic vibe again rose to prominence in the early 1990s, when the incoming futurism of global rave culture fused with and rekindled California's penchant for psychedelia. Expanded cinema found its way into the photon jams of local club VJs, especially in the subculture surrounding trance music. (This explicitly psychedelic dance music, characterized by invariant beats and squiggly, heavily flanged melodies, has only recently begun to lose ground as the dominant party genre of Black Rock sound systems.) Although the digital mixtures of abstract graphics and mystic iconography associated with the trance scene rarely rose above candy-

flipping kitsch, a smaller group of sound-and-video artists continued to push the experimental edge, exploring modular programming tools and complex algorithms to massage and plumb new patterns of hypnotic abstraction.[14]

But the screen only gets you so far. Given the ubiquity of LCDs and cathode ray monitors in our everyday lives, and the impossibly high production values that go into mass consumer simulations like Hollywood movies or Middle Eastern wars, a truly viable cult of flicker must reclaim the visual space outside the box. This is perhaps Burning Man's greatest aesthetic triumph: the creation of an immersive and chaotically collaborative space of expanded cinema that marries a wide range of visual media, both fancy and crude, with the most powerfully archaic flicker tech of all: fire.

From the burning bush to Viking funerals to the iconography of hell, fire carries an intense symbolic load. But the true greatness of fire lies in the fact that such symbolism is nothing more than cardboard and Kleenex in the face of the blazing thing itself. We are all metaphysical children before arc lights or bonfires or propane explosions, fascinated by fire's all-consuming alchemy of beauty and threat. This fire-lust flickers at the core of consciousness itself. Twenty thousand years ago, when the Black Rock Desert lay beneath tons of Pleistocene sea, our ancestors had already spent untold generations with fire. Its shadow dance must have formed the visual track to oral tales, proto-dance, and goddess knows what manner of ancillary rites. We often hear that modern consumer culture has replaced the hearth with television, but we seldom draw the full implications out of this received notion, which is that *fire was the old ones' TV*. Some of that hypnotic power continues to animate the fire-twirling that remains, despite its formal limitations, Burning Man's signature performance art. For spectators, these highly ritualized performances function as a syncretistic cult of flicker and flesh; for twirlers, they offer a literally elemental encounter—a dance of power and risk, a mutual seduction, an erotic opportunity to lick and swallow an incorporeal event that feeds on matter itself.

As the festival's early madness gave way, perhaps inevitably, to the demands of safety, the destructive potential of Big Fire was significantly curtailed. Burning Man's central event has now become a controlled fireworks display far less immersive than the fearsome and toxic rites of earlier years. In the Debordian sense, fire has become increasingly *spectacular* in these latter days of the Burn. For Debord, the spectacle—the totalizing pseudo-world of

technical mediations that grease the capitalist system—profoundly alienates us from actual life through its endlessly circulating images.[15] Though Burning Man works against this alienation and scrambles its relationship to capital through a gregarious potlatch, the central event of the Burn, whose neon inflagration mingles with a myriad of camera flashes, reminds us that the festival is also shaped by postindustrial circuits of technical mediation. But perhaps Debord's situationist critique cannot really touch Burning Man's Big Fire; perhaps the central conflagration itself is so deep and so old, so visceral and profoundly excessive, that for a spell it consumes all frames.

Although Burning Man has gentrified fire, the festival has also intensified the technology of flicker. Though screens are relatively rare in Black Rock City, the nighttime playa-scape has itself evolved into a vast, three-dimensional display of artificial *lumiere*. At night we find ourselves navigating through the after-images of a friendly arms race of lighting designers, who continue to push the envelope on relatively new (and increasingly cheap) technology like lasers, electroluminescent wire, LEDs, glow sticks, and computer-controlled strobe lights. Myriad lines, dots, and blinky lights dance before your eyes, many forming specific icons like Mayan pyramids or mobile jellyfish. Even the high beams and sirens of law enforcement vehicles weave themselves into the virtual scene, especially on Sunday night, when a bit of the old-school fire chaos returns. It's bardo time: the street signs are stolen, familiar structures are gone, and you are forced to navigate by nothing more than a hazy constellation of confusing lights, slowly shutting down.

The Cult of Juxtapose

Like the institutionalized postmodern art it both imitates and mocks, the aesthetic language of Black Rock City is a language of juxtaposition. A potential effect of all collage and assemblage, the energy of juxtaposition is released especially where heterogeneous elements are yoked together without the intent to smooth out their differences. Juxtaposition is the fundamental strategy of surrealism and its postmodern descendents, which most certainly include Burning Man.

One often hears Burning Man dismissed as a theme park, but what's more important is that it contains thousands of theme parks—little pocket universes butting heads. Space-time itself seems to morph into a flea market,

a masquerade of memes, or the Mos Eisley spaceport from *Star Wars*. Even though many of Burning Man's camps and costumes are, in themselves, devoted to a particular theme—the bayou, Bedouins, octopi—these elements inevitably crisscross in the turbulent, constantly flowing serendipity of playa life. Here juxtaposition is revealed as the basic formal operation of synchronicity, as two apparently unrelated events or elements suddenly form a secret link that strikes, in the mind of the perceiver, an evanescent lightning bolt of meaning. Even lame or boring expressive moves can be redeemed through the chance collaborations that define Black Rock City's densely layered polyurbanism, where synchronicity becomes a basic operation of social and cognitive reality, a kind of "grace" that emerges through clashing fragments.

Juxtaposition is also the chief strategy employed by many art installations, costumes, art cars, and theme camps. As in the case of Arcimboldo's Mannerist paintings depicting human heads made out of fruits and twigs, many art objects derive their power through the juxtaposition of image and material—Dana Albany's *Bone Tree*, say, or her 2001 *Body of Knowledge*, a cross-legged man, built from old hardcover books, who bore more than a passing resemblance to Arcimboldo's *Il Bibliotecario*. Other surreal contrasts arise through the placement of objects—huge red fuzzy dice, a bed, a lone piano—against the stark minimalism of the playa itself. Theme camps like Elvis Yoga stitch together elements associated with divergent cultures; costumes are often thrift-store patchworks featuring bold clashes of color, material, and iconic evocations of forgotten subcultures.

These different modes of juxtaposition generate many of the well-loved effects of the festival: absurdity, instability, irony. But they particularly inform the festival's treatment of spiritual and religious forces (recall the hybridized *Beyond Belief* figure on the Burning Man flyer discussed above). In this context, juxtaposition allows people to invoke sacred forces while sidestepping issues of belief, earnestness, or responsibility. I can think of four recent examples here. For his recurrent Center Camp piece *Twinkie Henge*, Dennis Hinkcamp used the perennial Hostess treats to construct a small-scale version of the famous megalithic monument. In 2002 and 2003, the playa was blessed with a huge seated Ronald McDonald—a gold-painted inflatable sporting a Nepalese third eye and smiling beatifically onto the crowds. Since 1998, Finley Fryer has occasionally presented an incandescent chapel built of recycled plastic. And in 2000, David Best began a series of enchanting and celebrated Temples that came to demarcate the most authentically reverent

spaces on the playa; with the exception of 2003's mosaic Moghul confection, he conjured the exotic filigree of these structures from the pressed-wood scraps left over from the manufacture of kids' dinosaur puzzles.[16]

The apparent irony of these gestures is actually a doorway into a deeper and subtler movement of spirit. Modernity has bequeathed to many of us a profound disenchantment with both the cultural and institutional forms of religion as well as the beliefs that sustain them. At the same time, many feel the sneaking suspicion that such forms may be necessary as vehicles or containers of the visionary insights and sacred energies many continue to crave. Though these forms may successfully channel the spirit for a time, they inevitably fail: they become consumer idols, or safety blankets, or cheesy parodies of themselves. By affirming an ironic relationship to these forms, we draw attention to their incompleteness, to their inability to satisfy our yearning or sustain the disenchanting movement of spirit. This sort of irony is more than a cynical operation in cahoots with the secular disavowal or mockery of spirituality. Rather, it is a sacred irony, one that itself marks the margins, and occasionally the core, of historical religions. When Ramakrishna donned ladies' clothes, or Yun-men proclaimed that the Buddha is a shit-stick, the point was to shatter form through contrast. Ironic juxtaposition, in this context, is revelatory. For minimalists of the spirit, such irony may clear the air for the formless beyond; but the maximalists at Burning Man gather together the wreckage of forms into a fallen Humpty Dumpty bonfire of apocalyptic collage.

West Coast spiritual culture has long shown an affinity for juxtaposition. Part of this is rooted in California's syncretistic religious supermarket, especially in Los Angeles, where Hindu onion domes and Mayan Masonic halls fit in just fine alongside eateries shaped like oranges or hats. But this sensibility also emerged from the plastic arts of the place, particularly the love of appropriation, collage, and assemblage (or structural collage). As Peter Plagens noted in his 1974 book about West Coast art, *Sunshine Muse*, "Assemblage is the first home-grown California modern art."[17] During the late 1950s, Beat artists such as Bruce Conner, George Herms, and Wallace Berman constructed objects and made collages that strongly engaged images of sex, fetishism, and spirit. Hearst Castle showed that even the wealthiest Californians yearned to sample and slam together times and places. But the iconic grass roots example remains Simon Rodia's *Watts Towers*, three famous free-form spires built, without plans, from pop bottles, tiles, and teacup handles.

The bohemian economics of making art far from New York partly drove this bricolage—artists started playing around with bits and pieces for the same reason the Merry Pranksters were driven to scavenge thrift stores—and hence history—for clothes. An alchemy of trash emerged, one that not only made a virtue of necessity but also suggested a new kind of aesthetic pleasure. Today we enjoy some Burning Man artworks simply because of the low cost and crappiness of their materials. But such regenerative work has far deeper implications. According to the San Francisco poet Robert Duncan (who used collage techniques in his gnostic modernist verse), "The trivial is as deep as the profound because there is nothing in creation that does not go to the profound."[18]

Of course, the reverse of this claim may be just as true. One result of today's corporate colonization of the unconscious is that even our most cherished profundities are trivialized. Burning Man plays with both movements in its topsy-turvy game of sacred and profane. But the redemptive potential of juxtaposition goes beyond the binary oppositions that compose such hierarchies, pointing toward a deeper and more continuous alchemy. Probably the greatest expression of the West Coast poetry slam remains Allen Ginsberg's 1955 "Howl," resplendent as it is with weirdly fused phrases like "hydrogen jukebox." In the poem, Ginsberg speaks of those in his generation who open up to the eternal through culture clash and the imaginal confrontation with urban junk. Forty years later, Burners have now decisively joined those "who dreamt and made incarnate gaps in Time & Space through images juxtaposed ... "[19]

The Cult of Meaningless Chaos

Perhaps you are wandering aimlessly across the playa at night, and, lo and behold, some distracting marvel captures your attention. In the ambiguous distance, you glimpse a filigree of light and shadow, an oasis of surreality, a portal to some possible pleasure. You head toward the dusty fairy lights as if they were a Sci-Fi tractor beam, the amazement increasing until you finally arrive and discover a rag-tag structure consisting of a few 2 x 4s, some rebar and wire, and a nest of duct-taped blinky lights feeding off a grumbling generator. Ingenious! Against the glimmering canvas of the night, this jury-rigged contraption produced just the right visual cues to conjure an empty

thing of beauty and wonder right out of your own nervous system. You are simultaneously satisfied and disappointed; you admire the creative gift but sense a strange, smirking con in the works. The cosmic carnie barker leans forward and whispers in your ear: "Just a show, my friend, you pays your quarter and you takes your ride. Up for another turn on the wheel? Just watch out for those smoky lights..."

Burning Man's backdrop is more than the blank playa or the desert nightscape: it is the Void. The barbarous, post-punk, devil-may-care panache of so many Black Rock citizens is only the most obvious sign of the nihilistic underpinnings of the event—especially resonant these days, when the cybernetic meltdown of posthuman civilization only magnifies the old familiar zero at the heart of the human condition. Burning Man's apocalyptic undertow—mocked, ignored, and indulged in with equal abandon—rescues the festival, at least some of the time, from frivolity and cliché. By opening its arms to the void, without fear or hope, Burning Man thickens the event's "official" discourse of celebration, creativity, and community, lending these optimistic cultural narratives a darker urgency. Burning Man's void is not, however, a meaningless blank—it is a creative chaos, an intense invocation of novelty, humor, and weirdness on the lip of the abyss. This hyperactivity represents Burning Man's debt to the expressive mania shared by the Dadaists, the Pranksters, and every other group of void-gazing *artistes* who made kinky love among the ruins. But whereas the Dadaists unleashed their gibberish in small clubs in Berlin and Zurich, Burning Man turns the city form itself into a theater of the absurd—not just Marx Brothers absurd, or Kierkegaard absurd, but downtown-Hong-Kong-on-a-Saturday-night absurd.[20]

Burning Man's manic and generous creativity also suggests a deeper teaching. Buddhism, Taoism, and Hindu Tantra all suggest that the reality that lies on the far side of form, the reality of emptiness or the unstructured Tao, is *full of potential*. Like the quantum vacuum pictured by free energy enthusiasts, the void flings phenomena out of itself. Some Taoists considered meditation and ritual as means to return to the original unformed chaos that would connect them with the sources of life before returning them to the world of our senses five. At its oversaturated best Burning Man rides the formless edge of form, generating shapes and signals that constantly slip back into noise and confusion. The festival beckons us, in Lex Hixon's poetic paraphrase of a line from the *Prajnaparamita Sutra*, "to

abide without abode, to dwell where no objective or subjective structures can dwell, without any underlying physical or metaphysical foundation, totally isolated from conventional conceptions, perceptions and descriptions."[21] This is the realm of sacred chaos.

The classic Eastern notion of the pregnant void also mirrors one of the core intuitions of Western anarchism, which is that things get along just fine without order being imposed from without. Anarchism and Taoism's chaos spirituality thus share a faith in the spontaneous and fecund powers of the creative process, and a sense that this productive flux diverges from the overt organization of social forms. In Deleuzian terms, the Tao *deterritorializes*.[22] This process remains in a precarious and sometimes agonistic relationship with civilization, which not only demands order from without, but order from above. As N. J. Girardot wrote:

> The Taoist accepts the fact of being born into a civilizational order but does not accept the possibility that civilizational values define what it means to be fully alive and human. The acceptance of phenomenal existence requires a more profound recognition of the fact that fulfillment and renewal of human life depends on a periodic return to a chaotic or primitive condition.[23]

Civilization is not what it used to be; today's destratified empire of global capitalism has learned to absorb, exploit, and deploy chaos in sophisticated ways. Nonetheless, the archetypal conflict between chaos and civilization remains one of our deepest structuring binary myths, right up there with good and evil or male and female. In one of the primary versions of this tale, the Mesopotamian hero Marduk, the god-king of Babylon, kills Tiamat, the old goddess of primal chaos. From her corpse he makes the heavens, with its fixed stars and ordered constellations. This myth suggests the way in which the urban state, with its investment in complex organization, would come to demonize the ancient seething matrix from which it emerged, and that always threatens to engulf it again in waves of destruction and social anarchy. Although traditions like Taoism retained organic connections to the pregnant void, and carnivals allowed little bits of chaos into Christian culture in the West, most avatars of chaos were shunted into the shadows of increasingly patriarchal religious forms.

The antiauthoritarian tendencies of bohemian culture have long given it a taste for Dionysian chaos, and its spiritual regimens have privileged

a Rimbaud-like derangement of the senses. Aleister Crowley, for example, in addition to his prophetic enthusiasm for sex and psychoactive drugs, reimagined the demonic dimensions of Western occultism as an atavistic and Nietzschean force field capable of creatively destabilizing patriarchal civilization. But the explicit countercultural worship of chaos proper did not take form until 1958, when two beatniks, known eventually as Omar Ravenhust and Malaclypse the Younger, had a vision of the goddess Eris (or Disorder) in an all-night bowling alley in California. Whether or not this origin story is true (and why not believe it?), Malaclypse the Younger, whose given name is Gregory Hill, eventually put together the *Principia Discordia: Or How I Found the Goddess and What I Did to Her When I Found Her*. The pamphlet is a visionary assemblage of nondual wisdom, hotdog jokes, and appropriated collage art—a core sutra in the cult of juxtapose. An underground hit in the late 1960s and early 1970s, the *Principia Discordia* communicates an eclectic, goofy, and skeptical antidoctrine of spiritual chaos or "Zenarchy." "If you can master nonsense as well as you have already learned to master sense, then each will expose the other for what it is: absurdity."[24] This "magnum opiate," with its corny profundities and free-fall praise of the sacred Chao, would go on to influence Robert Shea and Robert Anton Wilson's *Illuminatus!* Trilogy, the Church of the Subgenius, and, eventually, Burning Man.

Whether interpreted creatively or destructively, chaos proclaims the impermanence of all forms. This is why it is both funny and terrifying. In the case of Burning Man, one form that has notably fluctuated is the relation to chaos itself. The festival has witnessed some dramatic changes in structure and character over the years, and has passed through at least two major bifurcations. In 1990, the Cacophony Society's John Law led the gathering to the Black Rock Desert from San Francisco. Seven years later, after Law departed from the organization in a disagreement about how to manage the growing crowds, Burning Man moved off the main playa to a smaller, privately owned site known as Hualapie Playa. Although fortunately temporary, this move was accompanied by a permanent ban on automobiles and firearms, along with the imposition of the semicircular concentric grid of streets (and street-signs) that continues through today. The 1990 event was still a loose gathering of friends, whereas Burning Man has now shifted into a well-established and specifically *urban* phenomenon. In other words, like some freak show replication of *Sim City*, this festival of chaos came to replicate the core framework of civilization itself.

There were many reasons for this later, more "developed" phase: population pressure, the demands of various bodies of the state, and the inevitable desire to creatively improve public works. As such, this urban transformation by and large occurred with an air of organic inevitability. Burners with strong anarchist principles griped that these developments compromised the festival's incarnation of what Hakim Bey famously dubbed a "temporary autonomous zone."[25] After all, the sacred Chao would have us interrogate all linear narratives of inevitable development—particularly when those developments concern the sacred Chao itself. Although not necessarily cooler or more engaging, Burning Man was a significantly more disordered (and less civilized) event before 1997. The presence of assault rifles, the lack of safety controls and street signs, the dizzying distance from mountains and roads, the more feral demographic—all these elements brought participants into a greater proximity to chaos, emotional and perceptual as much as physical and infrastructural. In contrast, the chaos of today's festival often feels contained, more semiotic than corporeal, a perversion of the already surreal attention economy one finds in Las Vegas or Times Square. And much of this derives from the crystallized architectonics of the festival: the invariant city layout, the establishment of dance-clubs along the esplanade, the neon "advertising" of the nightscape, and the centralized logo of the Man.

No one should be surprised by this calcification; certainly not students of spiritual chaos. As Tom Wolfe showed in his study of the Merry Pranksters, the spontaneous immediacy of a weird scene's early "Now" is tough to maintain as the gospel spreads and the masses turn on. Sociologist of religion Max Weber described this process as "routinization."[26] In Weber's view, religious movements begin with the otherworldly charisma of an extraordinary, even supernatural leader who punctures the everyday grind. Over time, in a quest to guarantee that believers have dependable access to this charisma, it becomes institutionalized in schools, positions of authority, and dogmas. "Charisma cannot remain stable, but becomes either traditionalized or rationalized, or a combination of both."[27] Thankfully, Burning Man's charisma does not lie in a singular individual, but in the nonhierarchical social field of the collective. Although Burning Man's routinization has not created a particularly visible hierarchy of authority, the problem of routinization remains. In a sense, this problem is manifested as the urban form itself—a form that maintains a febrile and polyvocal diversity even as it constrains the more unsustainable excesses of chaos.

We should not conclude from this that Burning Man has at all lost its sacred spark. As the vampiric tendrils of consumer media and the surveillance society wrap themselves ever more tightly around the heart of human experience, the festival continues to successfully ride the paradox of regulating a temporary autonomous zone. The cults I have outlined all speak to the power of this paradox, since they reflect streams of cultural continuity that remain fresh and unstructured partly by erasing their own historical traces. Moreover, a powerful assemblage of social and creative energies has emerged from Burning Man's turn toward urban organization. The festival's late phase has also been marked, unquestionably, by its greatest art, art that absorbs and permeates social space and personal interactions. Utopia, we should not forget, is a city. For a week or so, Black Rock City is a polis without cash, where citizens walk and ride bikes more than they drive, where people finally begin to realize the admonition of that annoying Berkeley bumper sticker: "Practice Random Acts of Kindness and Senseless Acts of Beauty."

Northrop Frye reminds us that William Blake identified Eden with the realized human imagination, and that the poet saw this paradise not as a peaceful garden, but as a fiery city.[28] Not a Rainbow Gathering, in other words, but a Black Rock town, going wild.[29] Like the human imagination, the city is an absurd excess: it flickers, it intoxicates, it energizes forms that its own energies consume. And we can see terrible forebodings in this incandescence, pulsing like warning lights on the near horizon of space-time. Burning Man stages the city as utopia and as inevitable catastrophe simultaneously. But this city is also imaginal, remember, as much inside *us* as out. Rome burns as we burn, amazed adults in a Pleistocene playground, belting out the old refrain: *ashes ashes we all fall down.*

NOTES

The first epigraph is from John Everard, *The Divine Pymander of Hermes Mercurius Trismegistus: In XVII Books. Translated Formerly out of the Arabick into Greek, and thence into Latine, and Dutch, and Now out of the Original into English; by That Learned Divine Doctor Everard* (London: printed by Robert White, for Tho. Brewster, and Greg. Moule, at the Three Bibles in the Poultrey, under Mildreds Church, 1650), book 15, section 40. The second is from Friedrich Nietzsche, "Thus Spoke Zarathustra," in *The Portable Nietzsche*, trans. Walter Kaufman (New York: Viking, 1954), 129.

1. Editors' note: ADD is attention deficit disorder.

2. Marvin Meyer, *The Ancient Mysteries* (Philadelphia: University of Pennsylvania Press, 1999), 38.

3. Darryl Van Rhey, "The Burning Man: A Modern Mystery," *Gnosis* 36 (1995): 6.

4. See George Mylanos, *Eleusis and the Eleusinian Mysteries* (Princeton: Princeton University Press, 1961), 262.

5. Sigmund Freud, *Civilization and Its Discontents*, trans. James Strachey (New York: W. W. Norton & Company, 1989), 10.

6. Available from http://www.anonsalon.com/bman02/bm02stills6.html (accessed June 3, 2004).

7. Available from http://www.burningman.com/themecamps _installations/bm03_theme.html (accessed June 3, 2004).

8. William James, *The Varieties of Religious Experience* (New York: Longmans, Green, and Co., 1902), 12.

9. See Victor Turner, *The Ritual Process: Structure and Anti-Structure* (Ithaca, N.Y.: Cornell University Press, 1969. See also Arnold van Gennep, *The Rites of Passage*, trans. Monika B. Vizedom and Gabrielle L. Caffee (Chicago: University of Chicago Press, 1960 [1908]) and Mircea Eliade, *Rites and Symbols of Initiation* (New York: Harper & Row, 1958).

10. Tom Wolfe, *The Electric Kool-Aid Acid Test* (New York: Bantam, 1968), 26.

11. Ibid., 164.

12. Gene Youngblood, *Expanded Cinema* (New York: Dutton, 1970), 41.

13. David Curtis, *Experimental Cinema* (New York: Universe Books, 1971), 75.

14. Editors' note: candyflipping is a colloquial term that refers to the practice of combining LSD with Ecstasy.

15. Guy Debord, *Society of the Spectacle*, trans. Donald Nicholson-Smith (New York: Zone, 1994).

16. See Pike's essay in this volume for more on the Temples.

17. Peter Plagens, *Sunshine Muse* (New York: Praeger, 1974), 74.

18. Peter O'Leary, *Gnostic Contagion: Robert Duncan and the Poetry of Illness* (Middletown, Conn.: Wesleyan University Press, 2002), 112.

19. Allen Ginsberg, "Howl," *The Portable Beat Reader*, ed. Ann Charters (New York: Viking, 1992), 67.

20. Personal communication with Speed Levitch, San Francisco, November 23, 2003.

21. Lex Hixon, *The Mother of All Buddhas* (Wheaton, Ill.: Quest, 1993), 5.

22. See Gilles Deleuze and Félix Guattari, *A Thousand Plateaus*, trans. Brian Massumi (Minneapolis: University of Minnesota Press, 1987).

23. N. J. Girardot, *Myth and Meaning in Early Taoism* (Berkeley: University of California, 1983), 95.

24. Malaclypse the Younger, *Principia Discordia* (Port Townsend, Wash.: Loompanics Unlimited, 1958), 74.

25. Hakim Bey, *T.A.Z.: The Temporary Autonomous Zone, Ontological Anarchy, Poetic Terrorism* (New York: Autonomedia, 1985).

26. Max Weber, "Charismatic Authority and its Routinization," in *The Theory of Social and Economic Organization* (New York: Oxford University Press, 1947), 358–72.

27. Max Weber, *Economy and Society*, eds. G. Roth and C. Wittich (Berkeley: University of California, 1978), 246.

28. Northrop Frye, *Fearful Symmetry* (Princeton: Princeton University Press, 1947), 49. My final comments are indebted to many passionate conversations with Edward Phillips.

29. For more on the Rainbow Gathering, see Hockett's essay in this volume.

Burning Man ticket (2003). Photograph by Roth Hall.

Fires of the Heart

Ritual, Pilgrimage, and Transformation at Burning Man

Lee Gilmore

Among the numerous qualities of the Burning Man experience that are shared by all festival participants—the heat, the dust, the Burn—there is one aspect that is of necessity universal: the journey. Whether they come over the Sierra Nevada range from the San Francisco Bay area, through the rainforests of the Pacific Northwest, by plane from the East Coast or across the pond, or simply down the road from nearby Gerlach, the festival's remote location on the Black Rock Desert playa requires all attendees to travel to join in the happening. I take the rituals of this voyage as my point of departure. Year after year, thousands of individuals seeking a temporary alternative to their ordinary daily lives make a pilgrimage to Burning Man. A large majority make this journey more than once, despite the numerous challenges and hardships necessitated by the location's harsh desert environment, and many return with the feeling that their lives have been irrevocably changed. What is it about this journey that engenders such widespread feelings of transformation for so many? Is there something intrinsic to the event's rituals or desert sojourn itself that leads participants to frame their experience as one of transformation and release? I seek to address these questions by

examining the ritualistic frameworks of Burning Man, its performance as an annual pilgrimage, and participants' narratives of their experiences.

In my quest to understand this phenomenon, I turned first to the work of anthropologist Victor Turner, whose theories of ritual and pilgrimage invite comparison to certain attributes of the Burning Man festival. Turner famously described three distinct phases through which participants in rites of passage are said to progress: *separation* from the mundane world into a *liminal* realm outside of normal society and perceived as being "betwixt and between" the sacred and the profane, and finally *aggregation*, whereby the initiate returns to the mundane or secular world with new status and/or experiential knowledge.[1] Turner further characterized liminality as prompting an experience he called *communitas*, marked by feelings of communal unity and egalitarianism that disrupt the structure of normative hierarchical relationships. Noting that the traditional liturgy and sacraments of his own Catholic faith offered little in the way of the sort of liminal experiences that he identified in his fieldwork in Africa, Turner, in collaboration with his wife, Edith, looked to the phenomenon of pilgrimage in the Christian world, where they perceived the processes of liminality, antistructure, and communitas in action. In the ritualized journey and hardships encountered through a pilgrimage, Turner identified, "some of the attributes of liminality," including:

> release from mundane structure, homogenization of status;
> simplicity of dress and behavior; communitas; ordeal; reflection
> on the meaning of basic religious and cultural values; ritualized
> enactment of correspondences between religious paradigms and
> shared human experiences; emergence of the integral person from
> multiple personae; movement from a mundane center to a sacred
> periphery which suddenly, transiently, becomes central for the
> individual, an *axis mundi* of his faith; movement itself, a symbol
> of communitas, which changes with time, as against stasis
> which represents structure; individuality posed against the
> institutionalized milieu; and so forth.[2]

Those who have attended Burning Man may recognize many of these aspects in their own experience (with the possible exception of dress and behavior, which is typically flamboyant and eccentric, yet still indicates participants' shared condition). The experience certainly cultivates a strong sense of connection and communitas among participants. Nor is it without

its moments of ordeal, ritualized enactments, and reflections on self and cultural values. In the collective journey to a distant desert outside the realm of ordinary experience, participants may encounter transformations of perspective and identity that reach deeply and unexpectedly into their lives in an enduring, even permanent, fashion. I am by no means alone in my recognition of the ease with which Turner's work can be applied to Burning Man, as is attested by some of the other contributions in this volume.[3] Indeed, Turner's theories appear to have permeated popular culture such that the ritual frameworks he outlined function not only as apt descriptions of Burning Man, but to some extent serve to define the context in which such an event has taken shape. Burning Man can be seen to reflexively embody other theories of ritual, religion, and culture, and Turner's critics are not without their own insights into what makes this event tick. Event participants too have their own discordant voices and alternate interpretations. In order to illustrate how these theories are reflected in the rites of Burning Man, I turn now to a discussion of these events.

Ritual without Dogma

Burning Man has been said to offer an experience of ritual without dogma, and participants are encouraged to make whatever they can or will of their experience of the event with only minimal recourse to an explicitly demarcated "meaning." As one longtime participant wrote, "Burning Man employs ritual, but it is ritual removed from the context of theology. Unhindered by dogma, ritual becomes a vessel that can be filled with direct experience. Burning Man is about having that experience, not about explaining it."[4] Of course, we academics cannot resist the tantalizing opportunities Burning Man presents for analysis and explanation (indeed, our own immediate experiences of the event may at times be dominated by the quest for understanding and interpretation) and these ostensibly "empty" ritual contexts offer themselves up for explication.

The stated refusals of doctrine notwithstanding, Burning Man nevertheless encourages attendees to tap into a vast, multicultural well of symbolic resources with which to playfully explore and locate their experiences. In order to provide a framework for this exploration, event organizers have, since 1996, conceived of annual "themes," which have grown in complexity

as the event itself has matured.[5] While never encompassing the totality of creative expression at Burning Man, these themes do provide a mythological starting point by teasing out various symbolic threads that are embedded in our culture(s). These themes are then made manifest in much of the interactive artworks and performances created for the event.

Furthermore, while they may categorically reject any orthodoxy, Burning Man organizers do promote an orthopraxy by way of a clearly delineated ideology of ethics and culture, encompassing principles of personal, social, and environmental responsibility. Perhaps the most important of these key values is the emphasis on *participation*. The oft-repeated tenet "no spectators" reflects a community ethos that strongly encourages attendees to be actively engaged as "participants" in the event, rather than remaining passive and disinterested as "spectators," although the specific means or manner of participation is theoretically limitless. Some demonstrate their commitment to community by filling volunteer roles for the Burning Man organization, while others create or participate with the numerous, and often ambitious, interactive art installations. Through art and performance, festival participants engage in a reflexive process that engages syncretically with global cultures. This can be observed in the extraordinary range of costuming that is displayed at the event, allowing individuals to "perform" a host of cultural symbols such as horned demons, winged angels, and blue-skinned faeries, as well as aliens, clowns, and Santa Clauses. The endless variations by which participation manifests at Burning Man can in themselves be seen as a form of ritualization.[6]

A great deal of the ritualizing at Burning Man involves fire, which operates both as a symbol and as an agent of transformation. The most conspicuous rite in which nearly all festival attendees participate to some degree is "the Burn"—the conflagration of the Burning Man effigy itself, which traditionally marks the climax of the event. During the days and even weeks preceding the Burn, participants' collective levels of excitement and anticipation rise, fostering heightened expectations and charging perceptions of the moment with elevated significance. The towering wooden figure is lit with multicolored shafts of neon and filled with explosives designed to detonate in a carefully orchestrated sequence. In some past years, the Burn was accented by four massive fire cannons, which shot fifty-foot flames of kerosene into the sky, although this practice has ceased given general safety concerns. The Burn also typically features a choreographed production involving scores of

fire performers and dancers, although the crowd is so large that many cannot see what is happening.

Recently, the forty-foot effigy has been further elevated on lofty platforms, which augments visibility and facilitates an increasingly bombastic pyrotechnic display. In keeping with the event's mandate for interactivity, these platforms have evolved into complex artworks in themselves. For example, in 2003, the Man stood atop a forty-seven-foot-high red and gold pyramid, or "Temple," featuring niches around its perimeter in which participants could sit and thereby manifest "avatars" of their own fanciful conjuring. In 2004, the platform became a massive spherical "Vault of Heaven" or "Observatory," and featured numerous dioramas of alien worlds, which participants were encouraged to "inhabit" through theatrical performances. While the Man's elevated position serves to increase visibility during the crowded Burn, it has also resulted in decreased access to it throughout the festival. Some longtime attendees decry these changes, longing for what is perceived to be a simpler time in which the Man simply stood atop the playa surface, or perhaps atop a simple stack of hay bales, rendering the figure itself immediately accessible. Ultimately, however, these changes do not seem to have dampened the fervor with which most participants greet the Burn. The frenzied anticipation escalates as the arms of the Man are raised in dramatic surrender and peaks as sparks fly, the figure ignites, and is ultimately consumed in a blaze of glory.

One participant from Berkeley, Jeff, described the Burn and its importance in his own experience, stating:

> In the beginning, the Burn was complete catharsis. The first
> time, I had no idea what to expect. For one, it was so different
> from the rituals that I knew—my Bar Mitzvah was nothing
> like this! The drums, the night, the flames, the spectacle,
> combined into an intoxicating whole. When the Man burned,
> you knew that something was happening. Shit was coming
> down. The old, the heavy, the burdensome, was going up
> in flames.[7]

After the towering structure itself has come down and the wide safety perimeter around it has opened, thousands converge on the central bonfire to dance and celebrate. Some participants toss an object into this central fire as a form of personal sacrifice, or as a way of symbolically releasing a burden or pain

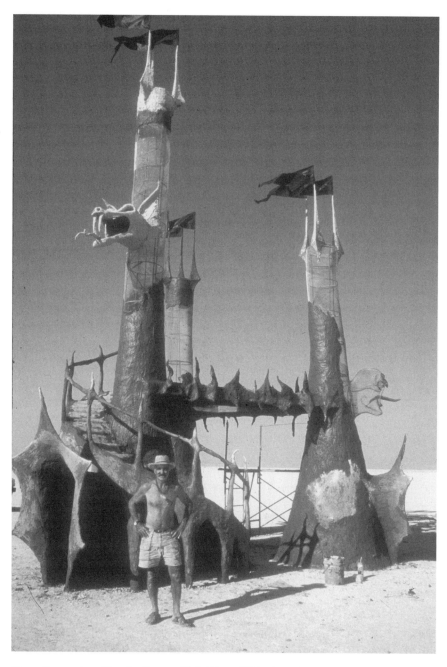

Pepe Ozan standing in front of his City of Dis *(1996).*
Photograph by Christine Kirsten (a.k.a. Ladybee).

that they no longer wish to endure. Jeff also recounted the unexpected poten-cy he had discovered in this simple ritual act, saying that it

> has more meaning for me than any other during the year,
> with the possible exception of Passover. It started by writing
> things that we wish to get rid of in our lives on pieces of paper,
> pouring in gunpowder and wrapping them around with—
> what else—duct tape. . . .We threw in the packets, and with
> them went whatever we had written.

Burning Man has long featured other large-scale, sometimes extensive-ly choreographed, ritualistic performances involving fire. For example, from 1996 to 2000 San Francisco artist Pepe Ozan orchestrated elaborate "operas" around various religious and mythical motifs. In 1996, when the festival's theme was *The Inferno* performers costumed as devils, demons, and insects danced around a twenty-foot-high, hollow, three-towered sculpture made of rebar and chicken wire covered with dried playa mud. This was filled with wood and set aflame as performers chanted the lyrics "devils' delight, fire tonight" and danced around the structure. With the *Fertility* theme in 1997, a similar towered construction was deemed a *Temple of Ishtar*, the Babylon-ian goddess of love and war, and performers enacted a "sacred marriage" between Ishtar and her consort Dumuzi as the sculpture burned.[8]

These "operas" were a topic of controversy among some participants, as they resisted becoming passive audience members—or (gasp!) spectators—during these performances. Ozan attempted to respond to this criticism by devising ways for some members of the audience to interact with or contribute to the performances, thus attempting to make his ritualistic performances more like rites in which many participants could engage. In 1999, the opera utilized a Vodou theme for *Le Mystere de Papa Loko* in which many audience members were guided into the performance space where they passed through a "portal of life and death" between the structure's two towers. The culmina-tion of this performance included a "rite of transformation" in which perform-ers, or "devotees," as they were referred to in Ozan's script, passed through three familiar stages. First was the "Requiem for Time," in which devotees were "taken out of the world of time, responsibility, and individuality." The second stage was "the Breach," described as a "liminal stage [in which] the devotees are betwixt and between the positions assigned by life and society. This ambiguous state is likened to death, to being in the womb, to invisibility, to

bisexuality and to darkness." And finally, came "The Ordeal":

> In order to emerge from the liminal stage deprived of all
> information, the devotees rip their clothes and throw them to
> the fire along with altars, flags and objects of adoration as their
> last step toward total liberation from the past and from their
> identities. They are reborn at the time of the origin of man,
> naked and bewildered ready to descend into their ancestral
> subconscious.[9]

With language unmistakably inspired by Turner's work, *Le Mystere de Papa Loko* engaged in direct dialogue with ritual theories and provides a particularly striking example of the self-consciousness with which some participants conceive of the transformative power of ritual and performance made available at Burning Man.[10]

Fire rituals are also performed with many other artworks. Three especially moving examples took place in 2001, 2002, and 2003 with large installations entitled, respectively, *The Temple of Tears* (also known as the Mausoleum), *The Temple of Joy*, and *The Temple of Honor*.[11] Initially created by artists David Best and Jack Haye in connection with the 2001 theme, *The Seven Ages*, the Mausoleum represented the final stage of life—death.[12] Constructed of intricately cut plywood puzzle remnants in 2001 and 2002, and of elaborate papier maché in 2003, each manifestation of the Temple was a chapel-like structure in which participants were invited to congregate to honor loss and remember the dead. Nearly every available space on the Temples' walls was inscribed with memorials to beloved dead. For several days during the event, participants who visited these structures discovered a deeply reverent and introspective space devoted to remembrance and forgiving. People sat in corners and stood along walls, weeping and quietly contemplating their most personal and painful sorrows. Finally, on the night following the Burn, each Temple has been set aflame. In 2002, the rite began with a rendition of "Amazing Grace" sung by an operatically trained vocalist, and the crowd was hushed as the Temple burned, in a stark contrast to the ebullient and boisterous displays of the previous night's Burn. This silence was punctuated only by a spontaneous performance from some gathered near where I stood of "New York, New York"—a clear tribute to the September 11 tragedy.[13] In some ways, the emotional potency of these rituals have served to eclipse the Burn as the preeminent, and most visceral

large-scale rites in recent years. The Temples provided a poignant reminder of loss that served to transport participants back to the gravity of the "real" world, while also creating a powerful and accessible healing ritual.

Best's Temples and Ozan's operas were but a few of largest and most visible examples of ritualization at Burning Man. Most of the other rites enacted at the festival tend to be smaller in scale, thereby involving individual, personally significant acts, or rites shared by smaller groups of friends and campmates. For example, a simple communal rite took place amongst a group that I camped with during the event in 2000. Several campmates had come to feel that the infrastructure required to host a large theme camp at Burning Man had grown unwieldy and unenjoyable, and that the group itself had become uncomfortably large. It was determined that it was time to "kill" the camp, and in response a flag emblazoned with the camp logo—a corruption of a well-known corporate brand, Motel 666—was draped atop an empty coffin. The group marched in a funeral procession—complete with a trumpet sounding "Taps"—to the site where the Man had burned on the previous night. A communion of sorts, consisting of a bottle of Jamison's Irish Whiskey and a bag of peanuts (said to have been the only food and alcohol that the original camp founders had brought with them their first year), was passed around the gathered assembly. Individuals stood one by one to say a few words about the history of the group, what "the Motel" had meant to them, and to recognize some of the group's original founders who were not present. Finally, the coffin was ignited with bottle rockets. In this way campmates both reinforced their shared identity as "Moteliers" while also recognizing and releasing some of the tensions that had emerged within the group.

Rites of Pilgrimage

Burning Man participants generate a wide variety of rituals intended to manifest some transformation—whether in recognition of or hope for some change in individual or group status, or simply in an effort to achieve mindful awareness of the moment and experience (which so often escapes us in daily life). But what of the journey itself and the transformative capacities of pilgrimage? "Pilgrimage" I define as a ritualized journey to a specific location that has been tinctured with cultural meaning, intended to connect individuals to a shared experience of something outside their ordinary existence, an

experience frequently described as having "sacred" or "spiritual" qualities, and which can arise in both religious and secular contexts. By this measure, Burning Man can be understood to fulfill these qualities.

As noted above, the pilgrimage to Burning Man resonates with Turner's understanding of pilgrimage, as participants leave behind their mundane urban contexts (separation), enter into the para-urban festival setting of Black Rock City (limin), and often return home with a changed perspective or renewed understanding of themselves in relation to the world (aggregation).[14] The very act of making the trip to Burning Man has certain ritualistic elements as the necessary preparations, often repeated year after year, combined with the journey to a distant and unforgiving environment, converge to give participants a sense that they are performing ritualized behaviors and enacting a kind of pilgrimage. Participants must be prepared to endure a degree of hardship and sacrifice in the harsh physical environment of the desert, and it is not without significance that deserts have a long history as loci of transformative possibilities in the Western popular imagination, from Christ to Carlos Castañeda. Burning Man participants also often make enormous commitments of time, energy, and money well above the cost of admission and supplies, in order to create elaborate art projects and theme camps. Admission and supplies are in themselves not trivial expenses, as tickets in 2004, for example, ranged from $165 to $350 (depending on date of purchase) and participants are required to bring all their own supplies, including food, shelter, and a minimum of a gallon and a half of water per person per day.

The spatial metaphors of liminality are also pertinent here in participants' physical movement from home to desert and back again. The Burning Man's first journey to the Black Rock Desert, organized by a group of pranksters and adventurers called the San Francisco Cacophony Society in 1990, was dubbed a "Zone Trip." As described by one participant:

> We all got out of our cars as one member drew a long line on the desert floor creating what we accepted as a 'Zone gateway.' This was one of our Cacophony rituals, for the zone as we defined it took on many forms, it could be a weird house, a particularly strange neighborhood (like Covina, CA), or a desolate, deserted warehouse. Today it was the base of a mountain range in Northern Nevada. We crossed the line and knew we were definitely not in Kansas anymore.[15]

Today, this threshold takes the form of a long queue of cars on approach to the now strictly enforced gate. This extended entrance is marked with numerous and frequently humorous signs intended to help set the tone of participation. Following the gate check for tickets, adequate supplies, and stowaways, arrivals proceed to a "greeter's station" where they are more warmly welcomed "home" and oriented to the festival. Here, "newbies" have in some years been encouraged to step out of their vehicles and onto a waiting platform to ring a bell, a rite of passage that declares their intention to participate.

Having entered into this otherworldly zone, participants encounter a strong feeling of communitas, as related in numerous participant reports of social, emotional, and cognitive liberation. Burning Man has closely followed an arc of what Turner described as *spontaneous, normative,* and *ideological* communitas. At its inception in the late 1980s, friends and strangers spontaneously gathered on a San Francisco beach to create and burn an effigy for the simple and immediate joy of doing it. More recently, the entrance "rituals" are but one example of how highly organized the event has become, as a normative structure has been created to support free expression at what was once a much wilder and anarchistic event within a safer and more sustainable membrane. Further, at every opportunity, organizers promote a quasi-utopian ideal of "community" as the event is portrayed as providing a "better" model for how society could be.

Despite a pervasive sense of social reversal and egalitarian ideal, participants nevertheless replicate society's class structures and other differences by what they bring with them to the desert, thus undermining the ideal of communitas. For example, some can afford to travel and stay in RVs, others cannot; some have the resources to create large technologically complex art projects, others do not. Yet there remains a very real sense in which many of the standard hierarchical roles we live with in the dominant culture fall away at Burning Man by means of the shared experiences all must undergo in order to arrive at and survive in the desert. Indeed, many individuals cite "community" as one of the key reasons why they go to this festival, and it is also often one of the most pragmatic ways in which individuals take the event home with them. The connections with others that are forged or deepened during the festival often have real and lasting impacts that transform participants' daily lives well beyond the event itself. All of these ritualistic elements—symbolic experimentation and thematization, the agency and reflexivity afforded by participation, the visceral experience of fire, and the

arduous journey of pilgrimage—lend themselves to experiences of life passage and transformation.

Transformations

Transformation may or may not be consciously pursued by participants who make the pilgrimage to Burning Man, but many do experience profound and real changes in their lives as a result of their participation in this festival. I spoke, or corresponded via E-mail, with numerous Burning Man participants who asserted that their experiences at Burning Man had changed their lives or transformed their perspectives in some way.

Alex, who had attended the event for eight consecutive years when I spoke with her in 2000, told me that the altered sense of reality and culture she experienced at Burning Man had profoundly transformed her consciousness:

> I realized part of the trouble with the life I have outside of Burning Man has to do with being regulated by a lot of things that are really socially constructed and that aren't true [and] don't matter.... Because so many things can spring up spontaneously [here] you can have all kinds of realizations and insights that you wouldn't have ordinarily in the world. You get to stop and think and move in a different way because it's a different culture out here. I realized I wanted to live my life outside of Burning Man as though I were still at Burning Man, and made a vow like that.... My life has taken miraculous amazing turns that I would never have predicted and never have thought would be likely because of that decision and it came from this environment, it sprang organically from being here.... I went from [working with] computers into teaching tantra and meditation. I decided that I wasn't going to be bound by a lot of social conventions. I decided to experiment and be much more risk taking emotionally in the way that I ordered my relationships, which I don't think I could have done if I hadn't been out here and felt like it's a giant petri dish that I can experiment in. [It's] also [helped me] to remain open to magic and synchronicity and that weird impulse that says "hey, go do this thing" even though it makes no rational sense to do that.

This sense of being freed of "artificial" limitations was echoed by Dennis, a computer scientist from southern California, who told me that Burning Man had changed his life by helping to free him of his own perceived constraints and to transgress some of the social controls imposed by the dominant culture, without risking his status as a "normal" and functional person within that culture. He said that Burning Man had given him

> the ability to change my life by really feeling in control of it by facing the stark nature of the site, then challenging myself to not just exist but excel there. The community surrounding me there is self-selected . . . people interested in what is beyond mundane, normal existence. [Burning Man helps us see] that more can we all be in both taking care of ourselves and then giving beyond the necessary to improve and enrich the lives of those around us. . . . It is a sacred space that allows a spiritual safety for this kind of personal challenging and experimentation. It is different than your normal surroundings and allows you to be abnormal without sacrificing your safe, normal existence back home.

Rodney, who lived and worked in Ecuador as a tour guide when I spoke with him in 2001, told me that before he had gone to Burning Man he had experienced "duality" within himself, and felt that his "urban persona" and "jungle persona" were uncomfortably split. Burning Man, however, gave him the experience he needed to balance these two parts of himself into one, saying "I'm the same person in the jungle that I am in the city now." He attributed this personal integration to the people and the sense of community that he experienced in Black Rock City, saying that the event provides, "what you really need in life. You get a much clearer vision of yourself, and give in to your inner-childhood and eliminate distractions."

Mayfield, a volunteer with the Department of Public Works, told a similar story of personal challenge and transformation as he told me that Burning Man had given him "a way to completely shift my world, to force myself to pay attention to myself and really be honest with myself." For him, Black Rock City is

> A space where I can practice being a better human, and try to make this world a little better. This place gives me a good testing ground for that. Everything here is accelerated, so much stimuli and so many people that you have to keep moving. It helps me shed layers

of insecurity. . . . In a sense I was drawn spiritually [to Burning Man] because it's a celebration of life. . . . If a community is an organism, then this is a more healthy organism—all the cells are functioning.

Another and perhaps more surprising instance of an individual whose perspective on life and spirituality was transformed by the event was that of Randy, a young evangelical Christian pastor from the Midwest. In his own pilgrimage to Burning Man in 2000 his intent was to distribute five thousand bottles of water and packets of seeds as a "gesture of prophetic witness."[16] After conversing with several other participants during the event, he discovered that many of his own preconceptions about what lay at the heart of Burning Man had been challenged, as he was profoundly struck by the ways in which the event fulfilled people's need to connect with one another in community. He returned to find that Burning Man had changed his "personal definition of weird" and had deepened his own relationship with God. In an essay that he posted to his church's Web site, he wrote:

I no longer find it weird when people express themselves in ways I never thought of. . . . I think God likes our rough, creative ideas better than professional presentation. I have a gut feeling he delights in our most creative attempt to get his attention, because it shows our heart. With this in mind, I find it weird that the church world appears to have been made from a cookie cutter. While worshipping a God that values creativity, the church has managed to squash it at every turn. . . . Particularly in America, we have homogenized worship to the point where our distinctive [gifts], given to us to by God to be celebrated, have dissolved into an evangelical unitarianism. . . . I do find it weird that the church strives to convenience people when people really thrive on challenge. Getting to Burning Man is a challenge, but it's a challenge people rise to. The church in America has done everything they can to remove all challenge from attending, in hopes that if it's convenient, people will stumble into a walk with God. . . . Let me make it simple for you. Following God, pursuing him, is not as easy as getting to Burning Man.[17]

In this instance, it can be seen that the transformative power of Burning Man does not necessarily preclude mainstream religious traditions and can

in some cases even enhance them. This was also the case with Jeff, who, as quoted earlier, noted that Burning Man provided a far more exhilarating rite of passage than his Bar Mitzvah, but that it was of less annual spiritual significance to him than Passover. Yet another individual, Michael, a lifelong Quaker who lives in Austin, Texas, described how Burning Man had changed his life by quoting the Old Testament: "'I will entice you into the desert and there I will speak to you in the depths of your heart.' Hosea 2:14. It happened to me. I won't presume to speak for the meaning for anyone else." He added, "I'm reasonably sure my life would have changed anyway, but Burning Man provided a well-defined vehicle for it."

Despite the significant extent to which narratives of pilgrimage and transformation are readily discernable in Burning Man, it is also important to recognize the inherent heterogeneity of Burning Man, which intentionally leaves itself open to divergent interpretations and experiential modes. Not all participants necessarily experience this festival in ways that neatly replicate Turner's theories. While for many it may be a profoundly life-changing and even spiritual experience, for others Burning Man is only a grand party, an excuse for debauchery and a license for transgressive behavior that is disconnected from any overt sense of the sacred, or any occurrence of significant change in one's life, community, and culture. These motives are as much part of the overall experience of the event as are the spiritual or psychological transformations engendered by it.

Even those who have experienced profound life adjustments and transformations through Burning Man often outgrow what was once a deeply radicalizing experience. After attending for several years in a row, the once extraordinary experience becomes almost routine and the festival loses its initial magic for those who have now learned what to expect. Many formerly avid participants have stopped attending as they have "burned out," and chosen to move on to new interests and other life experiences. One former participant, Sena, described her decision to stop attending Burning Man by saying that it had become "too big, the event interferes with my appreciation for the desert environment, it's losing its impact on my psyche, and it's time to seek new perspective adjustment tools." Michael told me that he feels there are now "too many people [and] too much spectacle for the sake of spectacle. [I'm] moving on in my own life. I've been involved with Burning Man year-round for the last three years and I want a break." Still another woman, who had been a very active participant and an integral organizer

since the event first began trekking to the desert, saw this process as only natural. Individuals, she said, get what they need out of the event and then often reach a certain point where they need to move forward and take that experience out into other parts of their own lives and the rest of the world. This too is an aspect of the experience of transformation prompted by the Burning Man festival. Although many individuals on this pilgrimage repeatedly experience life-changing encounters with "liminality" and "communitas," it may be that this experience cannot be reproduced indefinitely even if the festival itself, theoretically, could.

It has been argued that pilgrimage is better understood as a realm of competing secular and religious discourses—while these events may temporarily break down societal structures, as Turner theorized, they also support and celebrate dominant ideologies. More often, pilgrimage can be shown to serve multiple functions simultaneously, as critics John Eade and Michael Sallnow have notably argued:

> It is necessary to develop a view of pilgrimage not merely as
> a field of social relations but also as a realm of competing
> discourses. Indeed, much of what Turner has to say could be
> seen as representative of a particular discourse about pilgrimage
> rather than as an empirical description of it, one which might
> well co-exist or compete with alternative discourses.[18]

While Turner tended to broadly constitute ritual in general and pilgrimage in particular as fitting into a universal model, he also acknowledged that the experience of communitas within pilgrimage was only an ideal.[19] Such cautions are particularly applicable to a secular pilgrimage such as Burning Man, for despite the relative ease with which ritual theories are applicable to this festival, numerous other discourses operate within Burning Man as participants seek to disrupt traditional and popular perceptions of community, ritual, and spiritual practice.

Conclusions

Burning Man is a complex and heterogeneous event. While stridently refusing simplistic categorizations through its inherent multiplicity and its resistance to dogma, aspects of the festival are clearly available to serve as venues

for spiritual expression, fostering personal transformation in ways that read-
ily mirror Turner's theories of ritual process. This is no coincidence. In events
such as Burning Man, it is apparent that Turner's theories about liminality
have manifestly infiltrated Western consciousness to the point that many
now take his ideas about rites of passage to be paradigmatic. Perhaps one of
the reasons why Burning Man can be shown to fit so neatly into a Turnerian
framework is the fact that its founder and ongoing director, Larry Harvey, as
well as several other key contributors to the event are familiar with Turner's
work as well as other scholars of religion and anthropology, such as Mircea
Eliade.[20] Indeed, the Man itself, with the spokes of the city's streets radiat-
ing around it in concentric circles, can readily be perceived as an exemplar
of Eliade's *axis mundi*—a symbolic manifestation of the sacred center of the
cosmos and the location of heirophany, the eruption of the sacred into the
profane world. Here, the Man forms the axis around which time and space
are fixed—time because the Burn is generally perceived as the festival's cli-
mactic zenith, and space because the Man forms the event's locus around
which streets are laid in concentric semicircles and in relation to which most
of the other art is placed. In 2003, when the *Beyond Belief* theme expressly
invited reflection on ritual and religious issues, this long-standing corre-
spondence was at last explicitly acknowledged as the Man's central locale
was labeled "axis mundi" on a Black Rock City map.[21] This is but one instance
of how theories of religion, ritual, and culture not only reflect, but also *shape*
our cultural conceptions of what "ritual" should be, thus serving to outline
the context in which an event like Burning Man can come to life as an alter-
native to conventional religion.

By design, Burning Man is a creature of contradictions and as such it
facilitates profound reorientations in time and space that often spark remark-
able life changes. The desolate landscape of the Black Rock Desert invites the
imagination to populate its open terrain, as participants create a mind-bog-
gling array of expressive projects, producing a stark visual contrast between
geographical emptiness and imaginative abundance. The desert also evokes
a potent imagery of mystery, abstraction, and limitlessness as well as time-
honored connotations of hardship, sacrifice, and solitude, creating the con-
text for an esoteric experience in a quasimythical setting. It is apparent from
participant reports that through making the pilgrimage to Burning Man, many
people experience something beyond the ordinary—they touch, for a moment
and in their own individual ways, a sense of something meaningful in their

own lives that was missing before. Through this pilgrimage, many individuals experience radical transformations in ways that vividly invite comparison to Turner's theories of rites of passage, liminality, and communitas. In an age when so many refuse the dogma of traditional religions, Burning Man provides a new setting in which to fulfill desires commonly conceived as spiritual—connection, release, and renewal.

NOTES

1. Turner was elaborating on the work of anthropologist Arnold Van Gennep. See Arnold Van Gennep, *The Rites of Passage*, trans. Monika B. Vizedom and Gabrielle L. Caffee (Chicago: University of Chicago Press, 1960 [1908]); see also, among others, Victor Turner, *The Ritual Process: Structure and Anti-Structure* (Ithaca, N.Y.: Cornell University Press, 1969).

2. Victor Turner and Edith Turner, *Image and Pilgrimage in Christian Culture* (Columbia, N.Y.: Columbia University Press, 1978), 34.

3. See in particular Hockett and Pike, this volume. Turner maintained a distinction between liminality, which he conceived as belonging specifically to the transitional phase of a rite of passage, and *liminoid*, which could be applied to instances of liminal-like phenomenon in industrial societies. Hence, by this definition, Burning Man would be considered a "liminoid" event.

4. Stuart Mangrum, "What is Burning Man?" Available from http://www.burningman.com/whatisburningman/1998/98n_letter_sum_1.html (accessed October 23, 2003).

5. See the introduction for a summary of Burning Man's annual themes.

6. Ritual studies scholar Ronald Grimes has defined "ritualizing" as that which "transpires as animated persons enact formative gestures in the face of receptivity during crucial times in founded places." This definition is readily applicable to the Burning Man festival as participation enables the distinctively animated attendees to engage in culturally inscribed and symbolically saturated behaviors. Such "formative gestures" are dialectically reflexive and transpire within a self-segregated time and space. These ritualized and performative aspects of Burning Man provide a context for spiritually charged transformations. See Ronald L. Grimes, *Beginnings in Ritual Studies* (Columbia, S.C.: University of South Carolina Press, 1995), 73.

7. Participant quotes are taken from interviews conducted at the festival and via the Internet. Names have not been changed unless specifically requested by participants.

8. The libretto of this opera was based upon actual translations of ancient Sumerian and Akkadian hymns to the Goddess Inanna/Ishtar. See Diane Wolkstein and Samuel Noah Kramer, *Inanna, Queen of Heaven and Earth: Her Stories and Hymns From Sumer* (New York: Harper and Row, 1983).

9. Pepe Ozan, *Le Mystere de Papa Loko: Opera 1999*. Available from http://www.burningmanopera.org/opera99/script.html (accessed October 23, 2003). In order to research Vodou for this opera, Ozan and a few of the other opera coproducers traveled to Haiti where they underwent an initiation into the Vodou tradition. Additionally, a Vodou priest and priestess, whom Ozan and crew had met in Haiti, were flown out to Burning Man as honored guests at the opera performance. See the Burning Man Opera Web site for a summary of their experience in Haiti: http://www.burningmanopera.org/history/opera_99/page_1/mystical/mystical.html (accessed October 23, 2003).

10. For a more critical analysis of Turner and the recursive absorption of his theories into contemporary ritual contents see, Lee Gilmore, "Of Ordeals and Operas," in *Turner and Contemporary Cultural Performance*, ed. Graham St John (NY: Berghahn, forthcoming).

11. See Pike, this volume, for more on these Temples.

12. *The Seven Ages* and their attendant art installations were: the infant/cradle, the child/playground, the lover/chapel, the soldier/coliseum, the temple of wisdom (which was the Burning Man itself), the justice/maze, and the pantaloon/mausoleum. The theme was modeled on a passage from Shakespeare's *As You Like It*, Act 2, Scene 7.

13. In addition, a case containing the names of each of the fire fighters who died in that event was placed upon the Temple's central altar, and there were numerous other memorials for 9/11 throughout Burning Man in 2002, which seemed especially poignant as the tragedy occurred just days following the conclusion of the 2001 Burning Man.

14. The Turners also noted that many Christian pilgrimages were historically associated with simultaneously occurring festivals, which were often the real attraction for many of pilgrims. With its strong emphasis on playfulness and a healthy dose of decadent display, the carnivalesque aspects of Burning Man can certainly be seen to function within this legacy. See Turner and Turner, *Image and Pilgrimage*, 36.

15. Louis Brill, "The First Year In The Desert." Available from http://www.burningman.com/whatisburningman/1986_1996/firstyears.html (accessed October 23, 2003).

16. Randy Bohlender, "The Redefinition of My Personal Concept of Weird." Available from http://www.next-wave.org/oct00/burningman.htm (accessed October 23, 2003).

17. Ibid.

18. John Eade and Michael Sallnow, eds., *Contesting the Sacred: The Anthropology of Christian Pilgrimage* (London: Routledge, 1991), 5.

19. Victor Turner, *Dramas, Fields, and Metaphors: Symbolic Action in Human Society* (Ithaca, N.Y.: Cornell University Press, 1974), 204, 206.

20. See Mircea Eliade, *The Myth of the Eternal Return; Or Cosmos and History* (London: Arkana, 1954).

21. See http://www.burningman.com/themecamps_installations /bm03_theme.html (accessed October 23, 2003).

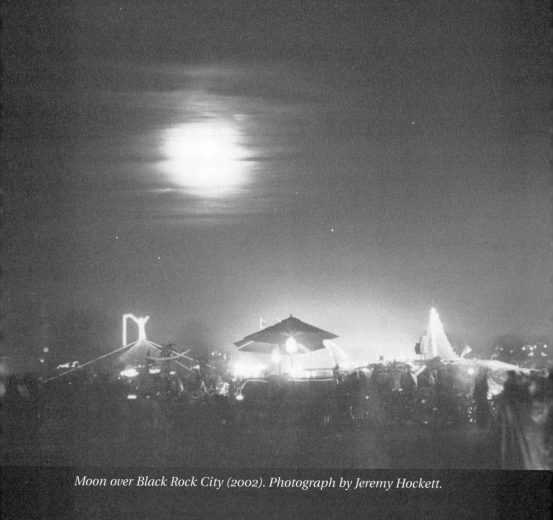

Moon over Black Rock City (2002). Photograph by Jeremy Hockett.

Participant Observation and the Study of Self

Burning Man as Ethnographic Experience

Jeremy Hockett

*Looking for something out of the ordinary to do this Labor
Day weekend? Visit Burning Man! It's the underground
event of the year! Just ask Melanie Warner of* Fortune
*magazine, who calls the event "a non-stop carnival" and
the "cybergeneration's answers to Woodstock." Or ask the
pink spandex-clad woman on the cover of August's* National
Geographic, *who is, as the caption reads, "Celebrating art
and anarchy . . . in the Black Rock Desert." Find out how*
Business Week's *Vicky Rubin, while living it up at this
"week-long bacchanal," realized that Chairman Mao was
wrong when he said, "Revolution is not an invitation to party."
Don't miss* Men's Health's *Burning Man fashion tips: "To
stay warm on those cold desert nights, we're wearing our
new 'Workrite jacket' ($180) made of flame-resistant fleece—
because one Burning Man is enough!" You can also find
articles on the annual "underground" festival of debauchery
in* Playboy *and* Hustler. *And if that doesn't convince you
to go, look for a blurb on Burning Man in* Entertainment
Weekly's *2001 Calendar, sandwiched in between the opening*

*of Jennifer Lopez's new movie and the Miss Teen USA pageant.
You've got to go! It's* the *thing to do![n]*
 —Carrie Hall, "Fuck Burning Man," 2001

Since the mid-1990s, Burning Man has received con-
siderable media coverage, although little of it has increased the public's knowl-
edge about the significance and complexity of the event. During the same
period, however, participants in the Burning Man community have been busi-
ly committing their experiences to various written media, such as the "e-playa"
forum on burningman.com, in testimonials and personal journals on the
Internet, and in Black Rock City newspapers like *Piss Clear, The Spock Science
Monitor,* and the *Black Rock Gazette.* A sizable rift now separates the descrip-
tions proffered by mainstream, commercial media outlets and the personal
accounts written by Burning Man participants. In the former, Burning Man
tends to be viewed as little more than a countercultural spectacle, an enter-
taining diversion to be treated with clichéd analogies and superficial stereo-
types. In contrast, participant-driven characterizations of Burning Man tend
to be much more personal, culturally aware, and socially significant.

I first attended Burning Man in 1997, an experience that utterly trans-
formed my perception of the world and of what is possible when minds and
resources are collectively directed toward the creation of culture. Everything
at Burning Man seemed motivated by a deep desire to express ideas and
meanings, and most importantly to let others generate meaning for them-
selves in the process. The act of cultural creation became nothing more than
an act of making sense of the world, and at Burning Man all was open to one's
own interpretation. When I returned home, I realized that I kept seeing
things in terms of how they related to, or could be incorporated into, next
year's event. Recurring dreams of Burning Man in strange new places—in a
mountain valley, on a cruise ship, at some rural fair grounds—animated my
sleep and stirred my imagination. By 1999, a year after beginning my Ph.D.
program, I began to understand Burning Man as a mode of communication
that transmits a unique kind of knowledge about societal structures and the
ways in which they might be reinvented simply by *imagining* and *enacting*
other ways to live our lives. It was from these experiences that I first began
to conceive of Burning Man as an environment that is geographically and

culturally distanced from the so-called "normal" world, temporarily manifesting as an alternative to a culture of commodity. In academic-speak, we could say that Burning Man inherently promotes a critically distanced, self-reflexive understanding of both the individual self and the culture of signification within which interpretations and actions take place. The idea of "distancing" has been identified as a fundamental aspect of cultural "reflexivity" by many postmodern theorists, which basically entails the ability to distance oneself from what is given as "normal" or "natural" in order to examine the structures within which one lives and acts.[1] I argue, like many "postmodernists," that the capacity to remove oneself from a given context in order to reflect upon that context has been eroded in our contemporary culture of commodity, characterized as it is by the reduction of human creativity to the pursuit of profits and expanding markets, and that Burning Man reestablishes the means to gain such a perspective, through what we could call a "reflexive ethnographic experience."

Reflexivity vis-à-vis Burning Man works on many levels at once. First there is the individual's experience, which is personally reflexive, as new roles are played over the course of the week and free association begins to break down the routine of mundane life in an environment of playful language and aesthetic intensity. Next there is a social reflexivity—as individuals engage in the ritualistic activity Burning Man generates, this "new" individual is then reintegrated into an also re-formed social dynamic achieved by the total ensemble of the burgeoning community. This experience in turn serves to present the participant with an alternative reality that becomes juxtaposed with the so-called "real" world, as it is reentered.

Over the last three decades or so, anthropologists and cultural critics from various fields have asserted that the "classical" ethnography undertaken during most of the twentieth century has chauvinistically imposed our own understandings and interpretations on the cultural practices of other peoples and societies. What is called "reflexive" ethnography has been an attempt to overcome at least some of the difficulties presented by such critiques, by acknowledging that any ethnography says as much about the perspective of the ethnographer as it does about the people being studied. This chapter associates the "classical" mode with the media's portrayals of Burning Man's "countercultural others" and the "reflexive" mode with Burning Man participants' conception of their own cultural contexts. As Burning Man participants become de facto ethnographers of their own sociocultural

conditions, their experiences tell us as much about the state of our "mainstream" culture as they reflect any "essence" of Burning Man.[2]

Looking through the lens of an anthropologist, the significance of this event can be viewed through these two distinct perspectives. On one hand there are the participants' observations, which make clear how deeply Burning Man's ritualistic and carnivalesque environments impact their perceptions of the world and their places in it. On the other hand, those who have not attended often only know of the event through shallow media interpretations, which rarely capture any of the fullness of participant experiences and often do little more than recapitulate and reinsinuate stereotypical notions of a "counterculture."[3] The pertinent difference is that media representations are made in order to attract readers and viewers, in order to *sell* the representation, so they tend to focus on the spectacular and sensational. Participant representations are motivated by the experience itself; they feel compelled to share their experiences because they are deeply significant to them.

Media representations of Burning Man typically reference a number of stereotypes and behaviors, associated with the so-called "counterculture" through reference to things like Woodstock and Lollapalooza. Although there are certainly enough surface-level resemblances to render such a claim easy to make, the imposition of this particular framework on the event and the community by the media has a rather sensationalist levity about it. Such levity renders it one-dimensional with a tone of, "been there, done that," standing in stark contrast to the "vivid presence" experienced by participants. The media assumes an interpretive role in our multicultural society, such that it can be said to be the ethnographic mediator between a normative "us" and the many cultural "others" in our midst, thus replicating an approach for which the field of anthropology has thoroughly taken itself to task. The contrast between these two perspectives reveals the gap between an informative mode of communication (like *reading* a classic ethnography) and a performative mode of communication (like *doing* a reflexive ethnography), or between a mediated experience and a direct experience.

Temporal Distancing and the Media

Anthropologist Johannes Fabian conceived the notion of "temporal distancing" to describe the ethnographic tendency to distance cultural others from

the Western world by portraying the objects of anthropology, so-called "prim-
itives or savages," as existing in a time of "our" past, occupying a position "our"
culture and society held previously.[4] In similar fashion, media representations
often employ definitions and stereotypes that result in distancing our own
"countercultural others" from mainstream culture. Terms such as hippie,
weirdo, party, and freak—even when "self-described"—have dominated
much of the media's interpretations of Burning Man, distancing the event's
participants from what is presumed to be "normal." The event and its partic-
ipants have become strictly associated with leisure and play, devoid of seri-
ousness and purpose, and thus are not *really* real. This is similar to what
Frederic Jameson meant when he wrote that our society transforms "the 'real'
into so many pseudo-events [in which] countercultural forms of cultural
resistance and guerilla warfare . . . are all somehow secretly disarmed and
reabsorbed," by reducing them to spectacles.[5] French Situationist Guy Debord
theorized "the society of spectacle" as one in which our creativity has been
stifled under capitalism, and in which our attention is endlessly diverted from
the political sphere leaving us unequipped to see, let alone influence, the eco-
nomic processes that regulate our lives.[6] These distancing techniques give the
impression to those who lie outside (in this case) the sphere of Burning Man
that it is nothing more than a highly entertaining diversion peopled by large-
ly marginal types seeking to escape reality rather than to change it by exper-
imenting with alternative ways of being in the world. But Burning Man does
much more than merely offer a means of escape—it offers the means to per-
form alternatives, and to enact a different social reality that may have practi-
cal implications.

In his book *People of the Rainbow*, Michael Niman writes about the ways
in which "media distortions" have been consciously or unconsciously used
by national or corporate media outlets when describing the annual Rainbow
Gathering—a nomadic, utopian community founded in 1972 "committed to
principles of nonviolence and nonhierarchical egalitarianism."[7] Niman ex-
plores the negative effects of media coverage on the group's image and its
potential threat to their ability to continue holding their events. Some of the
language used to describe the Rainbows clearly displays *temporal distancing*:
"holdover hippies," "a scene from the past," "a subculture most now regard
as a relic," and "aging remnants of the flower generation" all serve to distance
the "Rainbow Tribe." Niman states that these "'hippie style' descriptives triv-
ialize Gatherings, stressing dress, language, age, and style over politics and

ideals."[8] The Rainbows are characterized as being beyond relevance, placing them not only in some distant past, but also in some other place. The media's coverage of "countercultural" activities, here almost exclusively associated with the '60s *era*, as opposed to a *disposition*, reads more like gossip on the entertainment pages than it does the reporting on the culture or politics pages.[9] Niman does explain that not all media are equally guilty of distortion, stating that the

> difference in reporting reflects the fact that, in general, the tenor of the press coverage is directly related to the amount of contact reporters and editors have with Rainbow Family members. Those with little contact are more likely to be condescending. The national press usually expends little effort on what it regards as fluff pieces and therefore leaves negative stereotypes unchallenged. On the local level, where the Rainbow Gathering is a major story, additional coverage often exonerates the Family from the negative preconceptions held by many outsiders.[10]

As with Burning Man, it is the lived experience that results in and reflects a deeper understanding. But too often, representations of the "counterculture" are condescending, trivializing, simplistic, and superficial. Such descriptions are not necessarily or intentionally malevolent; rather, they are symptomatic and endemic.

Although Burning Man is similarly saddled with labels such as "neo-pagan" and "tribal," it has also been described as a "bonfire of the techies," a place where Silicon Valley "digerati" come to play with their toys, and is portrayed as cutting-edge debauchery and avant-garde excess.[11] But it too has been reduced to mere spectacle and diversion for crazy kids, eccentric dot-com millionaires, holdover hippies, and "artists," raising all manner of moral panics concealing the simple, practical experience provided by the event.

In perhaps one of the more extreme examples of cultural distancing, David Skinner, an associate editor for the *Weekly Standard*, began his article, "What I Saw at Burning Man," with a sardonic invitation to: "Meet the new counterculture."[12] He then introduced Andrew and Amy, a couple in their twenties, who have (rather foolishly, he seems to think) sold their house, quit their jobs, paid off their bills, bought a year's worth of health insurance, and "hit the road." Their first stop, he wrote, was "the annual *spectacle* known as the Burning Man project," where a "large wooden *dummy*"

is torched and participants "pay $100 apiece for the *privilege* of camping on a playa."[13] Continuing in this condescending vein, Skinner wrote, "for all the highfalutin talk, it's hard to avoid the obvious: The counterculture remains, as it has always been, a sort of shell game. It's considered bad manners to say so, but the art is often just decoration for a lot of sex and drugs."[14] Suggesting that Burning Man organizers are culpable in exploiting and concealing this knowledge, Skinner further explains:

> A release form I was asked to sign when I arrived said, "Producer agrees not to broadcast any footage featuring individuals engaged in sex acts or drug use," both of which, clearly more than the art, have made Burning Man "a legend," as one first-timer describes it. Such is the counter-culture: one excuse-making factory run into the ground only to be replaced by another. Now it's Burning Man's turn to deny that decadence is the reason for the season, when it is plain as day to the guys who took photographs for their private collections.[15]

Nowhere does Skinner define what he means by the term "counterculture." Burning Man is simply guilty by association based on the mendacious terminology he employs. Throughout the article, Skinner stigmatizes Burning Man participants as juvenile, self-absorbed, sexually promiscuous, drug-using, free-loaders. He writes, for example, "They talk about discovering themselves. It's radicalism circa *high school*," then adamantly confirms, "They want, in short, to do a lot of drugs, preferably someone else's."[16] Beyond writing this article, it would seem that Skinner had no apparent reason for going to Burning Man, except perhaps to confirm his own vehemently held prior assumptions and prejudices about all things "counter cultural." There is not a single compliment, positive statement, or hint of any redeeming value to be found at Burning Man in his diatribe. At the end of his essay, as people are "writing down wishes and dropping them into the flames" of a burning wooden dinosaur, Skinner is *finally* compelled to participate.[17] He wrote, "I got out a notepad and wrote down my wish: to be returned to the 'normal world.'"[18]

Despite the condescending tone of Skinner's characterizations, it is difficult to disagree with the media's descriptions of Burning Man as "the world's wildest party,"[19] an "annual arts/hedonism festival,"[20] a "tribute to the weird,"[21] "a living canvas of radical art, pagan idolatry and puckish fun,"[22] "an annual celebration that's a mix of Mardi Gras, Woodstock and *Alice in*

Wonderland,"[23] "a temporary city of the odd,"[24] "'Mad Max' meets Wood-stock,"[25] "a cross between a love-in, Mardi Gras and the Doo Dah Parade,"[26] a "primitivist conflagration,"[27] "the great escape,"[28] a festival "for America's misfits,"[29] "flower power, with PowerBooks,"[30] or "a '60s happening for the '90s."[31] I contend, however, that such characterizations carry with them specific signifiers and cultural associations that act to marginalize and distance Burning Man—as an event and as a community—from the realm of reality (or *to* the realm of the hyperreal), separating it from mainstream normative life. Characterizations such as "Desertpalooza" and "Weirdstock"[32] resort to easily recognizable shared cultural associations, automatically establishing connotations that cannot come close to an actual description of Burning Man, and may in fact irreversibly distort its image such that it becomes difficult to take the event seriously or to find any utility in the experience it provides. The effect is to obfuscate the potential social and personal benefits of creating such cultural outlets of expression and interaction in a collective performative experience.

There are, of course, professional writers and journalists who question the use of trivializing labels and who do not use simplistic descriptions that overtly or unwittingly characterize Burning Man in order to "defend the interests of the dominant groups in society."[33] One goal of any ideology is to invoke an atmosphere in which those engaged in its defense are not fully aware they are doing it, and to make it appear utterly natural so as to require no defense at all. Such marginalizing strategies are repeated over and over in media descriptions of Burning Man, Rainbow Gatherings, youth culture, antiwar and antiglobalization protests, labor rallies, and human rights demonstrations. All are described as consisting of radicals or extremists who are out of touch with reality.

It is important to add that such descriptions are not only generated by journalists, but also by participants. However, participants may feel compelled to distance *themselves* and Burning Man from the mainstream—with its attendant commercialism and co-opting tendencies—in order to assert a perceived "authenticity." Perhaps Burning Man must be conceived in opposition to what is normative, strategically describing itself as an insider event for those with outsider dispositions in order to retain its identity and maintain the cultural distance between the hip and the hopelessly homogeneous hordes. But reinforcing the boundaries between "them" and "us" also perpetuates the disintegration, segregation, and decay of social relationships, fostering alienation

between those who create communities that provide reflexive knowledge, and those who might stand to benefit from an experience with such communities. I turn now to a discussion of the significance of that experience as understood by the participants themselves.

Observing the Self by Experiencing Otherness

Understanding itself to have risen above superstition and ignorance, the West has adopted a scientific (anthropological) outlook on the "rest" of the world that seeks to construct meanings from *their* traditions and rituals to fill the void left by the loss of *our* ritual modes. James W. Carey makes a similar assertion in his book *Communication as Culture* when he writes, "we [remain] possessed by that which we no longer [possess]: rituals and narratives that are in the strict sense anthropological."[34] He continues, "we understand that other people have culture in the anthropological sense and we regularly record it—often mischievously and patronizingly. But when we turn critical attention to American culture the concept dissolves into a residual category useful only when psychological and sociological data are exhausted."[35] In other words, "we" have tended to study ourselves using the analytical tools of psychology and sociology, while reserving the methods of anthropology for those cultural others who are still thought to be in the throes of superstition and the supernatural. We in the West have ostensibly overcome the need to create and maintain ritual traditions outside the sphere of capital, and yet, maintains Roy Rappaport, "It seems apparent that ritual is not simply an alternative way to express any manner of thing, but that certain meanings and effects can best, or even *only*, be achieved in ritual."[36]

Ritual traditions and technologies, largely eclipsed by the scientific revolution, have become commodified ritual simulations, a process by which culture itself is transformed into a set of "product lines" to be consumed for profit. By producing an infinite array of commodified pseudorituals, like Christmas or the Super Bowl, which no longer fulfill a reflexive role—yet infinitely entertain and divert, typecast and pigeon-hole—we have filled the ritual void left by the steady progression of scientific knowledge. This has resulted in a nearly total loss of efficacy and functionality of our discarded reflexive ritual techniques. A culture of commodity merely recapitulates and reinforces the structures in which it is embedded, creating a virtually invisible ideology of

consumption, with scant recourse to reflect upon its framework. Burning Man, on the other hand, exposes the system and its inherent ideology to scrutiny through the critical reflexivity brought about by "performing" and "acting out" alternatives to it. Anthropologist Victor Turner called this "performative reflexivity"

> a condition in which a sociocultural group, or its most perceptive members acting representatively, turn, bend or reflect back upon themselves, upon the relations, actions, symbols, meanings, codes, roles, statuses, social structures, ethical and legal rules, and other sociocultural components which make up their public "selves."[37]

This idea is reflected in the following excerpt from the "e-playa," Burning Man's official online bulletin board:[38]

> I cried while in my van going to burning man, and I cried while waiting in the line to leave. My experience was fantastic and moving on so many levels. I am glad to be part of the crowd who "gets it"! The Man, an entity we all created, becomes alive, with it's own consciousness. This flame becomes part of us all, and helps us change and grow.

Burning Man serves to reestablish a "sacred" liminal ritual for a secular people that is characterized by *options* and *individuality*, yet also instills a sense of *obligation* and *collectivity*.[39] One is free to participate or not, but in participating, certain "civic" duties are entailed, and certain obligations to fellow Black Rock citizens become apparent, engendering an emotional investment in the community. This then extends back to the everyday world by "heighten[ing] the social awareness of values and norms."[40] As a reconfiguration or adaptation to emerging conditions *and* an agent of change, Burning Man is reflexive modernity's equivalent to premodern ritual liminality. Another e-playa excerpt expresses some of this:

> Once again, a life-changing, life-enhancing, purely beautiful experience. . . . We can indeed allow the Burning Man ethos to carry over into the rest of our lives. In fact, we NEED to. Living life as a participant among beautiful and caring people—it doesn't get any better than that! I spoke with many people out there about how it is easy to have a "perfect time" with 20–30 of your closest

friends. The amazing thing about BM is that same togetherness can be felt among a diverse and previously unacquainted crowd of 15,000+. That is real community! There are plenty of people there who may not seem to be "getting it"—but that's part of it also. I truly believe that the 'culture of Black Rock' urges people to get it . . . and get it in their own way. Aye Gahd, I can't even express it!

The twentieth century in the West was marked by the slow hemorrhage of traditional meaning-making rituals and collective actions. The causal factors contributing to this decline include: secularization; pluralization; commodification; the corporate cooptation of cultural resources, spaces, and expressions; the ensuing loss of public and collective cultural space (and time); the corporate consolidation of the media and the flow of information, which in turn influences politics; and the sharp separation of work and leisure primarily owing to the process of industrialization. In short, the transition from preindustrial to postindustrial society necessitated an equally dramatic transition in the evolution of the cultural performances through which we see ourselves. As Turner suggested,

> Cultural performances are not simple reflectors or expressions
> of culture or even of changing culture but may themselves
> be active agencies of change, representing the eye by which
> culture sees itself and the drawing board on which creative
> actors sketch out what they believe to be more apt or interesting
> "designs for living."[41]

Cultural performances can be understood as an essential social technology for negotiating—and bringing about—change. As an emergent ritual of a secular, global people—a people distanced from tradition, custom, and belief in magic—Burning Man functions to recover the utility of preindustrial liminal ritual transformations in a context of secular postmodernity or, "reflexive modernity."[42] Grounded in an eclectic quasi-awareness of the world's myriad religions, ceremonies, and cultural beliefs while not beholden to any, including what remains of our own religious heritage, Burning Man provides a ritualistic means by which participants can liminally, reflexively, and critically create "distance" from their "normal" sociocultural existence. In this sense, Burning Man can be understood as occasioning an "ethnographic ritual" that invites participant observation, as individuals

are encouraged to reflect on their own culture and their own roles in constructing that culture.

The establishment of critical distance from normative culture in order to reflect upon that culture can be thought of as one of the primary "functions" of certain ritual modes, such as Carnival, initiations, and rites of passage. In a democratic, technological, and individualistic society where critical self-reflection and awareness are paramount values in the process of making meaning, it may become imperative for citizens to engage in *collective* performative practices that are distanced from the mainstream in order to effectively evaluate their circumstances and heighten social awareness of how values and norms are constructed. We can imagine Burning Man as a logical extension of this process, which, because it is a part of the "praxis" of the West, presents an optimally situated environment for reflexive self-discovery. Endowed with such an understanding, we can seek to engage in ritualistic cultural performances that advance the acquisition of reflexive knowledge, which is to say, we can begin to study ourselves through the same methods and with the same mental attitude as those we study, in order to produce cultural reflexivity.

A simple Internet search for the keywords "Burning Man" produces thousands of links to personal Web sites, reflecting some of the ways in which participants try to put their experience into words. The "e-playa" is probably the most comprehensive ethnographic text generated by this community, allowing participants to engage in discussion topics that range from the very serious—such as rape, the war in Iraq, or September 11th terrorist attacks—to the humorous and frivolous—"What if Larry was one of us?" or "Why do we add goofy threads and try to keep them going????" Other topics relate directly to a reflexive consideration of the event itself, such as "Why Is Burning Man So . . . White?" Many topics are devoted to people's personal experiences and accounts, attesting to the deep significance that the event and its community have for them. Such descriptions do not simply reveal what Burning Man is— they represent the ethnographic perspective that it provides. What is being "observed" in an ethnographic sense is not the goings-on of Burning Man per se, but the goings-on of that which is not Burning Man. Many participants' post-Burning Man descriptions are induced by the contrast between Black Rock City and their everyday environments, an experience participants call *decompression*, accentuating what is unsatisfying or lacking in their normal lives when measured against the experience of Burning Man.

Many participants feel compelled to communicate what they have learned and experienced. Yet these things are difficult to describe because they stem from a *lived* transformative experience built on a *performative* mode of communication for which language can supply no sufficient analogy. Just as ethnographers have historically found it challenging to produce interpretive texts after completing their fieldwork, many Burning Man participants undertake the difficult process of creating an autobiographical "text" of their experience. Statements, taken from the e-playa in 1997–1999 and personal correspondence, illustrate this point.

> Burning Man is one of those experiences that is hard to describe to people, because it affects you at a subconscious level, not at the conscious level where it's easy to put ideas into words. Burning Man for me means another re-examination of society and my role in it. I find it hard to explain to my friends and family why this event is so significant. All I can do is show people my pictures and my new attitude.

> Like many others, I am at a loss to describe this event to my friends and family at home in Seattle. I think I just end up with my mouth open and my eyes wide like some sadly dehydrating trout. Last year I tried elaborating for hours on all that I saw and felt. After this year, I know that all I can truly say is ***WOW*** I became the patient and attentive ear to more than one confession of how Burning Man was changing a life or a perspective.

> I thought decompression was a joke. Then the tears started rolling somewhere south of Reno. By midnight I was dreading the LA County line marker like never before, and that's saying quite a lot. In past years I've looked at BM as a marvelously funny, frivolous charade. Today I feel the opposite, like the charade's not funny anymore and it's 360-odd days long. What happens when you realize that the people you love and the potential significant others you'd like to love and the values you love and the ideas and the art and the engineering you love are nowhere to be found 98 percent of the year? Am I supposed to just get over it, or re-examine my priorities, or am I simply supposed to get the hell out of LA?

The removal of participants from their normal environment to an imma-
nently experienced alternative world creates the conditions for reflexivity. This
idea was expressed in many interviews I conducted. For example, one male
respondent replied:

> In the real world your consciousness level . . . seems to be in
> overdrive. Sometimes you're not even aware of your surroundings,
> and when you are at Burning Man, partially because you're in
> the middle of a desert, partially because of the Burning Man
> phenomenon, you become very much aware of yourself, what
> you're capable of, what you're doing, what you're thinking, and
> what you're surroundings are like. You're just more aware of your
> immediate surroundings and your subconscious surroundings,
> I guess, much more than you would be in the real world, because
> in the real world you've got . . . everything's pretty much taken
> care of, is cared for. We've got instant food; we've got instant
> entertainment; we've got instant . . . oh . . . pretty much an instant
> world. And at Burning Man nothing's instant so you need to be
> very conscious and very aware the whole time.

By engendering critical distance, Burning Man induces an altered state
of consciousness. In asking respondents to comment on this proposition, one
participant exclaimed, "YES! I think the culture and environment combine to
create a strange place both physically and mentally." She went on to say:

> The gift economy has a lot to do with it, too, I think, as you really
> have to shift your thinking from a "how do I get that" to a "what
> can I give." [There is something] so delightful about having perfect
> strangers trying to give you things, whether it is a plate of nicely
> grilled tuna or a ring made in origami with a dollar bill, that you
> want to be able to give something in return. So even if your
> consciousness is only economically altered, it's definitely altered.

In this last quote, a Danish woman who first attended in 2002 best artic-
ulates the concept of reflexivity generated by Burning Man:

> I experienced [Burning Man] as a thing that shows people what
> they forgot in their own daily lives and reminds them of how life
> should be. . . . Personally it allows me to be free, and . . . it moves
> my limits. . . . When you go to work every day, and you get home,

Dust devils, Burning Man (2002). Photograph by Jeremy Hockett.

you cook food, you watch television, you have sex with your wife, and you go to bed, and you go to work, and you do the same thing again and again and again, you don't have to be so conscious, because you're doing it like a routine. You can do it without even noticing you're there yourself. At the Burning Man there is no routine, and every time you see something it's something new. So you get very conscious, and you realize things about yourself because you open up borders, and you don't do the same thing again and again, you actually have a look at yourself. And you look at yourself because you use all the other people as mirrors so you see yourself through all the other people.

Burning Man facilitates a context in which this kind of "critical distance" can be achieved by spatial and temporal—as well as a cultural and social—distancing, as participants are momentarily freed from the abstractions and ideological proscriptions that predominate in twentieth-century thought in order to forge new meaning in their world.[43]

Conclusion

Burning Man is certainly a great party, providing Bacchanalian spectacle and carnivalesque excess, but an extensive focus on this most obvious aspect buries its social functionality and potential political resonance. Behind the veils of naïve idealism, sex, drugs, and raves, the event's performative rituals of reflexive attunement can become marginalized out of existence. By comparing the media's distancing and marginalizing rhetoric with participants' narratives of their own lived experiences, we can catch a glimpse of the cultural and individual reflexive potential inherent in Burning Man. Underlying Burning Man is the simple idea of *communication* that stems from "ethnographic" experiences, generating the capacity to become culturally and individually reflexive. Anthropologist James Clifford called this process "ethnographic surrealism"—making the familiar strange and the strange familiar.[44] The significance of Burning Man is the cultural and collective frame it manifests through which individuals can gain a sense of self *and* community. The collective ritual, festal, and carnivalesque aspects of Burning Man foster self-discovery and provide a context in which to explore the possibility of an alternatively ordered society.

We have, by and large, lost the meaning-making engines of reflexive ritual participation so often referred to in anthropological descriptions of other cultures. The only way out is to become truly creative agents in the emergence and construction of reality. For this to happen, we must engage in an imaginative process, projecting the "what has been" and "what might be" into the "what is." We need "sacred" spaces in which to imagine and experience alternative ways to sustain dignity. Reflexive ethnography entails critical self-reflection and the extension of self into something larger, so that it can take on deeper significance. It provides the raw materials for novelty and expands the language through which we make meaning, allowing us to multiply our collective linguistic and existential systems of understanding,

establishing the conditions for elaboration and experimentation in the production of culture.

Ethnography, as practiced in the late twentieth century, and moving now into the twenty-first century, is slowly teasing out its own emerging awareness of self-reflexivity as part-and-parcel of the human endeavor. As Tom Driver asserts,

> Ours is an age that needs both the marking of known ways that are worthy of repetition and the groping for new ways in situations with scant precedent. Humanity's ritual traditions are rich but they were not devised to deal with the split atom, nor space flight, nor the hole in the ozone layer. Neither were most of them fashioned to uphold sexual, racial, cultural, and social equality.[45]

Burning Man is a contemporary ritual that provides the conditions for such "marking" and "groping," and in so doing it best equips its community of participants to "deal" with an increasingly complex, technologically sophisticated, and ever-changing sociocultural landscape.

NOTES

The opening quote is from Carrie Hall, "Fuck Burning Man: Bring that Flying Saucer Back Home," *San Francisco Bay Guardian Online* (August 29, 2001) [e-newspaper], available from http://www.sfbg.com/SFLife /35/48/cult.html (accessed March 21, 2003). Hall has never attended Burning Man, but her sarcastic comments serve to demonstrate the extent to which "Burning Man" has become synonymous with "counterculture," although she deploys it as an ironic assault on the authenticity of Burning Man as a countercultural event when it appears in such mainstream periodicals.

1. See Frederic Jameson, *Postmodernism, or, The Cultural Logic of Late Capitalism* (Durham, N.C.: Duke University Press, 1997), 49.

2. This essay too, then, is as much about the reflexive knowledge Burning Man transmits about the culture and society from which it has emerged, as it is about Burning Man itself.

3. Regardless of whether one learns of Burning Man via the media or participants, however, there is still no way to convey the depth of the lived experience, which is inherently performative and must be enacted.

4. Johannes Fabian, *Time and the Other: How Anthropology Makes its Object* (New York: Columbia University Press, 1983), 32. Fabian suggests that the chauvinistic *temporal distancing* techniques of classic ethnography might be avoided or at least reduced through performative modes of gaining knowledge from an encounter with otherness. One must become a performing participant rather than merely a passive observer to establish the legitimate coexistence of the other. Burning Man organizers have attempted to do the same, by encouraging the members of the media to participate rather than merely observe and thus to experience Burning Man immanently and personally rather than vicariously.

5. Jameson, *Postmodernism*, 48–49. See also See Jean Baudrillard, *Simulations*, trans. Paul Foss, Paul Patton, and Phillip Beitchman (New York: Semiotexte, 1983).

6. Guy Debord, *Society of the Spectacle* (Detroit: Black & Red, 1983).

7. Michael Niman, *People of the Rainbow: A Nomadic Utopia* (Knoxville: University of Tennessee Press, 1999), xi.

8. Ibid., 151.

9. Though it does increasingly seem that entertainment is culture, and politics entertainment.

10. Niman, *People of the Rainbow*, 159.

11. Kevin Kelly, "Bonfire of The Techies: Hordes of Playful Digerati Assemble for a Hallowed Annual Rite," *Time Magazine* (August 25, 1997).

12. David Skinner, "What I Saw at Burning Man," *The Weekly Standard*, September 27, 1999, 21.

13. Ibid. Italics mine.

14. Ibid., 21–22.

15. Ibid., 24.

16. Ibid. Italics mine.

17. Ibid., 24.

18. Ibid., 24.

19. M. Dion Thompson, "Drawn to the Flame," *The Baltimore Sun*, September 7, 1997, K(1).

20. Michael Colton, "The Empowering Inferno: Burning Man Goes Out With a Bang," *The Washington Post*, September 2, 1997, C(1).

21. William Porter, "Burning Man Fest Tribute to Weird," *The Denver Post*, August 31, 1997, B(1).

22. Joe Williams, "A Hot Time: Burning Man Fest Warms Nevada Desert," *St. Louis Post-Dispatch*, August 31, 1997, A(14).

23. Bruce Haring, "Burning Man Elevates the Surreal to an Art," *USA Today*, August 28, 1997, D(5).

24. Sandra Cereb, "Temporary City of the Odd Appears in Nevada Desert: Burning Man Fest Hosts Anarchy Art," *The Toronto Star*, August 27, 1997, D(5).

25. Elizabeth Lee, "Creativity Fuels Burning Man Festival," *The Atlanta Journal and Constitution*, August 27, 1997, C(3).

26. Dennis McLellan, "Firebrands," *Los Angeles Times*, September 5, 1997, E(1).

27. Edward Rothstein, "Technology Connections: Digerati are Unlikely Celebrants of a Primitivist Conflagration in the Nevada Desert," *The New York Times*, July 21, 1997, D(4).

28. Michael Stetz, "Fired Up: Bizarre, Brazen Burning Man Festival is the Great Escape," *The San Diego Union-Tribune*, September 13, 1998, D(1).

29. Ed Vulliamy, "Kings of the Weird Frontier," *The Guardian*, September 12, 1999, 5.

30. Abby Ellin, "Flower Power, With Power Books," *The New York Times*, September 3, 2000, C2.

31. Claudia Dowling, "Life Goes to the Burning Man Festival," *Life*, August 1997, 16–18.

32. Michael Colton, "America's Hottest Festival," *The Washington Post*, August 27, 1997, D(1).

33. John Storey, *An Introduction to Cultural Theory and Popular Culture*, 2nd ed. (Athens: University of Georgia Press, 1998), 83.

34. James W. Carey, *Communication as Culture: Essays on Media and Society* (Boston: Unwin Hyman, 1988), 2.

35. Ibid., 19.

36. Roy Rappaport, *Ritual and Religion in the Making of Humanity* (Cambridge: Cambridge University Press, 2001), 30. Peter Stallybrass and Allon White likewise assert that Carnival, for example, is "a *mode of understanding . . .* a cultural analytic." ("From Carnival to Transgression," in *The Subcultures Reader*, Ken Gelder and Sarah Thornton, eds. [London: Routledge, 1997], 293. Italics mine.)

37. Victor Turner, *The Anthropology of Performance* (New York: PAJ Publications, 1986), 24.

38. See http://eplaya.burningman.com (accessed June 2, 2004).

39. For more on the liminal/liminoid aspects of Burning Man, see Gilmore, this volume.

40. Denise Lawrence, "Notes on the Doo Dah Parade," in *Time out of Time: Essays on the Festival*, ed. Alessandro Falassi (Albuquerque: University of New Mexico Press, 1987), 134.

41. Turner, *The Anthropology of Performance*, 24.

42. I prefer the term "reflexive modernity" to "postmodernity," as the former implies not simply a moving beyond or coming after modernism, but a modernism critically engaged with itself and its own processes. See Yves Lambert, "Religion in Modernity as a New Axial Age: Secularization or New Religious Forms?" *Sociology of Religion* 37, no. 4 (1999): 303–33.

43. On the "denial of self" in "objective" forms of writing, see Patricia Williams, *The Alchemy of Race and Rights: Diary of a Law Professor* (Cambridge, Mass.: Harvard University Press, 1991), 92.

44. James Clifford, *The Predicament of Culture: Twentieth-Century Ethnography, Literature, and Art* (Cambridge, Mass.: Harvard University Press, 1988), 45.

45. Tom Driver, *Liberating Rites: Understanding the Transformative Power of Ritual* (Boulder, Colo.: Westview Press, 1998), 50.

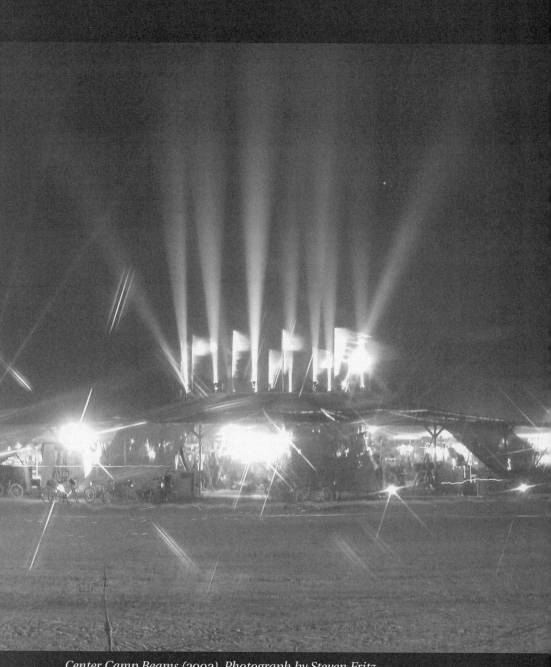

Center Camp Beams (2002). Photograph by Steven Fritz.

Welcome to the Black Rock Café

Robert V. Kozinets and

John F. Sherry Jr.

When we first heard about Burning Man, it was like being informed about the discovery of extraterrestrial life; our own bona fide b-school version of the Roswell incident. We are applied anthropologists who toil in the marketing departments of business schools. During the day we teach bright MBAs how to build brands that people will fall in love with and for which they will pay dearly. In our remaining time—call it the witching hours if you will—we investigate research questions about what our marketing culture is doing to other cultures, to the planet, to people, their communities, and their lives. In our research we like to stick with things we know—the media, movies, sports, TV, shopping, themed retail destinations, flea markets—the usual stuff. We speculated about the possible existence of life outside the marketplace— an interesting theoretical question—but no one expected it to come crashing into our everyday reality.[1]

But crash it did, right into our worlds of business and marketing. When we spotted Burning Man on the cover of *Wired* magazine in fall of 1996, it was like hearing that the saucer had landed. We read voraciously about it. We bought the giant HardWired book, which—like Burning Man's ideas—was so

big it refused to fit into any bookshelf. In that book, Burning Man's founder Larry Harvey is quoted as calling the event "Disneyland in Reverse,"[2] while the volume's editor professes that ". . . unlike a convention or Superbowl, Burning Man has been stripped of commercial motives."[3] That was what we had wanted to hear. In our field, researchers speculate about the relationship between consumers, markets, and communities. Could we envision a space where people consumed outside conventional marketing forces? This was key in the hunt for the unified field theory of marketing: a place outside the gravitational pull of the market.

Burning Man held a lot of promise in our quest. Billed as a Temporary Autonomous Zone, "a guerilla operation which liberates an area of land, time, and imagination,"[4] it had specific rules that were intended to lock out the market. No vending. No brand names. Participate. Finally, a place where we could investigate the absence of markets, the lack of marketing. We were, as our students put it, stoked.

We got ready to pack our bags and head out to the desert. We bought a lot of stuff. Purchasing tents, tickets, sleeping bags, camping gear, food, costumes, airfare, rental cars, we rapidly ran down our research accounts, but it was all in the service of antimarket research. By the time we got to Reno, then Gerlach, then Black Rock City, we had spent considerable sums just to evade the nefarious grip of marketing. How amazingly ironic it was, then, to walk through Burning Man for the first time, to walk through the vast neon-tubed, electroluminescent-wired, *über*-strip mall of the place, the signs competing for attention, the touristic cameras, the elevated RVs on prime real estate, the lowly K-Mart tent shanty-towns, to get to Center Camp, and see the sign.

In the distant zone of this autonomous land, where brands were supposed to be vanquished, we found a sign that mocked capitalism while also celebrating it—the familiar round sign of the Hard Rock Café, that retail eatertainment downtown essential of commercialized hipness. "Welcome to the Black Rock Café" it said. And, even more astounding, nearby was the sign for the official Burning Man coffee bar, offering espresso, cappuccino, lemonade, and a cornucopia of other warm and cold beverages for sale. We had gone a long way to penetrate the antimarketing zone, only to be once again confronted by popular brands and commodities for sale.

"How much for a tall chai?" We reached for our wallets.

Before we can understand these important paradoxes—the antibrand event that uses the language of brands, the anticommerce zone that looks like a strip mall, the antimarket event that sells coffee—we must explore the important relationship among markets, culture, and communities. Rich (sub)cultural events that exist on the margins of mainstream society—like other resistant grassroots festivals (e.g., Gay Pride day), fan-run Star Trek conventions, and New Age spiritual gatherings—tend to bring to the surface the uneasy-but-frequent contemporary interaction of communities and markets. In this essay, we explore that interaction in several ways. First, we describe and analyze the prevalent antimarket and anticonsumer discourses circulating at Burning Man. Then, we introduce a body of postmodern theory that shares some of the Burning Man organizers' (and participants') negative views of consumption, and seeks emancipated spaces for consumers. We conclude with some thoughts about how Burning Man increases our understanding of the unstable and important relationship among markets, communities, and individuals.

Resisting Markets and Embracing Communities at Burning Man

Larry Harvey has often described the intent of the Burning Man "project" in terms of its community-building properties. For example, he has said that Burning Man is

> dedicated to discovering those optimal forms of community which will produce human culture in the conditions of our post-modern mass society. Within a desert wilderness we build a city, a model world composed of people who attend our event from all over the globe.... Living as we do, without sustaining traditions in time and ungrounded in a shared experience of place, it is yet possible to transcend these deficiencies.[5]

The chief expounder upon the significance (but never *the meaning*) of Burning Man then states that Burning Man is "a model world."[6] It is not stretching things too far to see that Burning Man is envisioned as a utopian project that seeks to rebuild community.

Theories and ideals of "community" are among the most important, complex, political, and dissent-filled discussions that circulate within Western

thinking and history.[7] Although the term *community* has been conceptualized in very diverse ways within these discourses, communal forms similar to those described by Harvey have often been raised as an ideal, which can be characterized as groups living together in close proximity, with social relations that are characterized by compassion, caring, and sharing of vital resources. In the late nineteenth century, Ferdinand Tönnies evoked this ideal in his notion of *Gemeinschaft*, which he posited as a form of social relationship characterized by its informality and emotional closeness.[8]

At Burning Man, this kind of community is almost self-evident. As soon as you arrive, you are met (some are hugged, the lucky are even groped) by official greeters. The hellos and hi's ring out as you begin walking around. Those who already have a history at the place are "welcomed home" by old friends. Food, drink, and stories are shared. The artistic, live-for-today, festal, bohemian culture encourages genuine expressions, the sharing of secrets, the giving away of smiles. Theme camps are like villages, and in fact larger groupings of theme camps are even called "villages." These villages are open to wanderers and strangers.

The original "sharing and caring" community arrangement is widely considered by anthropologists and sociologists to be the family or extended-family arrangement, the tribe, with its deep levels of interdependence and profound levels of trust. We can therefore think about idealized communities as being like large functional families. A return to idealized community is often spoken of in terms that echo of a return to family or, in Burning Man's case, a return home.

Community and family are experimented with and celebrated in a utopian fashion at Burning Man. But why do we need events like Burning Man? Why do we need to reform community? One of the main culprits blamed for the breakdown of community in contemporary society is the hegemony of capitalist markets, and the powers they give to large corporate interests. In Black Rock City, the mediating and socially distancing forces of the market are constantly on display. In signs, rules, and discourse, markets are consistently and constantly parodied, resisted, and, at least temporarily, shut out and suspended. One of the funniest and cleverest art displays we noted at Burning Man 2000 was a complete office cubicle set up in the middle of the desert. There was a desk, chair, filing cabinet, two lamps, a water cooler, shelves, books, magazines, a "Success" poster, a whiteboard, and a computer. On the white board was written messages like "Meeting, 12:30 P.M.,

lunch" and "Henry, your wife called—it's over." The computer was covered with Post-It notes with reminders such as "Reread p. 165 of The Gorilla Game" and "Research. Organize. Implement. Follow thru." In its completeness and its contextual evacuation, this artwork brilliantly spoofs the white-collar authority familiar to many Burning Man participants in their daily lives.

Another example was contained in the opening edition of the 1999 *Black Rock Gazette*, which stated the official rules against vending, and also included suggestions to "mask, hide or disguise" the brand logos that "get in our faces constantly and without our consent" outside of Burning Man.[9] The differentiation between inside–Burning Man–utopic–community, and outside–"real world"–dystopic–market is also present within the "signs of a community" published in the Burning Man organization's 2000 *Survival Guide*, stating that while communities such as Burning Man recognize the uniqueness and contribution of each member, the tendency of "commerce and the public sector" is to define its members "on the basis of deficiency and need."[10]

Mass markets are thus defined in official Burning Man ideology as passive and isolating. Markets are also defined by their use of persuasion and overt exploitation, indicated by the use of money, advertising, and hype. Given that barter was an important (although never explicitly promoted) part of the Burning Man experience for many years, the *Survival Guide*'s distinctions tend to reject large, impersonal markets, rather than trade, exchange, or commerce itself. This is clear when one considers the traditional presence of the coffee bar, and even the presence of parodic quick-serve restaurant McSatan's (a.k.a. Big Daddy Love's) that served hot dogs and hamburgers from 1995–1997. In 2000, the official guidelines began to encourage a gift economy. Emphasizing gift giving at Burning Man became the focus of several Burning Man newsletter editorials and official public relations efforts.

Central distinctions and attitudes toward the market are institutionalized through the application and enforcement of directives like "No Commerce" and "Mask the Brands." Their repeated incantation serves several important cultural purposes. First, they mark out a space of difference. This is not Disneyland, or Woodstock, but Disneyland in Reverse, Woodstock the way it was meant to be: primal, real, true. The second cultural purpose is the creation of bonds through the identification of a common adversary, which represents a key ideological move. Most importantly, these rules attempt to reveal the hidden power of the market so that it can be resisted.

They seek to make previously taken-for-granted and therefore largely invisible market relations salient, visible, open to discussion and debate.

Consider the way mainstream market relations are discussed by Harvey:

> We've created this world in which they [marketers and corporations] do these demographic [marketing research] studies and they find out what people think they want. And then in a kind of séance they summon up before you The Ghost of Your Own Desire and they sell it to you. And it doesn't connect you to anything. It connects you to your own individual desires. And then it turns out, as it so often does in life, that what you wanted wasn't what you needed. So we spend all our time now, consuming stuff, consuming these dream images that nourish us spiritually like styrofoam pellets. They don't do us any good.[11]

Leaders and visionaries, like anthropologists, often seek to make the familiar unfamiliar. Harvey takes commonplace concepts and terms like corporations, marketing, consuming, and consumer and gives them a defamiliarizing, negative emotional charge. He equates marketing with metaphysics, false desires with the fakery of the séance. Marketing is linked to a sophisticated industry of deception in which consumers are made dependent, socially isolated, and miserable. From this critical perspective, which is related to neo-Marxist approaches and classic texts such as Adorno and Horkheimer's "The Culture Industry,"[12] consumers are viewed as passive recipients, spiritually empty, exploited through advertising and mind-numbing entertainment by powerful business interests.

This stereotyped sense of consumer passivity is present not only in the discourse of Burning Man's leaders, but also in the discourse of many Burning Man participants. For example, "Earth Goddess,"[13] a friendly fellow anthropologist who had previously written about the event, explained:

> That's really the difference between participant and spectator, the difference between being passively fed and that's part of why consumerism is shunned out here. Because that's [the consumer lifestyle is] passively fed to you, you just sit there and passively consume the product. You sit there and consume whatever the marketer's brand is rather than expressing your own idea.

Earth Goddess—who shared many of the values of participants and organizers—suggests that the passivity of everyday consumption actually shuts out, or replaces creativity and self-expression. This suggests that consumers are submissive, acquiescent, weak, and uncreative—and that marketers gain from this state of affairs because consumers are dependent on them.

Burning Man's resistance to this creativity-demolishing tyranny of brands and marketing was expressed by many other participants. In a wonderful artwork created by "Jungle James," and dedicated to his daughter, a female torso hung on a tall red crucifix onto which was pasted the covers of many different teen girl-targeted fashion magazines like *Seventeen*, *Self*, and *Glamour*. James explained to us that his artwork was dedicated to resisting the unhealthy body images spread and enforced as beauty by the fashion media and their advertisers.

"Seth of the Voodoo Temple" also exhibited a keen resistance to the presence of corporations within Burning Man in his response:

When you bring sponsorships and things like that in [into Burning Man], like, brand names and logos popping up everywhere, then it becomes less about the art and more about money and commercialism and everything like that.... it's nice to get away from it and have more of a focus on creative energy. And I think that allowing vending in would kind of break that down and destroy it. So I think it's important that they keep the vending outside Burning Man.

Seth counterbalances art and creativity with money and commercialism, pointing to another dualism associated with the evils of the market—that it crushes creativity as well as community.[14] At Burning Man (and probably in much of the rest of the world) markets are considered to be very different types of systems than the family-oriented ideal community of Tönnies's Gemeinschaft. In fact, the ideally functioning market can be considered similar to the social phenomenon Tönnies termed a *Gesellschaft*.[15]

A Gesellschaft contains social relations that are significantly more formal, contractual, and socially distanced than the relations characterizing a caring and sharing community. Social relations in a market are supposed to occur not for the sake of interdependence and mutual support, but for the sake of transactions and exchanges. It is widely held that the objective of

market transactions is to increase one's advantage, to try and get as much as possible from the person or persons with whom one is interacting. In ideal communities, however, the object is to try to care and give. This basic opposition between markets and communities is at the center of many debates. Consider, for example, the problems that creep in when religious, governmental, or educational institutions mix their trusted community relations with business transactions. Although sociologists have convincingly argued that markets are always embedded in social relations,[16] and some have claimed that communities based on brands are genuine communities,[17] as citizens we are often drawn to regard these claims with skepticism. Can the self-interest of money making and relations of deep trust truly coexist?

This stance probably explains why, throughout human history, markets and communities have generally been kept apart. But with the rise of industrialization and, especially, a postindustrialized service- and information-based economy, markets have increasingly appeared within social forms, times, and systems that were previously more like communities. This evolution perhaps reached its apex in the strange phenomenon of multilevel marketing, where endless Tupperware Parties and Mary Kay cosmetics gatherings mingle the social with the economic, where families and friends become distribution channels.

The postindustrialized mixing of markets and communities seems to render "community" a much weaker construct. Harvey relates this to his view of Burning Man's intent to discover "optimal forms of community" and to produce a meaningful, authentic sense of human culture "in the conditions of our post-modern mass society."[18] What are the characteristics of this postmodern mass society, and how exactly do they relate to this tension between Gemeinschaft and Gesellschaft? In the next section, we explore this question by drawing on the insights of postmodern scholarship.

Postmoderns in Paradise

Postmodern authors have been simultaneously fascinated and horrified by the growing interdependence of Western civilization and contemporary Western capitalism. Arguably, much of postmodern thought can be simplified as forms of resistance to different authoritative narratives such as this one. Postmodernism as a literary arena tends to question the authority of

science, rationalism, and technology, and in turn the forms of economy, leadership, and bureaucracy built upon them. Many postmodern scholars view society as having undergone a fundamental shift since World War II, in which a rise in the predominance of markets has left people isolated from one another, from self-expression, and from their true selves. This sad state of affairs is often blamed on the intertwined rise of the mass media and mass consumerism.

As with the Burning Man participants cited above, Fuat Firat, Alladi Venkatesh, Nikhilesh Dholakia, and other postmodern consumption scholars assert that the trend of Western society is toward increasingly individualized, private, alienated, and passive forms of consumption, and for this they blame the contemporary marketplace.[19] However, Firat and Venkatesh's liberatory postmodern perspective challenges researchers to locate the consumer in spaces that are emancipated from the market, and that enable them to assume a wide range of unpredictable and creative roles and identities. Following John Sherry's rearticulation of consumption and consumers,[20] Firat and Venkatesh envision a space outside the market system in which consumers can produce their own meanings and identities. Although they wonder whether these goals are actually realizable, they hold that a central project of researchers should be to "identify a social space beyond the reach of the market."[21]

Can consumers actually get outside the grips of the market? What could this social space be like? Firat and Dholakia extend their ideas further in an important later book entitled *Consuming People*,[22] in which they urge that, since consumption (in its literal sense of using products and services) is inevitable, a solution may be found through the consumption of experiences that offer new social possibilities and new social identities besides those of the passive, marketing-driven, conformity-seeking, brand-hungry consumer. Striving for a concrete example of a place where this would happen, Firat and Dholakia describe these possible market-emancipated spaces as "theatres of consumption."[23] Theaters of consumption involve performances that dissipate the passivity of contemporary consumption. The key to overcoming the passivity that makes the consumer such a sorry character is in acting, doing, and being. So theaters of consumption are conceived of as lively, expressive, creative, and temporary places.

Fuat and Dholakia criticize more "permanent" and "totalizing" attempts to escape markets such as "communes or kibbutzim."[24] These attempts, they

Reverend Billy and the Church of Stop Shopping, conducting a service at Burning Man (2003). Photograph by Gabe Kirchheimer.

argue, ossify, institutionalize, and become as bad as the repressive institutions that they were formed to resist. Instead, the utopian theaters would "avoid cooptation by the market" by developing "permeable but distinct enclaves that allow a free flow of people in and out, but maintain an autonomy from the mainstream market culture."[25] This portrayal of consumers, and the impetus for envisioning temporary social alternatives, is strikingly similar to that found at Burning Man.

Similar utopian social spaces have been found not only by those who envision escape from the market, but by those who travel along its margins. John Sherry found a sense of them in the temporary community of flea markets.[26] Eric Arnould and Linda Price discovered strong temporary connections blossoming in commercial river-rafting expeditions.[27] In the countercultural discourses of the Harley-Davidson subculture, John Schouten and Jim McAlexander observed that Harley culture could be thought of as "a sanctuary in which to experience temporary self-transformation."[28] In his ethnography of Star Trek fan culture, Henry Jenkins detailed how fan culture uses "the utopian dimensions within popular culture [as] a site for constructing an alternative culture."[29] Russ Belk and Janeen Costa explored the world of contemporary mountain men (historical reenactors) and found that their enclaves create "a sacred and fantastic time and place, providing escape, renewal, play, and a sense of community" in "an atmosphere set apart from everyday reality."[30]

It may seem strange that these studies present strong communities that exist within the market. Although they may be on the social fringe, Harley bikers and Star Trek fans are surely working in coordination with marketers and marketing forces. But they also form communities that are, in some sense, utopian and resistant. Fans create fan art, fan literature, fanzines, books, critiques, and then trade them in profitless harmony. Bikers customize their bikes and organize rides and clubs. Mountain men build costumes and equipment, stage reenactments, and live in temporary gatherings. Participants in each of these communities use products that have been produced, distributed, and bought commercially. They also, for a time, cohabit places that they transform and, in this sense, communalize and sanctify in (and with) their own images. Although they are still in the market, their styles of communal consumption do not seem based on a passive acceptance of homogenizing and disempowering images and roles created by large corporations. They have resisted not the market itself, but the Gesellschaft, the distanced, corrosive, exploitative social relations that people associate with the market.

This may be the core realization that makes these ironies, and the market's seemingly oppressive hegemony, tolerable. What may be important is not the actuality of total resistance to markets—which may be pragmatically impossible to achieve in an absolute way—but the appearance of it, its partial achievement. The act of resisting the role of the passive, uncreative consumer is instantly empowering. Following the influential work of postmodern writer Michel de Certeau, Yiannis Gabriel and Tim Lang conceive of some resistant forms of contemporary consumption as

> guerilla fighting in an occupied territory. The powerful define and construct 'places' like shopping streets and malls, houses, cars, schools and factories which they seek to control and rule, using strategies and plans. The weak, for their part, are forced to operate in these places, but are constantly seeking to convert them into their own 'spaces,' using ruse, guile and deception and relying on suddenness and surprise. To the strategies of the powerful, the weak proffer tactics, operating in isolated actions, forever discovering cracks in the system and opportunities for gain. The joy of consumption, then, comes not from the temporary sating of an addiction or from the fulfillment of greed, but from outwitting a more powerful opponent who has stacked the cards.[31]

This conception relates perfectly to Hakim Bey's idea of the Temporary Autonomous Zone (or "T.A.Z."). Bey, a utopian writer, envisions escape from the system in the Situationist's focus on the tactical and the everyday. All-encompassing social systems can be momentarily escaped, he holds, by embracing pluriform, often temporary, social forms. He sees this escape beginning communally and cunningly, in tight-knit social groups gathering to work and play outside of mediated structures and control systems (i.e., outside of work and the leisure marketplace). These autonomous groups may horizontally unite, becoming a tendency, then a movement, then a kinetic web of Temporary Autonomous Zones. A "T.A.Z." is "an uprising which does not engage directly with the State, a guerilla operation which liberates an area (of land, of time, of imagination) and then dissolves itself to re-form elsewhere/elsewhen, *before* the State can crush it."[32]

These theories all relate escape from confining bounds—the State, rationality, bureaucracy, authority, hegemony, the Man, the market—to temporary acts of spontaneous theater and self-expression. They relate community to art,

to gifts, and to temporary cohabitation. Yet as we examine the resistance of contemporary consumption, we are left with a range of important paradoxes. How can marketed, mass-produced goods be used in antimarket communities? Do contemporary communities have to engage in production practices of their own (becoming, in essence, isolated communes) in order to distinguish their consumption from the anticommunal taint of markets? Would not abstinence and conservation mark resistance to the market, rather than abundant consumption of all manner of mass-marketed products? The study of consumption at Burning Man, which is filled with concealed and unconcealed brands and prodigious amounts of indulgent consumption, raises almost as many questions as it answers. In our interviews with participants, we often found people waxing enthusiastic about the no-vending rule, wearing new branded hiking shoes, and slugging down large bottles of Gatorade they bought from the Reno Wal-Mart.

In 2000, a survey question by the Ministry of Statistics (a theme camp that collected and tabulated information from participants, but which did not, we hasten to emphasize here, do so in a rigorous or scientifically sound manner) asked participants how much money they spent to prepare for and attend Burning Man.[33] The median response fell between $500 and $750, with considerable percentages spending thousands of dollars. Participants seem well aware of the irony inherent in their massive spending. Fresh off the boat as Burning Man newbies, we initially described our interest in Burning Man as an "anticonsumption" event. Many participants laughed at our naiveté, noting that they had never seen so many people consuming so much in their entire lives. The massive expenditures spurred by the event have, in fact, helped it gain local political support, as power follows the money trail leading from Reno right through Gerlach.

To understand the event we need to dig deeper and ask how Burning Man's participants can spend so much and yet feel that they are escaping the marketplace. Why are these otherwise highly intelligent and creative people ignoring the brands that are right in front of them? We might speculate that it is not because the items or products themselves are being rejected, but instead advertising, sponsorship, and the more overt forms of marketing. Yet even marketing MBA students can quickly tell you that marketing encompasses everything about a product or service—the product or service itself, its design and formulation, the package, the salesperson, the channel it is sold within, the price—not merely advertising. Unless a Burning Man participant

were to leave civilization entirely behind, and live with the wolves, marketing would be very hard to escape. With every swig of Gatorade our antimarketing participants are, in some sense, subsidizing athletic sponsorships, bankrolling the production of another season of *Survivor*, paying for advertising, voting for the marketing system that produced it.

The statement of "Teddy-Be-Air," a longtime Burning Man participant, tells us much about the way some participants conceive of the massive amounts of purchase required for Burning Man: "Even though we have to buy things and bring things out here, that is done not so much for status as it is for beauty and community." Teddy's comment demonstrates how Burning Man's ideology helps participants psychically transform commercial goods into sacred ones. In ritual consumption, and in the giving of the gift, goods are transformed from mass commodities to singular items. They move from the selfish, individual-centered realm of "status" to that of the utopian ideals of "beauty and community." Through these terms participants themselves mark off the important differences between communities and markets. And, despite their material origins, it is from these symbolic gestures that all meaning emerges.

Taking this analysis further, we also must wonder why so many people feel a need to block out commercial relations and marketing. Aren't there many places in contemporary society where people go to escape markets? Aren't families, friends, and other close social and communal relations places where people expect trust to prevail over economic drives? Or has our society dispensed with even these fragile shelters? With a constant barrage of telemarketing, junk mail, television advertising, print advertising, and E-mail spam hitting us in our homes, marketing and advertising have completely infiltrated our private spaces. Consumers likely feel the hegemony of the marketplace (as is theorized by the scholars above) as an unending advertising barrage. Might our informants' enthusiasm for Burning Man's antimarket ethos reflect a sense that, in postmodern society, there truly is no place to hide from the market?

Burning Man seems to offer these participants a purgation and/or purification of the commoditizing forces of Western capitalist economies. In its exclusions of sponsorship and overt marketing, it offers participants a welcome break from Western markets glutted with repugnant social values, waste, and greed. While much of the world is seeking to build an American-style market economy, Burning Man provides a temporary refuge for those who have already become weary of its many psychic and social intrusions.

Markets versus Communities, or Markets and Communities?

The playfully ambivalent and cautious postmodern stance of a large group of Western consumers who cast modern markets and passive consumers as their ideological enemies is vividly revealed in Burning Man's rules, rites, art, and themes. Yet the symbols of "shopping," theme parks, strip malls, and especially of Las Vegas–themed entertainment spectacles abound. This cannot help but remind us just how deeply embedded we actually are in these phenomena. The urge for community may be utopian, but the presence of the market and its many spectacular manifestations is ubiquitous. We are locked into marketized social structures, existing as beings within a market culture that has a sure and steady grip. These social structures form not only our spaces, but also the structures of our discourses, the meanings of our sign systems, the rules of our sociality, the very foundations of our thoughts. Markets and exchanges date back to the dawn of human history. The ancient Greeks introduced single currencies, and economies bloomed. Exchange is in our nature now, and perhaps always has been. Commercialism and pop culture are inextricably tied up in our language. Why else would the Hard Rock Café morph into the Black Rock Café? Why else are brand signs, commercial parodies, pop culture and entertainment formats, and corporate references everywhere to be found on the playa?

So we can add to our list of awkward ironies yet another one. In its festal celebration of abundance and excess, Burning Man holds much in common with the mood and tenor of ancient marketplaces.[34] Marketplaces of old were located at the borderlands of civilized communities, where tricksters offered combinations of entertainment, danger, opportunity, and delight. Ancient marketplaces were remote, celebratory, and strange. People journeyed to them looking for excitement and even transformation. But while the demarcation of special times and spaces for social experimentation and personal metamorphosis may be ancient, it adopts a decidedly postmodern orientation at Burning Man.

Burning Man can be read as a demonstration of the powerful lengths to which consumers feel they must go in order to decommodify products, services, and even their own identities. But as even a first-time participant will be quick to point out, there is far more to the event than these recalibrations. Contrasted with a range of social forms that increasingly seek to graft markets onto communities,[35] Burning Man provides an alternate view on

this social construction, as it does on so many other social constructions, from gender and sexuality to art, governance, and religion. Poised at the precipice of consumer culture, teetering into post-postmodernism, Burning Man provides a sense of the tension behind the often exploitative social endeavors of late capitalism and the constant utopian yearning for a more communal world.

Although it is decidedly utopian, Burning Man is actually less like a unified utopia than it is like Michel Foucault's notion of a "heterotopia."[36] Foucault used the concept of heterotopia to refer to unsettling or nonordinary social space, asserting that every culture contains places "which are something like a counter-site, a kind of effectively enacted utopia" in which the world outside of that site is "simultaneously represented, contested, and inverted."[37] Heterotopias possess an aura of mystery or danger, and always contain multiple meanings for participants.[38] Graham St John developed this concept further in his work on the "alternative cultural heterotopias" at Australia's ConFest, a biannual alternative-life-style event hosted by a Melbourne cooperative. St John contends that these counter-sites contain not one single utopian vision, but many variant alternatives, multiple utopics.[39] Unlike the unanimity and conformity presupposed by many prior conceptions of utopias—which actually sound like the robotic consumer behaviors that people are resisting at events like Burning Man—heterotopias thrive on the social sparks created when diverse groups commingle.

We can give many examples of diversity and divergence at Burning Man. Conflicts over music volume levels are commonplace at the event, particularly late at night when some participants want to sleep and others want to party. In many cases, the Rangers step in to mediate disputes. Camps have even been organized into "louder" and "quieter" zones, in an attempt to ameliorate some of these conflicts. Other examples of communal division occur over the extremes to which self-expression can be taken. In 1999, a group calling itself "The Capitalist Pigs" was ejected by the Rangers, for bull-horning passersby with insults and obscenities. In 2001, there were divisions over the display of homoerotic art.[40] There are also constant and frequent debates about people's roles as spectators versus participants. With our omnipresent camcorders, we have frequently been verbally confronted by people who insist that we put our cameras down and start acting like participants (now!). E-mail bulletin boards and participant conversations are frequently filled with denigrating references to "yahoos" and "frat boys," referring to the incursion of the profane, passive,

spectatorial, touristic consumer stereotype into the sacred participative play-space of the festival.

Conflicts and divisions abound. Yet they are managed. The heterotopia requires adept, empathic, and nimble management and leadership, which Burning Man's organizers seem to possess in abundance. Simple rules and gentle volunteers who balance order and regulation with the anarchic mandate to radically self-express are amazingly effective, and even exemplary. The question remains whether this institutionalized regulation of diversity could work on a term longer than seven days. Burning Man organizers' aims are explicitly utopian. Postmodern scholars tend to see successful utopias as temporary and local. Can the two be counterbalanced? Can we find respite in conventional society through increasingly festal incursions that promote community and undermine distanced social relations? In our view, these are discussions and debates are well worth holding, though they will have to occur elsewhere.

In conclusion, when added to the insights in other studies on the inter-relation of cultures, communities, and markets, Burning Man's communal construction, antimarket discourses, and many intriguing ironies are of considerable interest. Careful consideration of the types of community that people hunger for and seek to construct is an urgent imperative of our time.

A key to understanding Burning Man is to realize that while it is anti-consumption, with hefty admission prices and frothy cappuccinos for sale it is clearly not anticapitalism. It is, instead, an attempt to ameliorate some of the social deficiencies of markets. Burning Man is one attempt, among many others, to inject some much-needed emotional and social heat into social relations by causing people to question what they thought they knew, to reexamine ossified ways of living, and to see the flexibility that can exist within a social system that is ultimately propped up only by our consent to live within it. In so doing, it releases a tremendous amount of creative energy, forms strong communal bonds, and, temporarily and locally at least, seems to achieve much of what it sets out to do. The strip mall appearances, the brand parodies, and the coffee bars are no longer paradoxical when viewed in this light. They are now seen as necessary elements of a resistance that uses the language of oppression to subvert the social rules that are viewed as oppressive.

So it seems that our quest to find a place outside of the market was a fruitless one after all. There is no such thing. For there can be no such thing,

not in absolute terms. But perhaps that is as it should be. Can a gift economy exist outside of a market economy? Can a market economy exist without a gift economy? Can production occur without the relations of trust built through communities? Can contemporary communities thrive without the work ethic and productive values propagated by economic rationality? Can order exist without some chaos? We continue to wonder, and to enjoy our chai, at Burning Man.

NOTES

1. We attended the event as participant-observers and videographers in 1999, 2000, 2002, and 2003. During that time, we videotaped and interviewed several hundred Burning Man participants. Our research is also based on virtual fieldwork, or netnography, of the Burning Man festival bulletin boards, which we hold to be its extended context. Other articles we have authored on the subject include: Robert V. Kozinets, "Can Consumers Escape the Market? Emancipatory Illuminations from Burning Man," *Journal of Consumer Research* 29 (June 2002): 20–38; John F. Sherry Jr. and Robert V. Kozinets, "Sacred Iconography in Secular Space: Altars, Alters and Alterity at the Burning Man Project," in *Contemporary Consumption Rituals: A Research Anthology*, eds. Cele Otnes and Tina Lowry (Mahwah, N.J.: Lawrence Erlbaum, 2004); Robert V. Kozinets, "The Moment of Infinite Fire," in *Time, Space, and the Market: Retroscapes Rising*, eds. Stephen Brown and John F. Sherry Jr. (New York: M. E. Sharpe, 2003), 199–216.

2. Kevin Kelly, "The Next Burning Man," in *Burning Man*, eds. John Plunkett and Brad Wieners (San Francisco: HardWired, 1997).

3. Brad Wieners, "Untitled," in *Burning Man.*

4. Ibid. Also see Hakim Bey, *T.A.Z.: The Temporary Autonomous Zone, Ontological Anarchy, Poetic Terrorism* (Brooklyn, N.Y.: Autonomedia, 1991).

5. Larry Harvey, Published Notes to January 1997 Talk at the 9th Annual Be-In: Burning Man and Cyberspace; available from http://www.burningman.com/whatisburningman/people/cyber.html (accessed July 11, 2003).

6. Ibid.

7. See for example, Jacques Barzun, *From Dawn to Decadence: 1500 to the Present* (New York: HarperCollins, 2000).

8. Ferdinand Tönnies, *Community and Association (Gemeinschaft und Gesellschaft)*, trans. Charles P. Loomis (London: Routledge & Paul, 1912 [1955]).

9. Fang, "First Time? Do It Right," *Black Rock Gazette* 8, 30 August 1999, 1.

10. Burning Man Organization (2000), *The 2000 Burning Man Survival Guide.*

11. Larry Harvey, Larry Harvey's Burning Man '98 Speech, September 5, 1998, Center Camp Stage, Black Rock City, Nevada. Available from http://www.burningman.com/whatisburningman/1998/98_speech _1.html (accessed July 11, 2003).

12. Theodor Adorno and Max Horkheimer, "The Culture Industry," in *The Dialectic of Enlightenment*, trans., J. Cummings (New York: Herder and Herder, 1972).

13. Pseudonyms are used throughout to protect the confidentiality of ethnographic informants. In this ethnography, pseudonyms were chosen that exemplify the colorful "nom de playa" adopted by many Burning Man participants.

14. For greater depth on this topic, please see Kozinets, "Can Consumers Escape the Market?"

15. Tönnies, *Community and Association.*

16. See, for example, Mark Granovetter, "Economic Action and Social Structure: The Problem of Embeddedness," *American Journal of Sociology* 91 (November 1985): 481–510.

17. See Albert Muniz Jr. and Thomas C. O'Guinn, "Brand Community," *Journal of Consumer Research* 27 (March 2001): 412–32.

18. Harvey, Published Notes to January 1997 Talk.

19. See A. Fuat Firat and Alladi Venkatesh, "Liberatory Postmodernism and the Reenchantment of Consumption," *Journal of Consumer Research* 22 (December 1995): 239–67; and A. Firat and Nikhilesh Dholakia, *Consuming People: From Political Economy to Theaters of Consumption* (London: Routledge, 1998).

20. John F. Sherry Jr., "Postmodern Alternatives: The Interpretive Turn in Consumer Research," in *Handbook of Consumer Research*, eds. Harold H. Kassarjian and Thomas Robertson (Englewood Cliffs, N.J.: Prentice-Hall, 1991), 548–91.

21. Firat and Venkatesh, "Liberatory Postmodernism," 247.

22. Firat and Dholakia, *Consuming People.*

23. Ibid., 157–59.

24. Ibid., 156.

25. Ibid., 157.

26. John F. Sherry Jr., "A Sociocultural Analysis of a Midwestern American Flea Market," *Journal of Consumer Research* 17 (June 1990): 13–30.

27. Eric J. Arnould and Linda L. Price, "River Magic: Hedonic Consumption and the Extended Service Encounter," *Journal of Consumer Research* 20 (June 1993): 24–45.

28. John W. Schouten and James H. McAlexander, "Subcultures of Consumption: An Ethnography of the New Bikers," *Journal of Consumer Research* 22 (June 1995): 50.

29. Henry Jenkins, *Textual Poachers: Television Fans and Participatory Culture* (New York: Routledge, Chapman and Hall, 1992), 280–83.

30. Russell W. Belk and Janeen Arnold Costa, "The Mountain Man Myth: A Contemporary Consuming Fantasy," *Journal of Consumer Research* 25 (December 1998): 237.

31. Yiannis Gabriel and Tim Lang, *The Unmanageable Consumer: Contemporary Consumption and its Fragmentation* (London: Sage, 1995), 140.

32. Bey, *T.A.Z.*, 101.

33. See http://www.dcn.davis.ca.us/~mos/stats2000/stats2000.html (accessed July 11, 2003).

34. Jackson Lears, *Fables of Abundance: A Cultural History of Advertising in America* (New York: Basic Books, 1994).

35. For example, the brand communities of Muniz and O'Guinn.

36. Michel Foucault, "Of Other Spaces," *Diacritics* 16 (1986): 24.

37. Ibid., 24.

38. Ibid., 13.

39. Graham St John, "Alternative Cultural Heterotopia and the Liminoid Body: Beyond Turner at ConFest," *Australian Journal of Anthropology* 12, no. 1 (2001): 47–66.

40. The Jiffy Lube Camp mounted a gigantic, spotlighted mechanical billboard by California sculptor Mark Canepa, featuring two muscular men, about twelve feet tall, cut out of plywood, and hinged so as to portray the two men having anal intercourse. Citing complaints from families with children at Burning Man, Pershing County law enforcement officials decided that the art violated community standards and requested that it be removed. Burning Man organizers agreed. A noisy protest followed. Hundreds of participants expressed their opinion that, given the nudity and lascivious art already on display at Burning Man, this act of artistic censorship was homophobic and oppressive. Eventually, after more vocal debate, the billboard was moved to a less publicly visible location within the camp. For more in-depth coverage, see Deirdre Pike, "Burning Ban," *Reno News and Review*, September 13, 2001; available from http://www.newsreview.com/issues/reno/2001–09–13/cover.asp (accessed July 16, 2003).

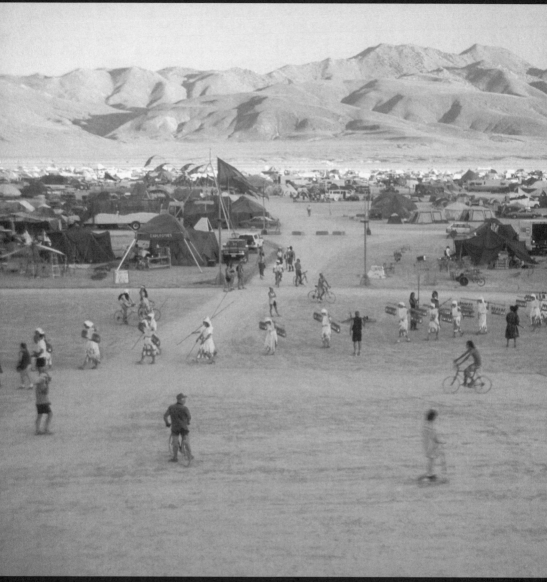

Lamplighter's procession (2001). Photograph by Holly Kreuter.

Incendiary Incentives

How the Burning Man Organization
Motivates and Manages Volunteers

Katherine K. Chen

Each year, the popular media issues colorful reports about the Burning Man event's annual manifestation as a temporary city in Nevada's Black Rock Desert. But much less attention has thus far been focused on the intensive year-round efforts that produce the week-long event. The seemingly "spontaneous" appearance and disappearance of Black Rock City is made possible by the San Francisco–based Black Rock City Limited Liability Corporation (hereafter indicated as the "Burning Man organization"). Unlike other corporations with the means to financially compensate employees, the small paid staff of the Burning Man organization is heavily dependent upon volunteers to carry out the majority of its organizational efforts. This dependence is explicitly reflected in the organization's mission statement, which emphasizes the need for members and event attendees to actively participate in the creation of the event:

> Our practical goal is to create the annual event known as
> Burning Man [and]... to generate an experience that encourages
> participants to do three things: (1) creatively express themselves,
> (2) fulfill an active role as members of our community, and
> (3) immediately respond to and protect that environment.[1]

By volunteering, some members fulfill this expectation of active participation and thus help ensure the continuation of the event and its ethos.

By analyzing two themes that comprise what the Burning Man organization calls "volunteerism," this essay strives to provide an alternative conceptualization to conventional understandings of what motivates people to contribute to voluntary organizations and places of employment. The first theme investigates what motivates volunteers to invest their time and labor into producing this event from year to year. The second theme examines how the organization manages volunteers, with particular attention paid to how organizers elicit timeliness and accountability. This is concluded with a brief speculation about the sustainability of such strategies and their relevance to other organizations.

Interviews and observations of Burning Man volunteers indicated that for some, volunteering fulfilled various individual needs that were unmet by their involvement in the workplace or general community.[2] For many of these volunteers, participation in the Burning Man organization complemented or supplemented their careers and provided a community of peers with overlapping interests, a significant attraction for those whose tastes and life-styles deviate from the mainstream. By volunteering for the organization, interviewed members cited how they gained the following specific benefits:

1. the ability to tap into multiple social networks of persons with different interests and backgrounds;
2. the opportunity to experiment with hands-on, creative, and challenging projects and environments;
3. the latitude to gain and exercise skills, particularly organizational and leadership skills, that were unattainable in the workplace;
4. immediate feedback and a larger sense of purpose in contributing to an organizational mission of enabling self-expressive participation; and
5. the autonomy to choose peers, tasks, goals, and supervisors.

Some volunteers valued their experiences so highly that they worked on Burning Man activities while on company time,[3] while others went so far as to specify the ability to attend the Burning Man event into their employment contracts.[4] A few even claimed (at least before the recession of 2001)

that they would leave their jobs if their supervisors would not let them attend the Burning Man event.[5]

From the perspective of the Burning Man organizers, reliance on volunteers has had substantial benefits and drawbacks. By harnessing volunteers' willingness to dedicate substantial time and effort, the organization saves on labor-related costs and capitalizes upon members' enthusiasm in the development and implementation of innovative creative projects. However, without the reinforcement of financial incentives, organizers have diminished authority to demand accountability and timeliness. To compensate for this, they recruit large volunteer ranks and reinforce volunteer conditions. By recruiting and training volunteers in numbers far greater than those actually needed, organizers increase the likelihood of meeting organizational needs. In addition, organizers have realized that they must allow for flexibility in recruiting and placing volunteers, who may require some time and effort to find proper roles. In creating conditions that elicit volunteer contributions, organizers have come to recognize that they must actively accommodate individual needs, a strategy less prevalent in salary-driven organizations. Such nonmonetary motivations include fulfilling individuals' desire for fun, community, and public recognition of their contributions. As a last resort, organizers selectively use financial incentives to heighten the likelihood that members will comply in a timely fashion.

For a significant subset of volunteers, however, intensive participation led to temporary or permanent burnout, a condition where volunteers can no longer physically or emotionally contribute. To cope with burnout, many volunteers reevaluated their priorities and reformulated their responsibilities to the organization. Others eventually withdrew from the organization, citing a change in interests.

Why People Volunteer for Burning Man

For many of the volunteers whom I interviewed, participation in the Burning Man organization complemented or supplemented their careers and recreational activities while also providing access to a desirable community. For instance, volunteers characterized both the event's community and organization as having the desirable attributes of diversity, depth, and freedom of interaction. For example, Tom Smith[6] used his patrols as a volunteer Ranger

to unselfconsciously mix with interesting individuals at the Burning Man event, which he considered to be "an ideal environment for human social interaction."[7] Likewise, Joe Cordes enjoyed the stimulating opportunity to work side by side with other volunteers on the Tech Team, a volunteer group that handles the organization's information technology needs:

> [there's] something about the excitement of a big group that I'm working for, one of the things that I was really into when I came on board was [being able to work with] some of the really cool people on the Tech Team . . . all these people [who] I really looked up to as being pretty much on the cutting edge of technology these days . . . that was really neat.[8]

Others admired how the norms of sociability governing the organization and the event allow them to interact with many people and thus cross over into previously inaccessible networks. For instance, the co-ed ranks of the Department of Public Works, the Burning Man department charged with building the city's infrastructure, have included art school students, punk circus clowns, former NASA employees, mechanics, riggers, architects, engineers, and other professionals.[9] By meeting and working in such a diverse group, individuals can develop and pursue new interests and skills, such as fire spinning or managing small arts events, thereby gaining opportunities not provided by less-well-connected networks:

> I think the amount that I can learn from people out at Burning Man is much more vast [than what is available at my workplace] because these people are bringing a huge resource of knowledge and skills and know-how just because they want to.[10]

In other words, members can learn how to pool resources, as well as question preconceived notions about individual differences that might have otherwise restricted contact and cooperation.[11] As Burning Man veteran John Rinaldi (a.k.a. Chicken John) vividly muses, the physical environment of the desert and the social norm of sociability joins otherwise disconnected people:

> So if you're like a rockabilly guy and you're like a reggae guy, and you're standing next to each other around a fire covered in dust, what difference does it make? Let me tell you—none. But if you're here in the city [of San Francisco and] you're a rockabilly guy, you're in your cowboy boots and your pompadour, and [if] you're

a reggae guy and you've got your dreadlocks and you're wearing your tie-dyed shit, are you going to talk to each other? I don't think so. That's the playa, it creates this wrecking ball that knocks down all of the walls that covers you with dust, it's nighttime and everybody is in a good mood.[12]

For some, this kind of collegiality reinforced their decisions to continue contributing to the organization: "I'm motivated by the enthusiasm and commitment from the people who are involved already... it's almost infectious, so I find myself being happy to be part of that."[13] The positive and fun outcome that results from such collective contributions only underscores individuals' satisfaction with volunteering. As volunteer Mike Wright commented, "When things work well, there's this sense of satisfaction, but mostly it comes out of having people that are fun to work with."[14]

By volunteering for the Burning Man organization, members also gained the ability to experiment with creative, hands-on projects and environments, and such experimentation has often led to a deeper understanding of individual and collective capacities for achievement. Members contrasted their experiences with more bureaucratic organizations that assign roles on the basis of demonstrated expertise, thus limiting their members' explorations of their abilities. In the Burning Man organization, members enjoyed taking certain creative and organizational risks, such as initiating a new project, and failing without the fear of being heavily penalized by the organizers. As one employee of Burning Man gratefully acknowledged, "you have the opportunity to screw up, and you're not docked your pay, or it's not something that goes on your record...."[15] Given the uncertainties of the desert's physical environment and the limits of human ability, both volunteers and attendees recognize that even the best-laid plans can result in spectacular failures and personal disappointments. But unlike other organizational environments, at Burning Man, experimentation is not just about achieving outcomes, but is also about understanding the intrinsic value of the experimental process. Organizers realize that ambitious projects that are initiated and/or undertaken by volunteers often require time to mature and that initiatives may repeatedly "fail" before achieving success. Unpressured by the need to demonstrate quarterly earnings that typify most publicly held corporations, Burning Man organizers are willing to support longer-term development with resources and time.[16]

In addition, many volunteers savored the ability to work creatively, especially if that opportunity was unavailable in their places of employment. For example, Scott Shaner's (a.k.a. Iceman) volunteer work allowed him to exercise artistic talents that were not part of his job as a picture framer. At Burning Man, he created professional-quality three-dimensional signs for various Burning Man services, and he also designed and helped build an impressive igloo structure for Camp Arctica.[17] Volunteers like Leslie Bocskor, a software entrepreneur and consultant (who also organizes the New York City regional branch of the Burning Man organization),[18] described his volunteer experience as a refreshing oasis from the constraints of the bottom line–obsessed paid work:

> [My volunteer work is] interesting because it's more rewarding because it doesn't have economics on top of it as a guiding principle. . . . I have found that economics will change the nature of an interaction [in my nonvolunteer work], I might not be doing it if it was not economically feasible. Whereas with Burning Man, the guiding principle is more one of what's going to be best for the community and for myself and other members of the community.[19]

Other volunteers valued working at different levels of participation from those of their workplaces. An environmental engineer who works at the federal Environmental Protection Agency (EPA), Karina O'Conner has taught an environmental preservation practice that event attendees can follow at the event and elsewhere. Such teaching constituted a hands-on opportunity unavailable in O'Conner's work with the EPA.[20] Likewise, Stephanie Szymanski felt that her volunteer work at the event as an Emergency Medical Technician presented more stimulating challenges than her job as an environmental manager, which, as she stated, "I can do it in my sleep."[21] Overall, members cherished their work for Burning Man as a special experience. As Will Roger (a.k.a. Mr. Klean, a former arts professor) described his work as a Burning Man organizer and head of the Department of Public Works, "I don't think there's another job quite like mine out there."[22]

By volunteering for the Burning Man organization, some could escape their pigeon-holed roles at work, especially if their workplaces did not fully meet their needs. Volunteers routinely developed a wide variety of skills beyond those that they were normally compensated for, and they applied

these skills toward a cause that they valued. For instance, volunteers on the Tech and Web teams enjoyed learning how to use new program development tools while also forming a community of peers. Others appreciated the opportunities to take charge of pet projects, oversee their implementation, and receive feedback, an expansion of abilities that enabled people to transcend the stifling boundaries of their everyday jobs. For Mandy Tilles, volunteer work helped alleviate her frustration with the constraints of her employment as a word processor in an engineering firm:

> [My workplace is] very family, [and] I love family, but . . . there
> is a definite line between who's the engineers and who's the
> admin[istrative] help. It's this real old model, and it's quite
> oppressive and depressing to me, and [in contrast, when] I work
> with Burning Man and obviously I like putting on events because
> I get to show up, and people appreciate what I have to offer,
> and I get to feel good about myself, and I get to go to these really
> fun events, and I get to see the fruit of my labor . . . that feedback.
> I do this, everybody's having a great time, and there are people
> who are happy with me. There are mistakes along the way, too,
> [but] it's all part of the process.[23]

Likewise, Molly Tirpak viewed her volunteer coordinator work as exercising and strengthening management skills that her previous job did not encourage:

> My [previous] job [as a Pacific Gas and Electric energy policy staff
> member] for most of this year has been very different, [and] it
> hasn't used some of my organizational leadership skills, and so for
> me [being a volunteer coordinator for] Burning Man is a chance
> to get back on my feet in San Francisco and demonstrate and use
> some of my organizational development and leadership skills.[24]

Some members even found that their volunteer experiences can enhance their resumes and capture the attention of interested employers. For instance, Shaner compared his experiences managing Camp Arctica's operations to managing a small business.[25] Antonio "Shona" Guerreo viewed his volunteer work as introducing a more balanced perspective regarding his work at an architectural firm:

> I think [that] being a volunteer makes me a better employee at my

real job . . . it makes me a better part of the team at my real job, and
it helps me to balance things out and helps me to realize that I'm
not my job, and [that] there's a bigger world out there from what I
do from 9 to 5. . . . It helps me to see that there's value in work and
there's value in play, and I have to ride the line between those
things and keep those things balanced—otherwise, I'll go nuts.
So being a volunteer gives me that perspective of the greater
whole of everything in terms of my real job.[26]

In entrusting volunteers with the responsibility of carrying out risky, cre-
ative ventures, the Burning Man organization provides conditions for individ-
uals to successfully develop and apply new skills that other organizations
neglect or discourage in the interests of maintaining control. In establishing
these conditions for individual and collective accomplishment, members
gained the inspiration to achieve and to improve on previous years' efforts.

Another aspect that interviewees valued was the opportunity to receive
timely and gratifying feedback. While some individuals had difficulties per-
ceiving the impact or relevance of their efforts at their places of employment,
they felt that their volunteer experiences were more rewarding because they
could directly deal with people and issues, as well as place their contribu-
tions within a larger context. Tom Smith savored the immediacy of human
contact and interpersonal problem-solving that characterized his volunteer
work, in contrast with the distanced feel of his work as a project manager:

The crises that happen with my volunteer job on the playa tend to
be very quick decision making, and it's either some type of activity
or some kind of communicative activity and very immediate and
very real, which is just generally more satisfying on a primal level.
There's just something more satisfying [in] dealing with people,
someone who [is] hurt or stressed out or angry [rather] than
dealing with some horrible email or computer files or something.
It's more immediate, more basic.[27]

In general, volunteers discovered that their Burning Man experiences
engendered more tangible meaning than that provided by their employ-
ment. For instance, Eric Pouyoul critically compared the visible immediacy
of his work at Burning Man with that of his work as a software engineer:

The work I'm doing there [at Burning Man] makes more sense to

me, too. It seems to have meaning, which my regular work has no meaning to me. I mean, writing a piece of software is useless, it's not going to change anything. Maybe making sure that the portapotties are clean may change some people's life. My work at Burning Man has more meaning than my work in the real world.[28]

Volunteers felt that they could relate their individual contributions to a larger community context, producing a more satisfying experience than the frequently alienating context of gainful employment.

Burning Man volunteers also appreciated exercising autonomy. In comparison with typical employment, volunteers claimed that they had more flexibility in choosing what type of tasks to do, how to undertake these tasks, which group of coworkers they could choose to work with, and which organizers to work for. This autonomy seemed to increase volunteers' commitment to their projects. For example, Pouyoul described a frank conversation with his boss about his commitment to volunteer work vis-à-vis regular employment:

I had this interview with my real manager, my paid manager the other day, and he asked me some questions because they do know that I'm working for Burning Man, because I do need free time, and my answer was, "well, I do respect my manager at Burning Man—Harley [Dubois]—much more than I do respect you because she doesn't pay me. You pay me, I didn't choose you, but I did choose her"... I'm working for Burning Man basically [it] is the work I choose to do, I'm choosing who I'm working with, and if I don't like it, well I just have to get out of it.[29]

A few volunteers like Pouyoul felt no compunction about prioritizing Burning Man commitments over work: "I would flake out my regular work at any time to make sure that I can do something for Burning Man and without fearing any consequences...."[30] Senter described her previous employer's reaction to her occasional prioritizing of volunteer work over regular employment:

I do ditch work sometimes to do Burning Man stuff, and I have actually consistently like burned work time to do Burning Man work... when I was [working as a project manager] at Wells Fargo, they were pretty supportive. They saw me working on Burning Man stuff when I was there.[31]

In such cases, employers seem to understand and support their employees' outside interests—but perhaps this understanding was because of the difficulties in hiring skilled labor during the tight pre-2001 labor market.

A few volunteers felt strongly enough about the rejuvenating value of the Burning Man experience to consider leaving their jobs if their employers would not approve an absence for the week-long event. When confronted with a hypothetical situation about choosing between work and Burning Man, interviewees such as volunteer Scott McKeown threw down the gauntlet:

> I would quit my job if I couldn't go to Burning Man. . . . Burning
> Man allows me to have the sanity to make it through the year being
> in the cube life and should that be taken away, [the job] wouldn't
> be worth it. I'd actually get a new job.[32]

Others like Mike Wright judged a workplace's worth by its support of employees' interests:

> it would have to be a really good company for me not to go
> to Burning Man for and in general, any company that I would
> consider that good would never have a problem with me
> going. That would be the first sign that they're not worth
> working for anyway.[33]

Anecdotal evidence suggests that during the process of volunteering, a number of Burning Man members experienced epiphanies in which they developed the impetus to leave unrewarding work to pursue more promising avenues.[34] For Jess Bobier (a.k.a. Nurse), working for the Burning Man organization as both a volunteer and a paid employee altered her expectations of employment:

> I think that I was really spoiled working at Burning Man, and I'm
> definitely going to have to step down and look at things more real-
> istically, but now I have a very high standard for how things should
> be, the way that I should be treated by people, the way I should
> treat people in a work situation . . . that we should all be humane
> toward one another, [more] friendly.[35]

The possibilities for self-determination made it easier for Burning Man volunteers to tolerate the constraints of most jobs, while for a few, tasting these possibilities shattered what they could tolerate.

While interviewees consistently praised the value of their participation in the Burning Man organization, they also identified how such commitments could lead individuals to burn out and reevaluate their priorities. This potential for burnout is especially high for those who are less able to pace themselves, as the organization does not necessarily set boundaries on how much individuals should contribute. The organizers are themselves overworked and usually have little time to monitor individuals for signs of burnout, and their own examples can encourage or pressure others into contributing more. The lack of clearly defined guidelines for volunteer work has allowed volunteers to exercise their creativity and produce results that they and others can appreciate. However, for some volunteers, this freedom becomes a hindrance if they cannot balance their tendencies to overwork, especially when they feel obligated to undertake work that they feel no one else can or will do. A number of volunteers such as Senter have experienced the condition of burnout to the extent that they elected to take a hiatus from the organization. Others decided to permanently leave the organization to pursue other interests or responsibilities.[36] Fortunately for the Burning Man organization, a constant refreshing of the ranks with new volunteers has prevented the organization from suffering the fate of other organizations dependent on highly committed members: organizational death.[37] A few volunteers, such as Shaner and Megan Beachler, have coped with potential burnout by reframing their volunteer involvement as a second job. In doing so, these volunteers recognized their responsibilities to the Burning Man organization, meaning that, unlike other attendees, they will not experience the event as a carefree holiday. Other volunteers such as Tom Smith and Tirpak viewed their volunteer activities as a desirable deepening of their commitment to the event's ethic of participation, which brought more rewards than drawbacks in terms of community and meaning. Nonetheless, these examples illustrate how burnout is a serious issue for any organization, including those that are more attentive to individual needs.

Organizational Strategies to Reinforce Volunteer Conditions

Burning Man organizers have discovered that they must employ concerted strategies to ensure that volunteers and members complete tasks on time. To cope with the inevitable attrition of volunteers, experienced department

heads have learned to recruit and schedule extra volunteers. In particular, the probability for "no-shows" increases during the event, which can overwhelm attendees with distractions and unanticipated challenges. To cope with such uncertainty, the organization has focused on training more volunteers than are needed and also on recruiting on-the-spot volunteers:

> One thing about time and being flexible, we are over-planning. If I'm raising a tower, it may take only ten people, but I'm training twenty people, because I assume ten may not know what day [the raising of the tower] is. . . . If twenty people show up for a five people job, that means fifteen people can find beer, and people feel valued. If you have the opportunity to, train people extra.[38]

In other words, organizers "stockpile" volunteers for various contingencies. In the best-case scenarios, all of the volunteers show up, get the job done, and have fun. In the worst-case, a volunteer coordinator must recruit volunteers at the last minute. But even in those circumstances organizers tend to feel confident that someone will step forward to meet or even exceed the requested requirements.

Once volunteers step forward, they may need time and effort to find a good fit between their skills and preferences and the organization's needs. Sometimes an initial placement may not work out, or will last for a limited time. During such trial placements, coordinators and volunteers may feel frustrated until a proper fit is found, as head volunteer coordinator Tirpak reminisced about how she successfully "repurposed" an initially irritating volunteer:

> I came to Checkpoint [an information station manned by volunteers during the event] last year. . . . The person was answering the questions wrong . . . [then] I got a call on the radio, the Café said that they needed a skilled volunteer, which this person isn't, and I said [to the unhelpful volunteer], "I can give you a ride on my golf cart home to camp" [to get him out of Checkpoint]. I told him I was looking for a rigger, and he said, "I know—the person I drove out with [to Burning Man] who was a sailor," [and this friend] tied knots for three days. That same guy who was a total nightmare at Checkpoint days later, him and his loud voice were at Recycle camp, pedaling [a bicycle-powered aluminum can crusher as a

volunteer], and he's now the volunteer coordinator of the
Recycle camp.[39]

Organizers have emphasized that, rather than just filling available posi-
tions, managers should redirect and "repurpose" volunteers to find a better
fit, even to the point of allowing some volunteers to create new positions.
Community Services organizer Harley Dubois shared how she placed two
initially reluctant volunteers, who attempted to crash the 1996 event with-
out purchasing tickets:

> When I get to the Gate [the entrance where incoming event-goers
> buy their tickets], a Gate person storms over and says for me to
> handle this. The two chicks had no money [for the tickets], no
> water, no food, nothing. They were getting more sassy ten miles
> in and ten miles out.... I said, "ok, you're going to work for your
> tickets." One [of them] whined, "You're going to make me scrub
> toilets." I said, "listen, bitch, I'm going to get you the best job,"
> and got on the radio and called around for people needing
> volunteers. Finally [I find out that] Plundertown [a theme camp]
> was doing a life-size game of Mouse Trap, I send them over, and
> I never see these people again [during the event].
>
> I come back to San Francisco and go to a Chicken John event
> and see this woman and man and another woman and man,
> it's Steve, Co, and Mark, they were their girlfriends. One [of the
> girls] said, "you were right, that was the coolest job ever."
>
> So suss [potential volunteers] out, find a match, it can
> be a good outcome.[40]

This story illustrates how positive intervention can change mutually
frustrating circumstances into a positive participatory experience for organ-
izer and volunteer alike. By taking into account individuals' interests and
aptitudes, organizers also increase the likelihood of retaining volunteers and
thus fulfilling the organizational mission.

In addition, volunteer coordinators believe that enticing work condi-
tions will ensure greater volunteer accountability. After a lukewarm turnout
from volunteers scheduled to staff Camp Arctica in 1999, Shaner took
responsibility for converting the original unappealing minimalist structure
into a full-fledged theme camp experience for the following year:

I spent four months organizing these volunteers, and I had like 130 volunteers ... these are people that I emailed personally that said, "thanks for emailing me back. We're selling ice, we need some volunteers, would you be willing to help?" and they would say yes. And then I get back to them and say "we need some volunteers at this time, like Tuesday and Thursday 1 to 5, does that work for you?" And then they would email me back and, "well you know, it might work—it works out for my friends, but it doesn't work out for me."

So I made a schedule and I wrote their names down ... and then just before the event, I emailed them and say, "these are your times. Do you still want to do this?" and they're like, "yeah, let's do it," like gung ho. And then nobody showed up. I had 130 people volunteer for this, and I spent four months of my life, which is now gone [said with indignant emphasis], and about ten people showed up.

I said ... "people don't want to come and hang out behind hay bales, and sit around for four hours, five hours a day, while the party's going on around them and schlep ice back and forth. We've got to make this fun, we got to make it happen, we got to have costumes, we got to have fun music going to be a part of this giant circus that's going on." So we got to be a theme camp.[41]

In Shaner's opinion, the large igloo-shaped structure, themed costumes, and communal activities established camaraderie and inspired volunteers' enthusiasm to the point where one contacted him to suggest that they start planning ten months before the following year's event.[42] While some coordinators found that merely altering physical conditions and routines enhanced or reinforced volunteers' commitments, others discovered that catering to individuals' emotional motivations for volunteering can increase accountability. Echoing Shaner's experiences, the Lamplighters created their own live-in camp and thus ensured that enough volunteers would light the city lanterns each evening. By meeting people's desire for a community home and identity within the larger event, the Lamplighters successfully resolved its previously uneven volunteer patterns.

As the organization has amassed more resources, organizers have increased their capacity to "thank" volunteers through a variety of means that

range from public acknowledgment to the distribution of small gifts and even stipends. By acknowledging volunteers' efforts on the organization's Web site and at semipublic gatherings, organizers can provide the recognition that volunteers might crave. The organization also sponsors "thank-you" mixers before and after the event, facilitating social interaction for volunteers across different departments. Some organizers distribute memorabilia such as stickers, CDs, videos, and commemorative T-shirts emblazoned with the official Burning Man logo or other departmental insignias. Volunteers who contribute substantial efforts, such as those completing long, labor-intensive shifts during the Burning Man event, might eat free meals at the on-site commissary. In select cases, organizers may provide discounted admission tickets, or even reimburse some volunteers for the full cost of their admission. In rarer instances, a few volunteers receive stipends for their efforts, which may or may not have been negotiated prior to the work.

Burning Man organizers have recognized that prenegotiated financial incentives, typically in amounts significantly below market rate, can help ensure accountability and afford more control over processes and outcomes. Belief in the organizational mission can motivate members to a certain degree, but given their financial responsibilities and the greater standard of accountability associated with receiving money, financial incentives can induce recipients to more highly prioritize their contributions to the organization. For example, one organizer voiced frustration about a volunteer who waited until the last minute to draft crucial legal documents and neglected to incorporate the work of other volunteers. From this organizer's viewpoint, financial compensation would have forced this volunteer to adhere to a deadline and work as a team member. As one interviewed volunteer astutely noted, incentives work differently in a voluntary organization: "You can't threaten to fire a volunteer if they don't do their job right."[43]

As Burning Man ages, the long-term feasibility of the organization's strategies for maintaining volunteers, particularly in a market-driven economy, remains to be seen. Ultimately, the ability of the Burning Man organization to utilize a clear organizational mission and maintain a strong ethic creates the potential for the exploitation of members' idealism for purely organizational ends, but this is balanced by members' abilities to exit the organization and to assert their personal needs within it. As Dubois explains, individual members must feel like their needs, insights, and inputs are incorporated into organizational considerations:

> In those days, we were all volunteers, and I felt as committed
> as [Larry Harvey], and he had only had a few more years [in
> organizing the Burning Man event] on me, "yeah, it's your idea,
> but I'm just as committed as you, and I'm a volunteer, and if you
> don't like what I'm saying and if you're not going to listen to me,
> I'm out of here." [laugh] So he really had to listen to everybody.[44]

So far, organizers are willing to concede to some individual-level demands to ensure that members continue contributing and to maintain continuity in the membership ranks.

Unforeseeable issues continue to challenge the organization; for example, with the dot-com bust and recession of 2001, a sizeable number of Bay-area volunteers in departments such as Media Mecca, the media relations department of Burning Man, have had to reassess their priorities upon losing their jobs. Nonetheless, attrition owing to volunteer burnout, reevaluation of priorities, and life changes has not yet significantly decimated the Burning Man organization, as newcomers constantly refresh the ranks. Organizers have had to contend with changing expectations, especially as some individuals realize that others are receiving financial compensation or other rewards for their contributions, as captured by the following exchange between a volunteer and organizer:

> Brien Burroughs: "Aren't there perks for volunteering?"
>
> Harley Dubois: "No."
>
> Burroughs: "You're a stranger from [Los Angeles] and
> you're not treated any better than if you work in the
> [Burning Man] office?"
>
> Harley: [no response to Burroughs' question, moves
> discussion to another topic][45]

To some extent, organizers have addressed such questions up-front by emphasizing the volunteer nature of the event, as is indicated by this position posting:

> **Participant Services Representative**
> (or whatever YOU want to call it)
> **Sales/Ticket Process Management**
> We are looking for someone full time. . . . This is a contract position,
> and salary is commensurate with experience. None of us are paid

what our "market value" is, but we endeavor to compensate as
fairly as possible.

 ... [job description] ...

One note, it is still necessary for Burning Man to be a primarily
volunteer organization. However, there are paid jobs that require
a high level of accountability and commitment. Positions may
be administrative, technology based or mission critical [Dept.
of Public Works] positions. For the most part, however, we still
depend substantially on the 1500 individuals who offered some
level of service/time to Burning Man at the event and throughout
the year. And, as always we tip our dusty hats to each of you that
do ALL you do to participate in our beautiful city/event/culture.[46]

By offering financial compensation, organizers and managers must active-
ly manage recipients' expectations, lest everyone demand financial com-
pensation or resent that they are not paid.

Most likely, the constant refreshing of the volunteer ranks and the
development of affiliated arts communities around the world will move the
organization closer to fulfilling its larger agenda of encouraging alternatives
to consumer entertainment and the institutional art world. Based on the
example of Burning Man, individuals who explore how to organize and
develop communities, such as regional branches of the Burning Man event,
artist retreats, and retirement utopias, may continue the lineage of the
Burning Man ethos long after the original event and its parent organization
cease to operate. The Burning Man experience thus adds to the cultural "tool
kit"[47] of organizing options by allowing individuals to learn alternative forms
of organizing. This unique intersection of individuals and organization has
initiated a social movement that continues to spread, expanding our aware-
ness to a fuller range of possibilities for organizing.

The challenges of eliciting and managing members' contributions are
not limited to volunteer-based organizations. Most organizations want their
members to internalize the desire to contribute on an ongoing basis. The
Burning Man example illustrates how an "unconventional" organization has
accomplished this by balancing the needs of organization and individual.
Although conventional organizations, particularly places of employment,
are less likely to attempt such a balance, individual contributors are learn-
ing to demand more recognition of their personal interests. By acting on

these demands, the Burning Man organization has provided a basis for others to learn and enact alternative forms of organizing for the fulfillment of common goals. As this knowledge spreads, we may see significant changes in how people organize.

NOTES

1. Excerpted from the Burning Man organization's mission statement. *Operation Manual* 2000, p. 1.1.

2. This essay draws upon interviews and participation-observations conducted from 1998 to 2001.

3. Interview with Eric Pouyoul, December 3, 2000, San Francisco. Interview with Monica Senter, October 6, 2000, San Francisco.

4. Interview with Monica Senter, October 6, 2000, San Francisco. Interview with David Oro, August 2, 2000, San Francisco. Interview with Jeff Oushani, October 8, 2000, San Francisco. Interview with Terri Hyatt-Oushani, October 6, 2000, San Francisco. Phone interview with George Paap, December 9, 2000.

5. Interview with Barney Ford, August 14, 2000, San Francisco. Phone interview with Scott McKeown, October 2, 2000.

6. A pseudonym used at the interviewee's request. Unless otherwise noted, I use both the interviewees' legal names and their Burning Man nicknames. Within the organization and the event, most people are known primarily by their nicknames.

7. Interview with Tom Smith (pseudonym), August 10, 2000, San Francisco.

8. Interview with Joe Cordes, August 7, 2000, San Francisco.

9. Interview with Will Roger, November 10, 2000, San Francisco.

10. Interview with Barney Ford, August 14, 2000, San Francisco.

11. Phone interview with Jim Lamb, August 10, 2000. Phone interview with George Paap, December 9, 2000.

12. Interview with John Rinaldi, November 3, 2000, San Francisco.

13. Phone interview with Susan Strahan, October 19, 2000.

14. Interview with Mike Wright, August 15, 2000, San Francisco.

15. Interview with Jess Bobier, September 20, 2000, San Francisco.

16. Interview with Chase Lehman (pseudonym), August 11, 2000, San Francisco.

17. Camp Arctica is one of two vendors allowed at the event. See Kozinets and Sherry, this volume, for a consideration of the other "approved" vendor, the Center Camp Café. Proceeds from Camp Arctica's ice sales benefit the local high school. Interview with Scott Shaner, December 5, 2000, San Francisco.

18. The Black Rock LLC encourages the development of local chapters of Burning Man enthusiasts, who hold their own events and maintain their own social networks.

19. Phone interview with Leslie Bocskor, December 13, 2000.

20. Joint interview with Antonio "Shona" Guerreo and Karina O'Conner, October 15, 2000, San Francisco.

21. Interview with Stephanie Szymanski, August 10, 2000, San Francisco.

22. Interview with Will Roger, November 10, 2000, San Francisco.

23. Interview with Mandy Tilles, December 9, 2000, San Francisco.

24. Interview with Molly Tirpak, September 20, 2000, San Francisco.

25. Interview with Scott Shaner, December 5, 2000, San Francisco.

26. Joint interview with Antonio "Shona" Guerreo and Karina O'Conner, October 15, 2000, San Francisco.

27. Interview with Tom Smith (pseudonym), August 10, 2000, San Francisco.

28. Interview with Eric Pouyoul, December 3, 2000, San Francisco.

29. Ibid.

30. Ibid.

31. Interview with Monica Senter, October 6, 2000, San Francisco.

32. Phone interview with Scott McKeown, October 2, 2000.

33. Interview with Mike Wright, August 15, 2000, San Francisco.

34. Observation of senior staff meeting, December 18, 2000, San Francisco.

35. Interview with Jess Bobier, September 20, 2000, San Francisco.

36. Interview with Jennifer Holmes, November 9, 2000, San Francisco. Interview with John Law, September 26, 2000, Oakland, California.

37. Sociologists define organizational death as the disbanding or disappearance of an organization. For useful discussions about group motivation and the structural factors that lead to organizational death, see Rosabeth Moss Kanter, *Commitment and Community: Communes and Utopias in Sociological Perspective* (Cambridge, Mass.: Harvard University Press, 1972); Joyce Rothschild and J. Allen Whitt, *The Cooperative Workplace: Potentials and Dilemmas of Organizational Democracy* (New York and London: Cambridge University Press, 1986); Anne Swidler, *Organizations without Authority* (Cambridge, Mass.: Harvard University Press, 1979); and Helen B. Schwartzman, *The Meeting* (New York: Plenum Press, 1989).

38. Observation of volunteer lead meeting, July 5, 2001, San Francisco.

39. Molly Tirpak, observation of lead meeting, July 5, 2001.

40. Observation of Greeters meeting, June 13, 2000, San Francisco.

41. Interview with Scott Shaner, December 5, 2000, San Francisco.

42. Ibid.

43. Volunteers who knowingly break established rules, however, are asked to leave the volunteer group and/or the event. Interview with Joseph Pred, October 18, 2000, San Francisco.

44. Interview with Harley Dubois, December 21, 2001, San Francisco.

45. Observation of Burning Man office, June 1, 2000.

46. Marian Goodell, January 10, 2001, "Job Opportunity" in *Jack Rabbit Speaks* E-mail newsletter, 5:4.

47. Ann Swidler, "Culture in Action: Symbols and Strategies," *American Sociological Review* 51, no. 2 (1986): 273–86.

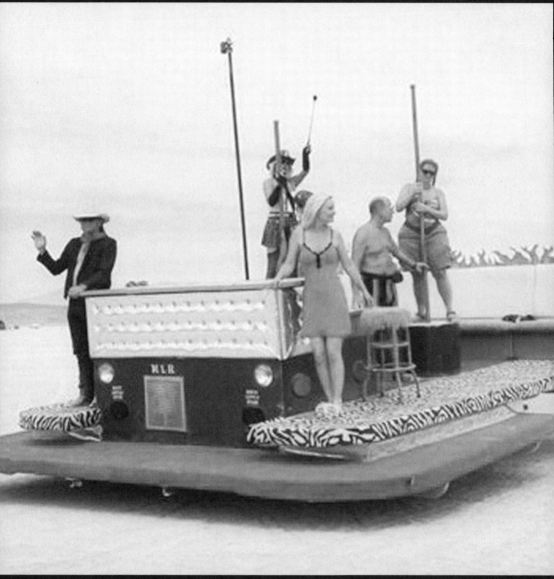

Pepper Mouser's Mobile Living Room *(1997). Photograph by Gabe Kirchheimer.*

Kaleidoscopic Cortege

Art Cars at Burning Man, and Beyond

JoAnne Northrup

The father implored to be taken too. Was it a very tiring walk?
Need one wipe one's shoes on the door-mat? And the boy went
to bed feeling faint and sore, and thankful for one thing—that
he had not said a word about the omnibus. It was a hoax, yet
through his dreams it grew more and more real, and the houses
of Surbiton, through which he saw it driving, seemed instead to
become hoaxes and shadows. And very early in the morning he
woke with a cry, for he had a glimpse of its destination.
 —E. M. Forester, *The Celestial Omnibus*

 While completing my graduate studies in southern California at the end of the 1980s, I was introduced to the world of art cars after becoming intimately involved with the creator of one of these mobile artworks. At the time, my friend and future husband drove a brightly painted Volkswagen bus embellished with several quotes borrowed from anonymous graffiti—the two most prominent examples being "ours is the only generation that wonders why Dorothy left Oz," and "orgasms are free." I was impressed by the iconoclastic spirit conveyed by these quotes, and this led me to become immersed in the art car subculture.[1] Even though my own perspective might best be described as that of a muse rather than a practitioner,[2] this essay will nonetheless explore the role played by art cars in society and at Burning Man.

Soon after this initiation, I was able to experience Los Angeles from the literal inside of art cars, and also from the figurative position of being an art car insider. Southern California has always been described as being the epicenter of car culture, but the denizens of this vast metropolis have not always been sympathetic to this most visionary strain of the automotive family. Because most drivers wish to retain the Blue Book values of their vehicles, they tend to be disinterested in any permanent personalization of them. Custom car culture is a modified version of the same market-driven aesthetic; although the cars are not new, the impetus toward keeping vehicles in a pristine state is very much the same. Preeminent car artist Larry Fuente, whose most well-known creation is *Mad Cad*, a 1960 Cadillac de Ville Sedan inlaid with beads and rhinestones punctuated with flamingo-adorned tail fins, explains the custom car aesthetic by saying: "They're involved in nostalgia. They're trying to make them exactly as they were when they came out of the factory. It's become incredibly expensive. The decent custom paint job can now run $10,000 at least, and that's just nice paint."[3] Naturally, the enthusiasms that form the basis for art cars fail to adhere to this aesthetic. In Southern California, our trippy bus's admirers included children, artists, and the low riders—our distant cousins. After the bus's ultimate breakdown, my husband Philo and I dreamt of turning a brand-new vehicle into an art car that could be driven at speeds in excess of 40 mph! And so, *The Truck* began its life as a perfectly pristine 1989 Ford Ranger pickup truck. One day, my husband took up his paint cans and power tools to begin transforming this generic vehicle into what would soon be known as the Truck in Flux, so named because it seemed forever a work in progress.

Some time in 1992, an acquaintance asked Philo if he planned to go and meet "the guy showing his art car movie" in Santa Monica. Soon thereafter, we met the art car avatar Harrod Blank, who was promoting his documentary film entitled *Wild Wheels* at independent theatres across the country. More than any other art car artist, Blank has been instrumental in introducing the general public to art cars and their creators, both in the U.S. and abroad.[4] It is common for art car artists to believe they are working in complete isolation before they are introduced to the loosely knit art car community, and Philo's experience was no different. Blank introduced us to other Los Angeles art car artists, and soon we began participating in car shows and other events along with our newfound compatriots.

After moving to Northern California in 1995, Philo and I attended Burning Man for the first time in the company of our fellow art car artists. In

recent years, Burning Man has become one of the most important annual destinations for art car pilgrimages. Art cars and Burning Man normally function as separate social and aesthetic ecosystems, but recently their destinies have been wed in a mutually beneficial way. Art cars now enjoy the privilege of being the only vehicles allowed to drive on the playa during the event—unadorned cars (or "mundanes" in art car parlance) can only drive to their campsites and park. Since 1996, the impact of these uncommon vehicles on the event has become undeniable, as art car artists have incorporated dazzling light displays and sculptural effects to build ever more spectacular creations. Now, the phenomenon has achieved the kind of critical mass that invites and deserves a thoughtful assessment.

The best way to understand Burning Man is to become immersed in its primal spectacle, as it is impossible to process all the sensory data that one apprehends at the event. To paraphrase Larry Harvey, Burning Man may be seen as a kind of petri dish, providing an ideal environment for individuals to escape the rules, regulations, and demands of everyday life.[5] In these circumstances, art car artists experience a sort of utopian life where societal mores are not allowed to inhibit their experimentation. The everyday world has the Department of Motor Vehicles, which tells us how and where to drive. Burning Man has its own DMV with a similar function—the Department of Mutant Vehicles—which also establishes aesthetic standards, demanding that vehicles be radically altered:

An Art Car is defined as any motorized conveyance that has been creatively modified from its standard configuration. Vehicles should no longer represent the base vehicle used (i.e., a bus should not look like a bus). Undecorated golf carts, vehicles stripped to their frame and engine or street vehicles with minimal changes or temporary decorations will not be considered Art Cars. Designation as an 'Art Car' will be determined by BRCDMV.[6]

In the everyday world, the most extreme art cars are towed to isolated parades or competitions and are driven for brief periods of time, after which they are returned to storage. At Burning Man, ordinary life is suspended and creativity is protected, cultivated, and encouraged to grow at an accelerated speed. For this reason, Burning Man provides the ideal environment for art cars to reach new heights of formal expression that expand their significance far beyond that of decorated transportation devices.

From Transgression to Celebration

Burning Man is but one of the many large festivals in which art cars play a critical role and it should be seen in the context of other such events. Therefore it seems fitting to begin with a discussion of two comparable events: Houston's annual Art Car Weekend, and northern California's ArtCar Fest. Unlike Burning Man, which takes place in a remote location, these two events are staged in populous urban areas. Their basic structure could be described as linear in that they move in an orderly fashion from one organized event to the next, unfolding over time. There is a definite start and finish to the festivities, which in some ways can be said to resemble a large family reunion.

In the spring of 1995, Philo and I decided to join our new friends in Houston for the annual Art Car Weekend. Since its official beginning in 1988, the Art Car Weekend has grown from a small folk-art gathering to a huge, citywide, and nationally televised event.[7] Joining us on the long drive to Houston was Harrod Blank and a film crew in his *Camera Van*.[8] The crew was in the process of filming Blank's second documentary on the subject of art cars, entitled *Driving the Dream*. We were also joined by Charles Hunt from Van Nuys driving *The Grape*, a 1964 Mercury Comet encrusted with bones; Jim Skinner from Portland driving Ron Snow's *Coltmobile* topped with 1,400 toy horses; and Ron "Rotten" Dolce from Oakland driving his immaculately crafted stained-glass VW *Marble Madness*.[9] The sight of an impromptu parade of these vehicles on the interstate was both stunning and outrageous. We all drove with CB radios, allowing us to be entertained by truck drivers speculating about the illegal drugs that led up to the creation of our vehicles. Within minutes of arriving at any given rest stop, the entire local population knew of our presence and came to see the cars, asking questions, snapping pictures, and sharing their own collections of interesting objects such as animal skulls or Elvis memorabilia.

By the time our road-weary group finally arrived in Houston, it seemed like a bastion of civilization. Houstonians have become accustomed to the sight of art cars and we were welcomed like family. Art Car Weekend is the oldest and largest of the nation's art car festivals, and is in many ways comparable to the annual motorcycle rally held in Sturgis, South Dakota.[10] However, the roots of Art Car Weekend were definitely modest. It began with the Orange Show, a Houston folk-art environment built by the late Jeff McKissack. A foundation was created to protect the site and to develop art and educational programming around it, resulting in a grassroots "Roadside Attractions: The

Artists Parade" beginning in 1988 with about forty vehicles.[11] In the past fifteen years, it has exploded in size and ambition, having found an appreciative audience. "The message of art cars is awesome," says Susanne Theis, executive director of the Orange Show Foundation. "It's not about critical theory or art works with layers of meaning. This is about self-expression and the idea that art can happen in places you don't expect it."[12] Art Car Weekend became the Pennzoil Art Car Weekend in 1999. Reactions among local artists have been mixed; they admit that the Orange Show was in desperate need of funding, and the sponsorship enabled the foundation to fulfill its mission of sustaining the Orange Show. After all, the Orange Show initiated Art Car Weekend as a means of promoting their programs, so the motivation behind obtaining corporate sponsorship was unassailable. However, many felt that the soul of the event was sold to the highest bidder—like other cultural phenomena, "branding" became a part of its identity. There is no doubt that the corporate sponsorship has helped to develop Art Car Weekend—there are now hundreds of participants and hundreds of thousands of spectators. But to some, this expansion represented a dubious trade-off.[13] There is always a hidden cost when corporations become entangled in art events—an implicit threat that the organizers of Burning Man have always resisted.

Gradually, the California contingent realized that it needed its own event, so in 1997, Blank and Philo Northrup organized the first annual ArtCar West Fest in San Francisco at the South of Market Cultural Center. The intent was to celebrate art cars with a lower-key, unadulterated version of the Houston event. Art cars of all stripes would be invited, but vehicles built as parade-only vehicles would be discouraged in favor of "daily drivers." Because hot rods and custom cars have their own shows where they are featured and championed, the founders determined that this event would exclude them. Since its first year the ArtCar West Fest has spent all proceeds to cover the cost of permits, insurance, and above all, paying precious mileage reimbursements to art car artists, thereby encouraging contributions from out-of-state and foreign participants. The event's purpose was to develop an engaged public focused on the artists and their talents. As Blank aptly put it, "I'm fueled by the audience, just like any artist. No one has defined this to the audience, and I think too often we have been reduced to clowns. The fact that you don't have to pay to see this belittles it in some people's eyes."[14]

In the building and the adjacent parking lot, viewers strolled around and examined the cars at close proximity. Featured vehicles included the

Mondrian Mobile, created by Emily Duffy of El Cerrito, California, one of the most photogenic art cars owing to its clean lines and bright primary colors. Duffy had recently graduated with an MFA from U.C. Berkeley, and had created her art car as a form of rebellion against the male-dominated history that she had been taught in her art history courses as well as a means of affirming her own stylistic impulses. "I wanted to do realism and I got very little support from my professors. So the painter Piet Mondrian came to represent to me the cold, unemotional, sterile, high-art, male, intellectual snobbery that I was experiencing. I decided, as a joke, to paint my car like one of his paintings. It's ironic, though, that what I created as a protest, people think is out of respect for Mondrian."[15]

Another exceptional vehicle that debuted at the 1997 ArtCar West Fest was David Crow's *Red Stiletto*. Crow's three-wheeler, a combination Hot Rod and provocative high-heeled pump, took the artist four years to complete.[16] The popular success of the show was David Best's *DC-23* (i.e. "decorated car"), with its original body unidentifiable due to the addition of so many ornamental elements, such as the head of a bison mounted up front in lieu of a hood ornament.[17] Best's art cars are works of idiosyncratic genius, and several of his "DCs" have been purchased at top prices for public and private collections, most notably by the di Rosa Preserve in Napa, California. The final day of the ArtCar West Fest culminated with participation in an already established parade and celebration, called the "How Berkeley Can You Be?" festival. After the success of the first year, the Fest organizers decided to continue on an annual basis. The name of the event was shortened to the ArtCar Fest after a Texas polka festival claimed trademark infringement.

After two years, the organizers decided that the San Francisco city permit system governing the event had become burdensome and too costly—it was time to move on. From 1999 to 2001, the Fest became a mobile festival. In 2002, the Fest agreed to hold their event at the San Jose Museum of Art. A fashion show and awards ceremony were held inside the museum, giving art car artists a sense of art world acceptance that they seldom experience. The event was a major success, and the museum hosted the Fest once again in 2003. If this model can be sustained the organizers will have accomplished their goal of devising a different model from the one used by the Pennzoil Art Car Weekend in Houston while still gaining the public approbation that the artists deserve.

Although there have been a few exhibitions of art cars in designated art and automotive museums, these shows reach out to an audience that

is more interested in the car aspects than they are in the vehicle's artistic implications.[18] Occasionally a contemporary art museum will endeavor to present an exhibition of art cars—the breadth of examples being determined by the load-bearing capacity of their facility. Several years ago the Triton Museum of Art in Santa Clara, California, presented a well-received exhibition of art on wheels curated by Susan Hillhouse.[19] The show was successful among art enthusiasts and brought new audiences to the museum. Nonetheless, the most enduring audience for art cars is still found at the supermarket, in the gas station, or on the highway. To paraphrase popular culture scholar Bernard Welt, if the label of folk art is applied to art cars, this descriptor should be taken seriously—it is a grassroots art form, as accessible to the blue-collar worker as to the educated professional.[20] Car artists may be perceived as flamboyant bohemians, yet the work they create is profoundly populist; they personalize their vehicles not because they don't wish to "fit in" to mainstream society, but as a form of self-expression. Their counterculture stance does not reject consumerism, but rather embraces old-fashioned American values of freedom and individuality. Car artists respond to the monotony of industrial design by transforming the anonymous product of an assembly line into the unique relics of individual autobiography.

The art marketplace, a system that funnels artists' raw creativity through art schools into the gallery system and ultimately into the homes of wealthy collectors, reconfigures unruly creative impulses into products that can comfortably reside within society's overarching consumerist framework. Supporting oneself through the business of fabricating and presenting unique objects provides an alluring, though illusive goal for many artists. Given the pressure to satisfy capricious, fashion-driven collectors, inevitably a degree of market-driven aesthetics filters down into their work—after all, these artworks ultimately exist for sale. The work of car artists has altogether different implications regarding consumer culture. The automobile, a potent symbol of consumer identity, forms the basis of their work; however, in the process of reinterpreting the moving vehicle as the tangible expression of an idea, they negate its corporate and commercial aspects and therefore its "value." Whether an embellished everyday vehicle or an extravagant conveyance glimpsed on the playa, art cars are presented to the public in an unmediated manner, rather than being filtered through the context of the art market.

It is difficult to underestimate the impact of unexpectedly encountering an art car in the context of everyday life. Multiply that reaction one hundredfold, and the potency of an art car event displaying between 50 and 250 vehicles becomes evident. Both the Houston and San Francisco festivals accomplish the task of providing a venue where numerous examples of the art car genre may be seen together, evaluated, and enjoyed by the artists and the general public.

The Petri Dish

The marked difference between the aforementioned art car venues and Burning Man is its setting on a vast dry lake bed. Participation in the event requires a significant commitment in terms of planning; one does not attend this event casually, because of the necessity for self-reliance. In 1995, the first year that I attended Burning Man, a description of the festival could be distilled into three nouns emblazoned on a bumper sticker: "guns, granola and videotape." That year, I participated in two events that typified the spirit of the time: the Disgruntled Postal Workers, and the Drive-By Shooting Range. Reverend Charles Linville, an art car artist, close friend, and arguably the most eccentric postal worker employed by the United States government, organized a mail delivery exercise.[21] For months preceding Burning Man, Linville had hoarded old uniforms as well as junk mail and circulars. Dressed in the uniforms and armed to the teeth with squirt guns, we delivered copies of *The Black Rock Gazette* as well as salvaged junk mail, to which we had affixed labels that read "Aging Hipster, Black Rock Desert" (along with some other more colorful ascriptions). This "mail" was delivered in an intrusive SWAT-team manner, complete with comical exercises in verbal abuse. The Drive-By Shooting Range was set up against a hill at the far outreaches of the playa, where numerous large stuffed animals had been arranged in various poses. Art car artists and other participants drove by, taking their best shot at the toys with live ammunition shot from firearms ranging from semiautomatic assault weapons to antique revolvers.

According to Blank, the first art car at Burning Man was Michael Michael's *5:04 P.M.*, a crushed yet fully functional automobile that served as a tongue-in-cheek testament to the survivors of the major earthquake that hit the San Francisco Bay Area at 5:04 P.M. on October 17, 1989. It wasn't until 1995

that art cars became a definitive presence at the festival when Blank helped to organize an art car theme camp.[22] Some of the cars present at that time were Hunt's *The Grape*, Linville's *Jesus Chrysler*, Blank's *Oh My God!*, Kathleen Pearson's *Love 23*, and Michael Gump's *The Host*.[23] The attendance at Burning Man that year was estimated at four thousand, and the event had no DMV or delineated perimeter, meaning that all automobiles and bikes had free access to the desert landscape. The results of these relatively lax security measures included members of the public sneaking into the festival site via alternate routes without paying for a ticket. The outside world was not in any way prevented from seeping in; law enforcement presence was aggressive, creating an atmosphere of intimidation. Retirees and curious townspeople from outlying areas drove their cars and RVs into the festival site, parked, and walked around like a tour group, gawking at the participants.

Blank organized several group drives across the desert in order to get some footage of the cars for his forthcoming movie on Burning Man, taking advantage of the undisturbed vista of the magnificent mountains that surround the area. As though providing a surreal counterpoint to the ubiquitous television commercials wherein smiling drivers tear up the desert landscape in a display of "independence," Blank arranged more than ten vehicles to drive slowly in formation, fanned out across the stretch of land like magnificent beasts. It was as though Blank had discovered the ideal framing device for the cars; normally surrounded by frenzied activity in the cities and towns where the artists live, the cars had been removed from all distractions and surrounded by stillness. This extemporized performance was only for the artists and camera; it took place far away from Center Camp where there was no audience, affording the artists an opportunity for unabashed revelry in the splendor of their vehicles. In those early days, art cars were not given an official definition by the Burning Man organization, but clearly they were becoming a prominent feature of the event. Most of these cars were 'daily drivers'—the lifeblood of the art car movement—licensed and insured vehicles that serve as primary mode of transportation for the artists who drove them from their homes to the event. Some cars were created especially for the event, such as Pepper Mouser's *Mobile Living Room*, a custom-made chassis outfitted with a twelve-by-twenty-foot deck, zebra carpet, swanky furniture, lamps, flashing lights, a two-hundred-watt, eight-speaker sound system, and a bar with blenders to mix frozen margaritas at forty miles an hour while as many as thirty people danced. *The Mobile Living Room* debuted in

1997, providing a precedent for all future people-moving vehicles. Others included decorated golf carts and bicycles, and most of these were designed for daytime driving and were parked at night. All of this would change in a few years.

My next visit to Burning Man was in 1999, at which point it had become a very different event from the one I remembered in 1995. It was more thoroughly organized and better managed, and its attendance had ballooned to twenty-three thousand. The crowd was sympathetic, and the police kept a lower profile, indicating a greater acceptance of the primal creativity that Burning Man could represent. Another major difference pertained to art cars—the rules had tightened regarding driving at the event, and art cars were the only vehicles with permission to drive about freely, albeit at only 5 mph. The art car theme camp that year was far from Center Camp, but the vehicles were still prominent and a big favorite amongst Burners. We especially noted a warmth of public approval when we drove the *Truck in Flux* about at night, with lights glowing and speakers blaring Bix Beiderbecke, causing passersby to dance an impromptu Charleston when we drove by.

Two subtle changes differentiated the 1999 experience from the earlier one, and both indicate the mounting sophistication of the event. First, I became aware that I was surrounded by an astonishing amount of wealth, owing to the economic boom of the late 1990s. One of my two lingering memories that support this view was the abundance of tip money I received as a volunteer barista making espresso drinks at the Center Camp Café (along with the ice concession, the only place where commerce is allowed)—people then seemed eager to throw their money at something. Clearly, this was no longer a crowd of unemployed poets. After that year's Burn, I took a moment to listen to the voices around me, noticing British and Canadian accents, as well as several young people speaking Italian and Japanese. Burning Man had become an international event. In addition to these demographic changes, there were other changes in the air that would influence the form that art cars would take at Burning Man.

In the late 1990s, complex lighting and fire effects were introduced into the design of art cars, and this revolutionized their overall look and feel. More visible than simpler forms of decoration, lighting has since become the determining factor establishing whether or not vehicles will be permitted to drive at night. Clearly there were some safety issues, because of accidents that had previously occurred. By 1999, Burning Man's Department of Mutant

Vehicles had been founded, and all vehicles wishing to drive about at the event, whether during the daytime or at night, were required to register at the entrance gate. Upon arrival, art car drivers were required to fill out some paper work, and have their vehicles evaluated by a member of the DMV staff. The driver was then interviewed about the vehicle, and briefed on the rules. After being issued a permit, drivers were required to carry it with them whenever they drove about the playa. Breaking the speed limit or driving without a permit could lead to the revocation of one's license and potential ejection from the event. This meant that Black Rock City had transitioned from an "anything goes" anarchy to an environment governed by a form of law and order. Clearly, these rules stemmed from liability concerns on the part of the Burning Man administration. However, they had a resoundingly positive effect in that they served to challenge the creativity of people who endeavored to create illuminated forms of transportation.

One of the most important tools for achieving dramatic lighting effects is electroluminescent (EL) wire, thin, flexible plastic tubing that emits neon-like light in all hues that can be used to create elaborate linear and animated designs visible at night. The use of these materials started out small, but grew rapidly. By 2002, Burning Man had essentially become a nighttime event, with many people sleeping in their tents and RVs during the day, awaiting the sunset before emerging out on the playa and driving about in their illuminated vehicles—or simply experiencing the glowing, other-worldly landscape that seemed like a setting for a science fiction novel. Imagine a flashing galloping horse striding past your campsite. Much like stationary neon lights advertising a business that shift momentarily from one linear image to another, this horse was mounted on a bicycle and had been created in a manner similar to the stop-action motion photographs of Eadweard Muybridge. It consisted of three separate views of the horse in movement, each described in EL wire and flashing in rapid alternating succession. Another successful early use of lighting was the electric carts designed to look like colorful jellyfish at night. In 1999, there was a small school of these creatures, their lucid bodies and tentacles outlined in phosphorescent pink, green, or blue, the designs seeming to float above the playa in graceful motion. In recent years these elegant creatures have continued to be favorites among those Burners who enjoy such gentle beauty as a counterbalance for the more aggressive forms of display at the festival, such as Austin Richards's mobile Tesla Coil electrobot or Jenne Giles's and Paul Cesewski's giant lotus garden filled with monumental fire-breathing flowers.

The full impact of these design innovations would not be felt until Burning Man 2000, when a veritable explosion of lighting effects set a new standard for the "radical alteration" of moving vehicles. In the past two years, the prominence of art cars at Burning Man has increased dramatically, and a large percentage of these creations are driven at night, creating the effect of an enormous free-form light parade. However, as Blank pointed out, in some cases, "these are not art cars made from a deep personal motivation; they are made to 'fit in.' They didn't want to make art cars—they wanted the right to drive."[24] While some Burners created remarkable interpretations of the personal automobile, a few artists took the notion of community to heart, and fabricated larger vehicles. A notable example is Lisa Nigro's *Draka, The Dragon Car*, a 124-foot-long, four-vehicle party wagon taking the form of a dragon that debuted in 2000. With glowing eyes and wings, *Draka* resembles the skeleton of a Viking ship, upgraded with the capability of belching twenty-five-foot bursts of fire. The following year *Draka* was modified to operate as Burning Man's first mode of public transportation in Black Rock City 2001—Dragon Public Transportation (BRC-DPT).

At their best, art cars combine the poetic and the prosaic, and perhaps the best examples of this synthesis are the creations of artist Tom Kennedy. From 1994 to the present, Kennedy's art cars have come to represent the pinnacle of art car design, as well as being illustrative and even exemplary of the changing art car conventions at Burning Man. Kennedy began his career on the loading dock and worked his way to a high-level position at the *Houston Chronicle* before leaving to pursue his dream of living a more independent and creative lifestyle. Having come from the headquarters of the largest annual art car parade in the nation, he developed an early familiarity with many examples of mobile art. His works have become recognizable even in silhouette—few people who have attended Burning Man during the past decade would fail to remember the shadowy image of *Ripper the Friendly Shark*, an enormous "land shark" gliding past. As Blank points out, "Today *Ripper* is one of our most recognized and inspiring art car icons, in part because Tom has taken the car everywhere—from Houston, where the shark has nearly landmark status, to nearly every art car event in the country, including five Burning Man festivals."[25] In spring 1995, I attended Houston's Art Car Weekend—and *Ripper the Friendly Shark* was there. At Burning Man 1995, Ripper was there as well, his silvery bulk swerving across the vast desert expanse with an animated tail restlessly shifting from side to side. Ripper was constructed on a Nissan body and

approximated the shape of a great white shark, sinewy and low to the ground with a saw-toothed jaw jutting out from the hood. The playa's dry lake bed provided him with an ideal environment. Here, Ripper was truly in his element, his lustrous body revealing a stunning sculptural simplicity that contrasted with the assemblage-based and painted art cars when Blank filmed them driving in formation. *Max the Daredevil Finmobile* was another of Kennedy's cars that attended the festivities. Both closely related to and distinct from Ripper, *Max* resembles a more abstract sea creature, with a van base and vertically oriented twin fins curving up from either edge of the windshield and stretching upward over thirteen feet off the ground where they end at the rear of the vehicle, transforming its silhouette into a giant rolling fin. In a performance at Burning Man in 1996, *Max* was painted red, white, and blue to mimic the design of the American flag, with white stars on a blue field painted near the cab, and red and white wavy stripes applied to the body of the van and fins.

Since the late 1990s, to prevent accidents the Burning Man DMV has increasingly diminished the freedom of art cars to move as they wish about the playa. Once the domain of 'daily drivers,' Black Rock City has since clamped down without exception on decorated cars, frequently revoking their rights to drive. Only art cars that radically depart from their base vehicle are allowed to drive in the daytime at Burning Man; and only those with pronounced lighting designs are permitted to drive at night. Whereas in the 1990s, art cars at Burning Man were epitomized by *Ripper the Friendly Shark*, today they are exemplified by Kennedy's latest creation, *The Whale*, a graceful and impressive creation inspired by Ahab's nemesis from Herman Melville's *Moby-Dick*.[26] One memorable night in 2002, the beast temporarily parked next to David Best's stunning and lyrical *Temple of Joy*.[27] The incongruous sight of a seventy-two-foot-long internally illuminated whale parked outside an elaborate four-story temple in a seemingly empty desert provided a typical Burning Man moment.

Unlike most art cars, generally made by individual artists, vehicles on the scale of *The Whale* are rarely the product of a single person. Due to the standards of radical alteration and the necessity of having lighting effects integrated into the piece, artists such as Kennedy tend to function as designers and team leaders, executing their work with the help of their peers. Kennedy's primary collaborators on *The Whale* were fellow artists Flash Hopkins and Dana Albany. Built from the ground up using a school bus as its base, *The Whale* was finished just in time for its 2002 debut. Seen from a

The Whale, *by Tom Kennedy (2002). Photograph by Steven Fritz.*

distance on the horizon, it appeared both massive and ethereal, an enormous bulk floating about the playa as though lighter than air. Made of white sailcloth stretched over a metal frame, interior lights caused it to emit a subtle glow perfectly capturing the feeling of a luminous Leviathan lumbering across the crusty expanse. Having had the privilege of entering this creation, I can attest to the fact that *The Whale* also includes a navigation and viewing platform open to the stars, near what would be the blowhole of a real sperm whale. Navigators could pull a spring-loaded lever to operate the whale's tail, causing the flukes to move up and down as though to propel the vehicle. The blowhole was equipped to shoot up to twenty-foot plumes of water (by day) or flames (by night). The plush red interior space, designed by Albany, features two upholstered and draped chambers, representing the whale's belly and intestines. Albany embellished the ceiling with a tile and glass mosaic on the ceiling, mimicking the whale's ribs, and added curved manzanita branches to correspond to the creature's blood vessels.

Celestial Omnibus

It is difficult to imagine a creation like *The Whale* coming about if Kennedy had not been driven to new heights of creativity in response to the maze of rules and regulations to which his cars were required to respond. Is it possible, therefore, that the codification of the DMV actually caused the development of more extreme and impressive art cars at Burning Man? Or have the abundant rules resulted in a proliferation of dilettantes—who wouldn't think of driving an eccentrically decorated vehicle in their normal lives, but who suddenly become art car artists for the sake of gaining the coveted permission to drive about the event? Should the artist's intention be considered in the evaluation of the resulting artwork, or is it irrelevant? The stringent standards to which art cars must adhere do seem to protect artists' creativity and elevate the stature of art cars at the festival. Realistically, a vehicle like *The Whale* may only be presented in a parade or as a mobile artwork at Burning Man, and not in the streets and parking lots of everyday life. Perhaps the value of Burning Man for art cars is the provision of an exhibition space for creations unlikely to be seen anywhere else. Cultivated and nourished in the petri dish that is Black Rock City, art car artists are afforded the opportunity to create a special strain of art capable of flourishing only within this context.

Clearly, the long-standing presence of so many art cars at Burning Man signals a collective synergy on the part of the artists associated with them, and such a synergy invites an attempt to put their efforts into a larger art historical perspective. Given their tendency to use the additive assemblage techniques commonly understood as "junk sculpture," it seems fair to draw a parallel between their efforts and the so-called "funk" art made by the California Beat subcultures that flourished in San Francisco and Los Angeles during the late 1950s. But this analogy extends far beyond the adoption of the surrealist-inspired technique of amalgamating everyday objects into miraculous fantasies. Like the Beats, art car artists have turned their backs on official cultural venues in favor of the devoted camaraderie of an insular group of dedicated aficionados, and like the Beats they see their work as having a performative aspect that ironically uses secret iconography to complicate their work beyond the point of being mere art commodities. Most importantly, both groups have made an effort to "make their own rules" concerning the reception of their art, and this admirable effort toward subcultural self-definition may prove to be their most durable legacy.[28]

The truly revolutionary aspect of Burning Man is the alternative society that it proposes and temporarily creates. In mainstream society, money and power are the most highly prized motivations. At Burning Man, this equation is upended. Eschewing monetary wealth and political clout, Burning Man reveres creativity in its many forms. Those who are able to create transformative art experiences become leaders in this community, and in the context of Burning Man, art car artists are among this leadership. They have become inextricably associated with the event. In fact, it has become a common occurrence to ask the drivers of art cars whether they will be driving their creations to Burning Man. Without a doubt, Burning Man has helped define the genre to a larger public by providing the perfect environment for experimentation and the development of new design ideas that ultimately filter down to the 'daily drivers.' But ultimately, Burning Man should be seen as a venue—a spectacular venue, but a venue nonetheless, because without Burning Man, art cars would continue to thrive in the world at large. They occupy a zone that bridges the two worlds, bringing something to both. Like the character Chihiro in Hayao Miyazaki's masterpiece of animation entitled *Spirited Away*, art cars have one foot in the spirit world, and the other in the real world.[29] Art cars embody the distilled essence of creativity that exists not only at Burning Man, but also in the outside world in less concentrated forms—in the form of 'daily drivers,' the true believers. They assimilate themselves into society, curtailing their more extravagant design impulses in order to maintain their insurance coverage and legality. Art cars, then, should be seen as a critical aspect of Burning Man, helping to define the festival to its participants.[30]

An annual journey to Burning Man shares some elements with sacred pilgrimages to holy sites.[31] It may also constitute the physical enactment of an inner journey, taken to clarify one's priorities in life, to engage in play, or to get in touch with one's primal humanity. On a smaller scale, art car artists make this journey each time they drive their creations on the streets, transgressing societal conventions. The transformation that they experience is not relegated to a specific venue, but rather comes from their commitment to put creativity and individuality foremost in their lives.

NOTES

The opening quote is from Edward M. Forster, "The Celestial Omnibus," *Selected Stories* (New York: Penguin Books, 2001), 33.

1. For a good introduction to the art car genre, see Roberta Ritz, "Vehicles of Self-expression: The California Art Car," *Artweek* (August 19, 1993).

2. This essay was initially inspired by a paper written by Todd Rowan in 1996 entitled "Spirit, Senses, Self and Society: An Art Car Parade in Chicago" (unpublished). Rowan is the creator of art cars such as *City on a Monster's Head.*

3. Maurice Roberts, ed., "Larry Fuente interviewed by Claire Poole," in *Art Cars: Revolutionary Movement* (Houston: The Ineri Foundation, 1997), 70.

4. It was not until after I interviewed Harrod Blank that I grasped the true relevance of art cars to Burning Man. I would like to thank him for demonstrating the vital contribution of art cars to contemporary culture through his films, books, public presentations, and, of course, his vehicles.

5. Joe Winston, *The Burning Man Festival* (film), Ow Myeye Productions, 1997. Copyright and distribution by NextGen video.

6. Department of Mutant Vehicles Black Rock City Vehicle Protocol 2002, Section 2; available from http://www.burningman.com/on_the_playa/playa_vehicles/dmv.html (accessed May 12, 2003).

7. Patricia L. Brown, "40 Fenders and Dada in the Rearview Mirror," *New York Times*, April 20, 1997, 1.

8. Elizabeth Pepin, "Obsessive Compulsive: Harrod Blank's Camera Van," *Juxtapoz* (fall 1998): 26–27. See also http://www.cameravan.com (accessed December 7, 2003).

9. Harrod Blank, *Wild Wheels* (Berkeley: Blank Books, 2001). (First edition published by Pomegranate Books, 1994). *The Grape* is pictured on page 38; *Coltmobile* on page 18; and *Marble Madness* on page 60.

10. Harrod Blank and Jennifer McKay, "The Art Car," *Raw Vision* 18 (spring 1997): 34–41.

11. Andrea Kannapell, "Car Artists Make Their Every Trip a Traveling Show," *New York Times*, October 20, 1999, 18.

12. Quoted in David Lyman, "Dream World Cruise: Houston's Art Car Parade is Fueled by High-Octane Imagination," *Detroit Free Press*, April 30, 2002; available from http://www.freep.com/features/living /acar30_20020430.htm (accessed May 10, 2003).

13. On November 7, 2003, the *Houston Chronicle* reported that Pennzoil decided to redirect their funding toward the Super Bowl in lieu of the Art Car Weekend. Available from http://www.chron.com/cs/CDA /ssistory.mpl/page1/2206858 (accessed November 10, 2003).

14. David Holmstrom, "Honk If You Love 'Art Cars,'" *The Christian Science Monitor*, February 27, 1997, 1, 16.

15. Quoted in Harrod Blank, *Art Cars: The Cars, the Artists, the Obsession, the Craft* (New York: Lark Books, 2002), 22–23.

16. Pierre Restany, "Nomadic Art on Wild Wheels," *Domus* 814 (April 1999).

17. For excellent images of David Best's *DCs*, see Roberts, 96–109.

18. See http://www.petersen.org for information about "Wild Wheels: Art for the Road," an exhibition at the Petersen Automotive Museum, Los Angeles, February 8 through May 26, 2003 (accessed December 7, 2003).

19. Dana Hull, "Driveable Sculptures on display at Triton," *San Jose Mercury News*, October 22, 1999, 1G, 4G.

20. Bernard Welt, "Mythomania: Wild Wheels," *ArtIssues* (November/December 1992): 12.

21. See Blank, *Wild Wheels*, 72–73 for more information on art car artist Linville and an image of *Our Lady of Eternal Combustion*.

22. Harrod Blank, telephone interview conducted by the author, May 20, 2003.

23. William Grimes, "No, It's Not a Mad Vision. It's an Art Car. Want a Ride?" *New York Times*, August 20, 1992, C15, C28. See Blank, *Art Cars*, 48–49 for an image of *Love 23*, and 104–5 for an image of *The Host*.

24. Harrod Blank, phone interview conducted by the author, May 20, 2003.

25. See Blank, *Art Cars*, 98–99 for more on Kennedy. See also John Plunkett and Brad Wieners, eds., *Burning Man* (San Francisco: Hardwired), 1997, 56–59 for photographs of two of Kennedy's creations: *Ripper, the Friendly Shark* and *Max, the Daredevil Finmobile*.

26. "Lit up by the moon, it looked celestial; seemed some plumed and glittering god uprising from the sea" (Herman Melville, *Moby-Dick* [New York: Bantam Books, (1851) 1967], 219).

27. See Pike's essay in this volume for more on Best's Temples.

28. Many thanks to Mark Van Proyen for observing that "art car artists can be seen replicating aspects of the beatnik/funk ethos understood as much as a social experiment as an artistic one." Electronic correspondence with the author, October 11, 2003.

29. *Spirited Away* (or *Sen to Chihiro no Kamikakushi*), animated film, direction and original story by Hayao Miyazaki, Tokuma Shoten, and Studio Ghibli, 2001. See also http://www.nausicaa.net/miyazaki/sen (accessed May 28, 2003).

30. "I think that art cars are part of the identity of Burning Man, and not vice-versa, and I think that Burning Man should continue to embrace that," telephone interview with Harrod Blank, May 20, 2003.

31. See Jennifer Westwood, *Sacred Journeys: An Illustrated Guide to Pilgrimages around the World* (New York: Henry Holt & Co., 1997).

The Medium is the Religion, *by Irie Takeshi (2003).*
Photograph by Mark Van Proyen.

Utopia, Social Sculpture, and Burning Man

Allegra Fortunati

I have very few ideas, but I have some strong desires.
I want what is not yet in the world.

—Carl Andre

This essay is dedicated to those Burning Man participants who make their event a pluralistic, self-expressive heterotopia and an arena for intrapsychic struggle and joy. It is also for those who have lamented the death of Modernism's utopian vision, bemoaning the fact that no new vision has replaced it, and recognizing that this circumstance has set artistic practice adrift in a sea of confused assumptions.

My goal is to put the Burning Man phenomenon into an artistic and cultural context by imagining how Karl Mannheim (representing utopian society), Thomas More (representing utopian space) and Joseph Beuys (representing the utopian individual) would respond if they visited Black Rock City. Following from Mannheim's 1929 book *Ideology and Utopia*, the word utopia is used here with an oscillating emphasis on its multiple aspects. As Mannheim wrote, "A state of mind is utopian when it is incongruous with the state of reality within which it occurs.... Only those orientations transcending reality will be referred to ... as utopian which, when they pass over into conduct, tend to shatter, either partially or wholly, the order of things prevailing at the time ... [and] have a transforming effect upon the existing

historical-social order."[1] Mannheim went on to distinguish wishful thinking from a utopian mentality. Though both begin with a dissatisfaction with current realities, wishful thinkers seek solace in fantasies: "myths, fairy tales, other-worldly promises of religion, humanistic fantasies, travel romances" compensate for what is lacking in actual existence, but offer no opposition or threat to the status quo.[2] Only when the "wish fantasy" of an individual becomes part of the political aims of a larger group can it be called a utopian mentality.

Mannheim's influential book described four "ideal-types" forming his notion of a utopian mentality, and each was understood as having its own basis in social class. At certain junctures, he described them as if they were stages, suggesting that history has progressed from one to the other in a linear fashion. In other passages, he described them as coexisting and even cooperating to overthrow the dominant mentalities of their times. The book's conclusion offers its most resonant message for the twenty-first-century reader, that being a lament about the complacent tendency of a modern world lacking a utopian aspiration stemming from transcendent forces. According to Mannheim, when people stop striving for a better society or world, where all is complete and whole, and everyone goes through life repeating what they did yesterday, all ideological and utopian elements will have disappeared. Without ideals, the human subject would lose its will to shape history as well as the ability to understand it. One would be hard pressed to find a better description of the postmodern condition.

Certainly, Mannheim's lament can be said to have a great deal of resonance with the Burning Man community, and it seems to give voice to their misgivings about the current state of American society. The Burning Man organization's many publications include numerous interviews and lecture texts written by Burning Man founder Larry Harvey, who remains the organization's resident social and moral philosopher (some might call him a "religious theorist" or "social capitalist"). From those documents, we repeatedly hear a basic complaint simultaneously focused on American mass popular culture and its institutional high-culture equivalent. According to Harvey, the postwar United States was

> a new kind of consumer society. The new economy was based on marketing, and television was its medium. More than ever, television made it possible to reach the masses on a massive scale.... It was capable of inducing, among millions of people,

a kind of hypnoidal trance which left the viewer uniquely receptive to the power of suggestion. It gave a new scope and potency to advertising.[3]

To paraphrase some of Harvey's other statements, television is said to create irrational desires for consumer goods. Markets supply these goods, but are contract- (as opposed to community-) based, failing to foster any significant human connection. The mass culture of modern American society is passive, anonymous, isolating, alienating, and materially wasteful. In Harvey's words: "We have become a nation of poseurs. It is not a life that's lived or shared, but an imitation of life, a kind of commercial for self. It's as if we ourselves are now TVs and broadcast images."[4] "I tend to think that the lust for sex, money, and power are just diversions for the basic need to be 'real.'"[5] In short, Harvey's claim is that television focuses our attention on our standard of living rather than the quality of our lives.

Following from this narrative is the notion that all creative and self-expressive ideas, objects, and images are perverted to sell products that are the building blocks of "life-styles." High art has also become a part of this system through its commodification and institutionalization. As public support for the arts via the National Endowment for the Arts and many state arts agencies has decreased, corporate support has increased. At some point during the past two decades, corporations have discovered that investing in art was good for business and had a great "exchange" value in that it allowed them to paper-over their failure to address human needs. As Harvey puts it, "in a market-based art world . . . all artists are competitors, and therefore [are] obsessed with distinguishing themselves from one another."[6] According to Harvey, much gallery- and museum-based art is trivial, not addressing larger issues, and is created to meet the demands of the art market. Encapsulating his response to such work, he wrote, "I yearn for art with a greater, grander and more inclusive scope."[7]

These statements indicate that the provision of an antidote to the malaise of commodification and spectacle are the intentions that motivate Burning Man. But how is this accomplished? The complex answer to this question begins by pointing to Mannheim's four ideal utopian types with an eye to how they might be seen manifesting themselves at Burning Man. Mannheim's first ideal type is described as the "orgiastic chiliasm of the Anabaptists" where chiliasm (i.e., "belief in the redemptive return of Christ"),

in an age of "spiritualized" politics, joins forces with the active demands of the oppressed, including peasants, wage-workers, the *Lumpenproletariat*, and fanatically evangelical preachers. "Ideas did not drive these men to revolutionary deeds. Their actual outburst was conditioned by ecstatic-orgiastic energies, . . . [with roots in] . . . deeper-lying vital and elemental levels of the psyche."[8] The characteristic experience of the chiliast is that of "absolute presentness"—not the ordinary sense of the here and now, but presentness as a "breach through which what was previously inward bursts out suddenly, takes hold of the outer world and transforms it."[9] For the chiliast, sensual experience is inseparable from spirituality. The chiliastic mentality has no sense of history, either past or future, or ideas. Intense emotionality is what drives a traditional chiliast, who is hostile to worldly striving as being incompatible with his or her "higher" striving for merger. In Mannheim's time, the modern version of chiliasm was revolutionary anarchism as exemplified by Mikhail Bakunin.

At Burning Man, rave enthusiasts and the devotees of the anarcho-mystical writer Hakim Bey are the representatives of chiliasm. Bey advocates something that he calls "immediatism," indicating an "antagonism to all forms of mediated, passivity-inducing leisure and culture" and a "festal culture"[10] based on hedonistic spirituality and tribalism working against the familial arrangements of conventional society. As Simon Reynolds has written, "The illegal free rave . . . is a perfect real-world example of Bey's Temporary Autonomous Zone. The TAZ is an advance glimpse of utopia, . . . a microcosm of that 'anarchist dream' of a free culture, but its success depends on its impermanence."[11]

At the 2002 Burning Man event, there were approximately twenty-six "large-scale sound art" theme camps, twenty of which featured techno-rave music. In addition, there were also about forty-five pirate radio stations, many of which were dedicated to broadcasting rave music. But the utopian question remains: does rave culture have a politics? According to Reynolds such politics include the promotion of tolerance ("mingling across lines of class, race, and sexual preference"), peak experiences, and anarchist politics. He alludes to John Moore as offering a model prediction of rave culture:

> Using shreds of historical evidence, Moore imaginatively
> reconstructs prehistoric pagan rites dedicated to Gaia worship;
> he argues for the contemporary revival of these "Eversion
> Mysteries," insisting that a ritualized, mystical encounter with

Chaos (what he calls "bewilderness") is an essential component of any truly vital anarchistic politics. . . . Crucial preparations for the mystery rites include fasting and sleep deprivation, in order to break down "inner resistances" and facilitate possession by the "sacred wilderness." The rites themselves consist of mass chanting, dancing ("enraptured abandonment to a syncopated musical beat . . .") and the administering of hallucinogenic drugs in order that "each of the senses and faculties [be] sensitized to fever pitch prior to derangement into a liberatingly integrative synaesthesia." The worshippers are led into murky, mazelike caverns, whose darkness is illuminated only by "mandalas and visual images." All this sounds very like any number of clubs with their multiple levels and corridors decorated with psychotropic imagery.[12]

Similar "rites" can be seen in numerous drum collectives, hypnotic fire dancing, group rituals, and the re-creation of raver clubs at some Burning Man theme camps. Reynolds also points to the use of Ecstasy (for some, a Burning Man staple) as promoting a sense of heaven on earth that intensifies sensation. It "actually makes the world seem realer; the drug also feels like it's bringing out the 'real you,' freed from all the neurosis instilled by a sick society."[13]

The Ecstasy-induced "spirituality" of chiliastic rave culture is of particular interest to organized religion. For Christians, it is the ravers' experience of communion and transcendence that is important. Ecstasy "induces a state of soul that approximates the Christian ideal—overflowing with trust and good-will to all men." For Zen Buddhists, raving is similar to meditation, as it encourages a "being in the moment." Moore is quoted by Reynolds as claiming that raves are also similar to the mystery rites: "The initiate becomes androgynous, unconcerned with the artificial distinctions of gender. . . . Encountering total saturation, individuals transcend their ego boundaries and their mortality in successive waves of ecstasy."[14]

Mannheim's second utopian mentality is called the liberal humanitarian idea. "The fundamental attitude of the liberal is characterized by a positive acceptance of culture and the giving of an ethical tone to human affairs."[15] The humanitarian liberal is guided by ideas and ideals rather than ecstatic passions, which according to Mannheim were best represented by

the aspirations of the French Revolution (presumably without the Jacobin bloodlust that came part-and-parcel with them). Rather than embracing the immediate moment in the manner of the chiliast, the liberal humanitarian's focus is on the future, the process of becoming and on gradual improvement. This was the utopian form of the ascendant bourgeoisie and intellectual class, which was interested in overthrowing the aristocratic-clerical-theological world view, and was (and is) preoccupied with seeking out rational norms of right and wrong, within which the exercise of "freedom" and "free will" could optimally exist.

At Burning Man, the liberal humanitarian ideal is significantly manifested by the organizers' attempts to foster the values of a common culture. The elements of this culture include the establishment of community norms such as safety, environmental respect, and self-expressive social behavior, but an effort is made to keep rules at a minimum in honor of the event's more anarchistic origins. One of the most highly prized principles issuing from those earlier times is "radical self-reliance," requiring that participants bring all of their own provisions (food, water, shelter) to sustain them for the duration of their stay in Black Rock. As Harvey describes the rationale for this principle:

> We ask that participants come to our event prepared to be self-sufficient in a barren environment that is dominated by volatile natural forces. This forces them to commune with their basic biological needs, as opposed to their consumer-based desires. We live in an over-mediated world, and we want to bring people's inner resources into immediate contact with external realities.[16]

The acceptance of this value is borne out in an unscientific survey conducted by the Burning Man organization in 2001. In it, Burners were asked, "What kind of shelter(s) did you bring with you to the playa?" Almost no one answered that they brought nothing and merely "mooched" off others. One of the most energetically promoted norms is "Leave No Trace," which is repeatedly underscored by the organizers before, during, and after the event. Yet it is not clear whether this ideal represents an ethical choice or is a political accommodation that allows the organization to renew its permit for the use of Bureau of Land Management (BLM) land. Other values promoted by the organization are "radical inclusion" and the requirement that participants not "directly interfere with anyone else's immediate experience." Very

few activities or theme camps have been shut down or censored at Burning Man. Notable exceptions include members of the Capitalist Pig Camp, who were ejected for verbal assault in 1999, and the removal of explicitly homo-erotic signage from public view at Jiffy Lube Camp in 2001. In the latter case, the questionable sign was thought to be too sexually blatant for children.[17]

Mannheim's third utopian mentality is called the conservative idea, even though, by definition, the conservative mentality cannot be called utopian. According to Mannheim, it lacks all "reflections and illuminations of the historical process which come from a progressive impulse."[18] Having mastered the status quo, conservatives are only concerned with ideas when they must engage in an ideological conflict with their liberal opponents, or when the need to master a new situation becomes exigent. Thus, the conservative stress is on the idea of a "counter-utopia" that serves as a means of self-orientation and defense. Conservative knowledge is of the sort that authorizes practical control, domination, and legitimates the use of violence. As Mannheim put it, "whereas all progressive groups regard the idea as coming before the deed, for the conservative... the idea of an historical reality becomes visible only subsequently, when the world has already assumed a fixed inner form."[19] Social reality is experienced as "the embodiment of the highest values and meanings."[20]

Though least represented at Burning Man, and often outside its control, conservative elements include the BLM (as land controller rather than owner) and the many state, federal, and local law enforcement agencies who patrol the event. The Black Rock Desert has been under U.S. federal government control since 1848 (and under BLM jurisdiction since 1946) and outside law enforcement has been a presence at Burning Man since 1990, when the event took place on San Francisco's Baker Beach. The Black Rock City LLC expends a great deal of time, energy, and money on public relations and legal affairs to "manage" these governmental entities.

Harvey's establishment of an annual theme for every iteration of Burning Man also echoes Mannheim's conservative type. These themes often bespeak an evocation of "timelessness" (such as *The Wheel of Time* or *The Seven Ages of Man*) and can also be called conservative elements. There have been some criticisms of themes. Harvey responded to one critic by saying:

> I do believe that an art theme is a positive thing. I think that it
> creates a sense of commonality, forming a sort of meta-story or
> myth that can be shared by large numbers of people. Stories and

their sharing are a kind of social solder that has always connected communities in the past. . . . I would hate to think a theme has constrained anyone. Art genres in any culture often cluster around well-known stories. This leads to much interpretation and reinterpretation by diverse creators, and it inspires artists to imitate and emulate one another. It can make art more accessible to a larger audience. It also promotes collaboration between artists.[21]

This effort to establish a sense of commonality runs much deeper than the liberal-humanitarian's agreements about rational rules and norms, and is related to Mannheim's fourth utopian mentality—the socialist-communist utopia. Similar to liberalism, it believes that freedom and equality can appear only in the remote future. But socialism views this future in a much more specifically determined way that posits that real freedom and equality will come with an "inevitable" breakdown of capitalist culture. Socialism weds the conservative embrace of determinism with the rationally progressive utopia of the liberal. It was said to represent an ascendant working class. For Burning Man, this type of utopian vision is manifested in an emphasis on what is called a gift economy, community, and the tolerance for all forms of self-expression, no matter how rough or amateurish.

Gifts are at the forefront of Burning Man, creating a unique economy that is perhaps the most radical aspect of the event. These take many forms, including the creation of large-scale artworks, theme camps, performances, art installations, art cars, costume spectacles, public service, and the distribution of small-scale artworks given away with no expectation of any return. Within this economy, market transactions (except for the purchase of ice and coffee) are forbidden. It reflects an ultimate "breakdown of capitalist culture" that also fosters a sense of human connection-within-community. Inspired by Lewis Hyde's 1983 book, *The Gift: Imagination and the Erotic Life of Property*, Harvey has gone to considerable lengths to explain his distinction between gifts and barter objects. According to Harvey:

A true gift never really belongs to the person who gives it. Think about a perfect gift you've given. When you thought of giving it to someone, didn't you first feel that's her or that's him? Didn't it feel as if it was already part of the person you were giving it to, that it was just passing through you? Likewise, think about your own

gifts, your talents. Any creative person knows that they don't really own their gifts. We say that these kinds of gifts are God-given, inherent in what we are. We really didn't do anything to deserve them. There isn't any deal involved. The true value of gifts is unconditional. They just flow out of us.[22]

In other words, we can see that community is created through the inter-activity fostered by the giving of gifts. Thus, in an unscientific survey executed by the Burning Man organization in 2001, 79 percent of the respondents indicated that they collaborated "with other people in an organized camp or theme camp to share resources"; 14 percent did volunteer work with Burning Man groups before the event, while 39 percent did volunteer work on the playa while at the event. Unfortunately, no questions were asked about art, performances, costumes, or the exchange of small artworks.

It is interesting to note that at Burning Man, none of these utopian types eclipses any of the others; rather, they operate in a state of peaceful coexistence. Of even greater interest is the fact that Burning Man goes beyond Mannheim's types by embracing a fifth type that supersedes the others—heterotopia. In Michel Foucault's 1986 essay entitled "Of Other Spaces," he posits "heterotopia" as a counter-site, "a kind of effectively enacted utopia in which the real sites, all the other real sites that can be found within the culture, are simultaneously represented, contested, and inverted."[23] It is, in other words, a willful jumbling of our ordered and fragmented world. All cultures create such counter-sites; some are sacred spaces, and others are places of deviation. Burning Man fits this scheme perfectly, but Foucault's heterotopia does not take on a transformative role vis-à-vis the larger society. Mannheim's utopian mentalities always addressed the question of "what next?" He saw a self-satisfied and complacent world that could only be undermined by two forces, the dissatisfied (as exemplified by socialists and communists) and a middle stratum, oriented toward the spiritual realm; an elite society of intellectuals. For Mannheim, "intellectuals" were more than the formally educated and degreed. They were the small group of those "who, consciously or unconsciously, are interested in something else than success in the competitive scheme that displaces the present one."[24] Their position presented no problem as long as their intellectual and spiritual interests were congruous with those of the class that was struggling for social supremacy.

He then proceeded to outline four alternatives open to intellectuals, but refused to make a prediction. Mannheim could not have foreseen the ascending class of twenty-first-century technocrats. Because of technological transformations, the tyranny of geography is no longer the primary factor in the formation of social space: theoretically one can now live and work anywhere. This engenders new possibilities for geographic nomadism, a new "order of things," a new cultural design. Cities do not have to be places of business, but could instead be areas where people meet for self-expression and community, and where creativity is revered. It is not surprising that the 2001 Burning Man survey lists computers/information systems/information technology and art as the two largest "industries" of participants.

Can we point to Black Rock City as a utopian space, and if so, what place does it accord the individual? We should remember that Thomas More coined the term *utopia* from the Greek words, *topos* (place) and a contraction of *ou-* (as in no-place) and *eu-* (as in good or right place). His 1516 book *Utopia* described an ideal crescent-shaped island with fifty-four walled towns, each identical in terms of language, laws, customs, and institutions; all laid out uniformly and "rationally" in a grid pattern to ensure equality, homogeneity, and social coherence. For More, the physical design of his cities would have a corrective power that could determine the behavior of the member of each community, establishing a new order that abolished differences and molded individuals into a collectivity that offered a sharp contrast to a corrupt and chaotic Restoration-era England.

Later utopians envisioned town plans that "were orthogonal, but circular and/or radial schemes . . . gained favor progressively. Variations on the circular form satisfied not only symbolic requirements—the focal seat of power reflecting both the microcosm (the human heart) and the macrocosm (the sun)—but also military ones."[25] Historically, utopian constructs have been organized around symbolic ideas or around practical needs such as hygiene, social harmony, and moral betterment, all understood as leading to universal pleasure and human happiness.

It is interesting to note that the German town of Cleve is partly based on the design of an ideal spiritual town as envisioned by Moritz von Nassau of the House of Orange in the seventeenth century. Cleve was also the birthplace of Joseph Beuys, the influential late-twentieth-century sculptor and art theorist. Beuys's sculptural installation *Tram Stop* (1976) was inspired by monuments placed by von Nassau at axial points around Cleve, establishing key

Burning Man 2003

City plan for Black Rock City (2003). Concept design by Larry Harvey and Rod Garrett. Line art illustration by Rod Garrett.

intersections from which long streets could radiate to express totality. "QUA PATET ORBIS (As far as the Globe extends), as [von Nassau] inscribed on one of his columns."[26] These monuments were cairn-like arrangements made of seventeenth-century mortar shells crowned by armed cupids. They represented the fusion of Mars and Venus, or of war and love. "Nassau believed that the transformation of war and love onto a spiritual level could bring happiness and contentment into the world."[27]

Another example of a traditional utopian town plan is Claude-Nicolas Ledoux's ideal city of Chaux from 1804. Here, for the first time, we see the designation and integration of a productive unit (i.e., a factory; in this instance, a salt works) and workers' housing, each designed according to the functions that they served. At Chaux, the workers' housing encircles the factory, indicating that its central value was labor, as was celebrated by socialism and early capitalism.

Black Rock City resonates with some of these traditional utopian schemes, such as geographic isolation and a circular ground plan. But it is no Utopia. More would have found it perplexing and appalling. In fact, *dystopia* (i.e., "bad place") would be a more apt term for Black Rock City. The desert provides an isolated venue, partially separated from the alienating, stifling, and destructive country that surrounds it, but it is not a livable space that could support a productive community. The presence of law enforcement provides a constant reminder that Black Rock City remains beholden to the values of the larger society. Extreme temperatures and dust storms are common, and winds can rage up to 75 mph. Although a survival guide is provided to Burning Man participants, the level of discomfort one experiences at the event is daunting.

In comparing the ground plan of Black Rock City to other utopian city plans, it is easy to see differences. Although it radiates around a central point marked by the Man, the streets only stretch to a limited point. This is unlike Cleve, where the streets seem to extend into infinity. Like Chaux, housing surrounds the central area of Black Rock City, but instead of factories and offices, we find the Man, art installations, and performance venues, indicating different values from earlier utopian cities, which emphasized economic production as the lifeblood and center of the community.

What most clearly distinguishes Black Rock City from other utopian spaces (real and imagined) is its temporary nature. Although it exists at the same approximate place and time each year, it is ultimately dismantled,

leaving not so much as a trace. At that point, it no longer exists in physical space, but is relocated into cyberspace where it continues on as the locus of a virtual community. The Burning Man organization expends a great deal of effort on community-building, communicating via E-mail newsletters, town hall meetings, their Web site, and at special events. It also offers assistance to regional groups of Burners.

Another feature of Burning Man that differentiates it from other utopian schemes is the central role that art and "artists" play at the event and in its community. Mannheim associates particular styles of art with different epochs and utopian mentalities. For instance, he discusses the relationship of the chiliasts to the paintings of Matthias Grunewald, but none of his utopias have a specified role for art. Harvey also has little to say about the aesthetics of contemporary art objects (other than voicing his desire that art be "interactive"). Instead, he concentrates on redefining and expanding the notion of who "artists" are, and what their social role could be in the psychological and institutional context amidst which they and others work and live.

Participants often speak of Burning Man as engendering a transformative experience. It is an immersive environment allowing them a glimpse of a different way of living that invites comparison with their everyday lives. This immersive experience often leads to new insights, evaluations, and profound life changes. In a 2000 survey, 63 percent of the respondents agreed or strongly agreed with the following statement, "Burning Man has changed my life." This emphasis on a transformation of art and life resonates deeply with Beuys's work and ideas. Certainly, Beuys took a much more direct approach in confronting society's ills, but it can be predicted that Burning Man's growing population and spreading popularity will make it impossible for the event to remain outside of pan-capitalist society.

Beuys was an artist of many dimensions. This discussion concentrates on those that were most akin to Burning Man—the function of his "multiples," his idea about the social role of "artists," and the related concept of "social sculpture." It is interesting to note several superficial similarities between the myths surrounding Beuys and Harvey. Both have origination stories that have become central to any interpretation of their work. For Beuys, it was the World War II plane crash in the Crimean peninsula, his near-death experience, and his subsequent rescue by nomadic Tartars. For Harvey, it was the dissolution of an intimate relationship that led to the first Burning Man on Baker Beach in 1986, at least according to a popular, if not entirely

accurate media myth. Both have signature costumes: for Beuys, it is a fisher-man's vest and felt hat; for Harvey, it is a stylish Stetson, aviator glasses, and omnipresent cigarette. More importantly, both have expanded visions of the relationships among art, artists, and their audiences.

Any discussion about Beuys's work needs to begin with his "aesthetiza-tion of the self" via the use of particular materials gleaned from his dramat-ic life experience, such as fat and felt, which his Tartar rescuers used to keep the wounded artist's body alive in the cold winter of 1943. Around 1970, Beuys moved toward politics by changing his relationship with his audience. He held a utopian vision that saw "that art could be used to help solve real social and cultural problems, and ultimately to transform society."[28]

In his early autobiographical works, Beuys essentially developed a pri-vate mythology around his experiences in World War II as an individual and as a German. His use of felt, fat, and other objects reminiscent of the Holocaust are indicative of his private history and also of the larger public history through which he lived. In producing these works, they often seem to have a reparative function that might represent a way of "making amends." Similarly, Harvey's definition of "radical self-expression" incorpo-rates the idea of a private mythology. He says:

> Self-expression might be anything. We don't dictate that. What we do ask, however, is that participants commune with themselves, that they regard their own reality [including their past history], that essential inner portion of experience that makes them feel real, as if it were a vision.... No one can say what that vision might be. We just ask people to invent some way of sharing it with others.... Ideally, participation is...something that takes you beyond yourself, that engages others, but also expresses what essentially you are. What makes all this so radical is its immediacy. We're asking folks to take what is most private and uniquely personal in their experience and contribute it to a public environment.[29]

It is interesting to note that much of the work created for Burning Man is about grief and restoration, but, like that of Beuys, it is also about connec-tion, as can be seen in the distribution of the small gifts, or "multiples."

Artistic gifts that participants make and/or bring to Burning Man index an intimate expression of their love of the Burning Man community. These

might include stickers, matchbooks, silk-screened panties, rings, lapel pins, medallions, and custom-made candies, among many possible examples. Such gifts communicate in ways that words cannot. Joseph Beuys also knew this and created small low-cost artworks that he called "multiples," which, he claimed, were parts of himself that he could give to others as a way of staying in touch and disseminating his ideas. By distributing gifts, Burning Man participants are also giving parts of themselves to others, creating a connection between individuals and ultimately, a community. Like Beuys's multiples, these gifts might be intended to spur discussion or a way of keeping the image of its creator (or an idea) in the viewer's mind. Unfortunately, participants are not encouraged to include their own names on these gifts, as Beuys did with his multiples. Often, however, the Burning Man logo is stamped on them. By wearing, displaying, or just accepting others' gifts, participants "stay in touch" with other community members, possibly for many years.

By encouraging participants to create collective rituals and actions in a nonjudgmental environment, Burning Man goes beyond Beuys's essentially individual mythology. But in keeping with Beuys's guiding credo, at Burning Man everyone is an artist, everyone "a creative being," everyone a participant.

Beuys viewed human creativity and capacity as being the real capital in society, foreshadowing Burning Man's idea of everyone being a participant. Much of the Burning Man ethos can be seen in the 1972 Manifesto of the Free International University, outlined by Beuys and Heinrich Boll. In it we find some of the underlying assumptions of Beuys's expanded definition of art in relation to his concept of "social sculpture." Here, I quote several extracts at length:

> Creativity is not limited to people practicing one of the
> traditional forms of art, and even in the case of artists creativity
> is not confined to the exercise of their art. Each one of us has
> a creative potential which is hidden by competitiveness and
> success-aggression. To recognize, explore and develop this
> potential is the task of the school....
>
> Creation—whether it be a painting, sculpture, symphony,
> or novel—involves not merely talent, intuition, powers of
> imagination and application, but also the ability to shape material
> that could be expanded to other socially relevant spheres....
>
> Conversely, when we consider the ability to organize material

that is expected of a worker, a housewife, a farmer, doctor, philosopher, judge, or works manager, we find that their work by no means exhausts the full range of their creative abilities. . . .

Whereas the specialist's insulated point of view places the arts and other kinds of work in sharp opposition, it is in fact crucial that the structural, formal, and thematic problems of the various work processes should be constantly compared with one another. . . .

The school does not discount the specialist, nor does it adopt an anti-technological stance. It does however reject the idea of experts and technicians being the sole arbiters in their respective fields. . . .

In a new definition of creativity the terms professional and amateur are transcended, and the fallacy of the unworldly artist and the art-alienated non-artist is abandoned. . . .

The creativity of the democratic is increasingly discouraged by the progress of bureaucracy, coupled with the aggressive proliferation of an international mass culture. Political creativity is being reduced to the mere delegation of decision and power. The imposition of an international cultural and economic dictatorship by the constantly expanding combines leads to a loss of articulation, learning and the quality of verbal expression. . . .

In a consumer society, where creativity, imagination and intelligence are not articulated, and their expression is prevented, they become defective, harmful and damaging—in contrast to a democratic society—and find outlets in corrupted criminal creativity. Criminality can arise from boredom, from unarticulated creativity. To be reduced to consumer values, to see democratic potential reduced to the occasional election, this can also be regarded as a rejection or a dismissal of democratic creativity. . . .

Hope is denounced as Utopian or as illusory, and discarded hope breeds violence. . . .

Since the School's concern is with the values of life we shall stress the consciousness of solidarity. The School is based on the principle of interaction, whereby no institutional distinction is drawn between the teachers and the taught.

'Non-artists' could initially be encouraged to discover or

explore their creativity by artists attempting to communicate and to explain—in an undidactic manner—the elements and the coordination of their creativity. At the same time we would seek to find out why laws and disciplines in the arts invariably stand in creative opposition to established law and order. . . .

[The School's] chief goal is the encouragement, discovery and furtherance of democratic potential, and the expression of this. In a world increasingly manipulated by publicity, political propaganda, the culture business and the press, it is not to the named, but to the nameless that it will offer a forum.[30]

Here we see that Beuys's notion of social sculpture was "the active mobilization of every individual's latent creativity, and then, following on from that, the molding of the society of the future based on the total energy of this individual creativity." Beuys saw society and art as being synonymous, and he worked for their greater democratization. Besides the Free International University, Beuys also helped found the German Student Party (in 1967), the Organization for Direct Democracy by Referendum (in 1970), and the German Green Party (in 1979), all of which he would count as works of sculpture. Burning Man also fits this definition, both as an event and community, a heterotopia where creativity is the central virtue.

But Burning Man's heterotopia moves away from the traditional utopian universalism of uniform cities and overarching schemes for creating model citizens. The spatial design of Black Rock City also reflects a new interrelationship of the binary categories of man/woman and self/community. Like the Round Table of the Arthurian Knights (where everyone was equal), Black Rock City is also circular.

It is interesting to consider the question of what this society would be like if the ideals and "norms" of Burning Man were adopted into the mainstream. In fact, we might consider how society is already moving in this direction. In their book *The New Individualists: The Generation after The Organization Man*, Paul Leinberger and Bruce Tucker reinterviewed some of the families featured in William H. Whyte Jr.'s *The Organization Man*, concentrating on the children of Whyte's original subjects. This book examined how social character has moved from the ideal of being "self-made" to the creation of a "man-made self" emphasizing authenticity, expressiveness, and creativity. It also highlights the problems of what this emphasis on the

cultivation of the private self means in terms of lack of engagement with civic issues, the content of expression, and a search for meaning, (as opposed to money), in work. This generation uses the myth of the artist as their occupational ideal, and often harbors dreams of artistic accomplishment. The authors explain how the idea of the artist

> remains central to their conceptions of themselves, providing an imaginary solution to the lived contradictions of personal identity versus public roles, desire versus duty, happiness versus success, individual authenticity versus social artificiality. . . . [T]he artist ideal represents an attempt to fuse the expressive values acquired at home in childhood with the instrumental values found at work in adulthood.[31]

However, the goal of self-fulfillment also undermines the ideal of the authentic self. As Leinberger and Tucker wrote, "in pursuing the ideal of the authentic self, the offspring produced the most radical version of the American individual in history—totally psychologized and isolated, who has difficulty 'communicating' and 'making commitments,' never mind achieving community."[32]

The authors also made predictions about what changes in social character will be needed to overcome the anxiety, aloneness, and lack of connection, to respond to the ups and downs of the changing economic and social structure. It is interesting to note that most Burning Man participants are of the generation twice removed from that of *The Organization Man*. Most are ages twenty-one to thirty-five, and much of the rhetoric around the event is increasingly about building community, engaging in cooperative projects, and making connections.

In an event that so emphasizes the expression of the "authentic" self, it is odd that it should climax with the ritual destruction of the Man. This ritual may be a prophetic harbinger of an end to the emphasis on the self and a stronger shift to community. It is also consistent with poststructuralist ideas about the end of "human nature," indeed of "man" as "he" was conceptualized in earlier centuries. I would contend that this acknowledgment of the "death of man" could be more effectively marked by burning the Man at the beginning of the event, freeing each participant to explore his or her own singularity and desire-within-community without the burden of Humanity.

NOTES

The epigraph is from a quote in Lucy R. Lippard, *Six Years: The Dematerialization of the Art Object from 1966–1972* (Berkeley: University of California Press, 1973), 157.

1. Karl Mannheim, *Ideology and Utopia* (New York: Harcourt, Brace & World, Inc., 1936), 192, 205.

2. Ibid., 205.

3. Larry Harvey, "La Vie Boheme: Bohemian Values, Populist Politics, and the New Avant-Garde," lecture at the Walker Art Center, February 24, 2000. Available from http://www.burningman.com/art_of_burningman/la_vie_boheme.html (accessed June 13, 2004).

4. Ibid.

5. "Interview: Larry Harvey," *they* (1999): 3.

6. Larry Harvey, E-mail to Meredith Wade, November 16, 2001, 2.

7. Ibid., 2.

8. Mannheim, *Ideology and Utopia*, 211.

9. Ibid., 213–14.

10. Cited in Simon Reynolds, *Generation Ecstasy: Into the World of Techno and Rave Culture* (New York: Routledge, 1999), 246, 169.

11. Ibid., 238. See also John Moore, *Anarchy & Ecstasy: Visions of Halcyon Days* (London: Aporia Press, 1988).

12. Reynolds, *Generation Ecstasy*, 241–42.

13. Ibid., 248.

14. Ibid., 242.

15. Mannheim, *Ideology and Utopia*, 220.

16. Tara Fatemi, "Interview: Larry Harvey of Burning Man," SXSW 2001, austin.citysearch.com, 2.

17. See Kozinets and Sherry, this volume (p. 106, n. 40) for a summary of the Jiffy Lube controversy.

18. Mannheim, *Ideology and Utopia*, 229.

19. Ibid., 230.

20. Ibid., 231.

21. Larry Harvey, "Afterburn report 2001." Available from http://afterburn.burningman.com/01/art/theme_art_letter.html (accessed June 13, 2004).

22. Darryl Van Rhey, "An Economy of Gifts—an interview with Larry Harvey," *Burning Man Journal* (summer 2002): 1. See also Lewis Hyde, *The Gift: Imagination and the Erotic Life of Property* (New York: Vintage Books, 1983).

23. Michel Foucault, "Of Other Spaces," trans. Jay Miskowiec, *Diacritics* 16, Issue 1 (spring 1986): 24.

24. Mannheim, *Ideology and Utopia*, 258.

25. Ruth Eaton, "The City as an Intellectual Exercise," in *Utopia: The Search for the Ideal Society in the Western World*, eds. Roland Schaer, Gregory Claeys, and Lyman Tower Sargent (New York: The New York Public Library and Oxford University Press, 2000), 125.

26. Caroline Tisdall, *Joseph Beuys* (London: Thames and Hudson Ltd, 1979), 247.

27. Ibid., 247.

28. Joan Rothfuss, "Joseph Beuys: Echoes in America," in *Joseph Beuys: Mapping the Legacy*, ed. Gene Ray (New York: Distributed Art Publishers, Inc., 2001), 43.

29. Quoted in an interview with Darryl Van Rhey, "The Meaning of Participation," *Burning Man Journal* (summer 2000): 1.

30. Quoted in Tisdall, *Joseph Beuys*, note 33, 278–81. According to Heiner Stachelhaus, in his book *Joseph Beuys*, trans. David Britt (New York: Abbeville Press Publishers, 1991) on page 106, "The Greens . . . owe a lot to Beuys. He was already ecology conscious at a time when the Greens had not even formed into a party, and he has every right to consider himself one of the founding fathers of the Green movement in Germany." On page 112, Britt continues, "In 1979, in the elections for the European Parliament, Beuys was the candidate of the Green party, but without success."

31. Paul Leinberger and Bruce Tucker, *The New Individualists: The Generation after The Organization Man* (New York: HarperCollins Publishers, 1991), 15. See also William H. Whyte Jr., *The Organization Man* (Garden City, N.Y.: Doubleday, 1956).

32. Ibid., 15.

Flock, *by Michael Christian (2001), welded steel, lights, 45' x 6' x 9' (approx.).*
Photograph by Holly Kreuter.

A Tale of Two Surrealities

Mark Van Proyen

The essence of the Surrealist message consists in this call for the absolute freedom of the mind, in the affirmation that life and poetry are "elsewhere," and that they must be conquered dangerously, each separately, and each by means of the other, because ultimately they coincide and merge and negate this false world, bearing witness to the fact that the chips are not yet down, that everything can be saved.

—Marcel Raymond,
From Baudelaire to Surrealism, 1947

The call: "Hidey Ho, all you Surrealists!"

And the response, as chorus: "Hidey Ho!"

Today's adventure is going to be a road movie of the imagination, and our quest will be for the best examples of the authentic spirit of Surrealism that can be found at the beginning of the twenty-first century. And because it is a special road trip, joining us will be some very special guests who have put away their historical antagonism to be specially reincarnated just for the occasion. Say hello to André Breton and George Bataille, the two most legendary of Surrealist writers!

Chorus: "Hi André! Hi George!"

That's right, Surrealism was a lot more complicated than a bunch of folks makin' paintings of dripping stopwatches and lacerated eyeballs; it was also a way of makin' photographs like those by Man Ray, an' films like the ones made by Luis Buñuel and Maya Deren, and even sculpture, like Hans Belmer's dolls! And you know what they all had in common? They all looked for a way to achieve a derangement of the senses just like Arthur Rimbaud[1] said they should. André, you once wrote a famous definition of Surrealism; maybe you could give it to us now?

André: "Surrealism is based [on] the belief in a superior reality of certain forms of previously neglected associations; in the omnipotence of the dream, in the disinterested play of thought. It tends to ruin once and for all other psychic mechanisms, and to substitute itself for them in solving all the principal problems of life."[2]

Thank you André. That was great! Now, as we all know, every road movie starts with an establishing shot, so let's begin at an event called *The San Francisco International Art Exposition* filling the cavernous interiors of the Herbst and Festival Pavilions during the third weekend of 2002. This event is usually just called "the Art Expo" and was organized by Thomas Blackman and Associates, who for many years have also organized the Chicago International Art Exposition on Navy Pier. With over ten thousand works of art on view, I'll bet that we can find lots of examples of Surrealism at the Art Expo. No? You don't think that photographs of Cindy Sherman playing dress-up are surreal? How about those pictures of Matthew Barney dressed up as a goat? How about Tony Oursler's shape-shifting video projections of contorted faces? OK, OK, these are works of Mannerist Surrealism, and much of their aesthetic is a function of expensive production values, but doesn't that count as being surrealist? George? André?

Well then, what about this place? I mean, look at how all those galleries have set up little white cubes, each with its own little swath of grey carpet, desk, and rolodex. Some even brought little ficus trees to make everybody feel more at home. And look at how all of the people here seem like the stock characters of a minstrel-show version of a surrealist play: some are students who hope someday to be included in it all, some are critics who want to seem important by explaining how and why the art on view is important, and others are diligent staff people working overtime to keep the corporate sponsorship signage and donor plaques in plain view. But most of the people at

the Art Expo are just curious tourists passing through, confused about the reasons why some paintings and sculptures cost as much as real estate, and getting no satisfactory answers from the gallery representatives hoping for the sale that would defray the cost of their participation in the Art Expo. Look closely at how each little white cube is set up to sequester the art that it contains, creating a situation where would-be viewers have to walk through a carefully guarded chokepoint just to steal a quick glimpse. Multiply that by the over two hundred galleries participating in this event, and we notice a lot of little white cubes with a lot of chokepoints makin' sure that only the high rollers can get in to see their artistic holy-of-holies. You even have to walk through two chokepoints just to get into the Art Expo after paying your admission fee, all of this just so that you can look at art in buildings built on rickety piers overhanging the San Francisco Bay. What if they had an earthquake? I'll bet the insurance company wouldn't like that!

André, why are you lookin' at that picture of Marcel Duchamp dressed up as Rrose Sélavy? Is that the only surreal thing that you can find? Oh, I see: you remember what Duchamp said about you at your funeral in 1962; what was it? "Breton loved as the heart beats. He was the lover of love in a world that believes in prostitution... for me, he embodied the most beautiful dream of youth of a moment of the world."[3] We were reminded of that eulogy when we read what the art critic Donald Kuspit recently wrote about the institutional cooptation of the avant-garde: "avant-garde art becomes part of a life-style, which turns it into neo-avant-garde art, that is, part of the social spectacle of capitalist consumption... for it is, after all, another way of manipulating the spectator, that is, giving him the illusion of having a lived experience, rather than a way of disillusioning him with the whole rotten system."[4] And you know what? If we really wanted to be real Surrealists, we would need to see how the neo-avant-garde art at the Art Expo is really pseudo-avant-garde art working on behalf of the new opiate-of-the-people called fashion, and we would need to do something about the fact that the worlds of advertising and marketing have taken the stylistic innovations of Surrealism and turned them against the libertine spirit of movement. And once we recognize these facts, we have to conclude that all of the works of art presented at the Art Expo are only small parts of a great big thing that Gilles Deleuze and Félix Guattari once called a "desiring machine," as a way to describe how theaters of legitimization confuse appearance and reality. Here is their definition:

a system of interruptions or breaks. These breaks should in no way be considered as a separation from reality; rather, they operate along lines that vary according to whatever aspect of them we are considering. Every machine ... is related to a continual material flow that it cuts into. . . . Far from being the opposite of continuity, the break or interruption conditions the continuity: it presupposes or defines what it cuts into as an ideal continuity. . . . The machine produces an interruption of flow insofar as it is connected to a machine that supposedly produces the flow. . . . This is the law of the production of production ... continually grafting the process of production onto the product.[5]

I know that sounds real complicated, but what it really means is that the art in the Art Expo can only be understood as having meaning because it's in the Art Expo, just like gargoyles only become meaningful when you understand how they are parts of a big cathedral, which is a representation of an even larger religious idea. Certainly, the idea of the desiring machine goes way beyond the Art Expo; in fact, it infects almost everything that we see. This is because, as is the case with all theaters of legitimization, it draws from other theaters of legitimization to create a great big regulatory fiction designed to simultaneously educate and confuse desire in a specific way. That's why so many of the works on exhibit at the Art Expo were by artists who had already presented their work at places like *Documenta* or the *Venice Biennial!* So when you take all of these things together, you can see how they function as parts of a desiring machine, or, as Guattari later defined it, a machine of subjectification, thusly described as:

The ensemble conditions which render possible the emergence of individual and/or collective instances as self-referential existential Territories, adjacent, or in delimiting relation, to an alterity that is in itself subjective. . . . Here, the scene implies a layering of enunciation: a vision of oneself as a concrete embodiment; a subject of enunciation which doubles the subject of a statement and the distribution of roles; a collective management of the game; an interlocution with observers commenting on the scene ... it's a question of becoming aware of the existence of machines of subjectivation which don't simply work within the 'faculties of the soul,' interpersonal relations or

intra-family complexes.... Subjectivity... produce(s) itself...
in the large-scale social machines of language and the
mass-media—which cannot be described as human.[6]

And that's the problem, because Surrealism was first and foremost a
mythopoetic art movement that was militantly opposed to the complacent lie
of so-called normalcy. Its aim was to connect with the deepest and most
human parts of the artistic personality completely unfettered by any regula-
tory commandments! Only later did it become a system of clichéd stylistics in
art and popular mass media. I think that Stephan L. Post said it best when he
wrote "as they saw it... Surrealists were speaking in metaphor and demon-
strating its validity... much of the appeal of Surrealism lies in the metaphors
it evokes in its audiences, themselves free from the shackles of theory."[7]

In fact, real Surrealists want to be free of all shackles, including those cre-
ated by folks who would use surrealist forms to achieve nonsurrealist ends. So,
to celebrate that freedom in the last place where it can be celebrated, we are
going to travel from the Art Expo to Black Rock City, Nevada. Hooray!

Most of you already know about the Black Rock from seeing it on tele-
vision as the horizonless backdrop for dozens of automobile commercials.
Some might even recognize it as the site of some monumentally antimonu-
mental earthworks done by Michael Heizer in the late 1960s.[8] The Black Rock
may well be the largest solid flat surface on the North American continent,
measuring well in excess of a half million acres, roughly nine times the size
of the entire city of San Francisco. It is very much a "blasted heath" to bor-
row a Shakespearean term, and not so much as a single blade of grass grows
upon it. Perhaps more than any other place in the world, it invokes an idea
of an eternal and immutable timelessness, seeming to simultaneously exist
at the moment before time began as well as after the point that it ended. This
makes it is the perfect place to build a surrealist city.

The semicircular ground plan of Black Rock City might remind us of a
crop circle, or perhaps it is more like a coral reef growing out from a sub-
merged atoll, its exoskeleton of cultural production continuing to be inti-
mately and vividly related to the human life forms that create and temporarily
inhabit them. This is a stark contrast to the Art Expo's array of dead relics of a
cultural activity once lived and since commodified. At Black Rock City, sculp-
ture, architecture, and performance all live and then die in vivid concert with
the brief efflorescence of a way of life that is commonly understood by those

who choose to inhabit the temporary metropolis, connecting all to a kind of ritual behavior that can only have a local significance in relation to a shared experience of an immediate time and place.

It is tempting to make much of the terms "esoteric" and "exoteric" (literally, "inside the earth" and "outside of the earth") to describe the difference between the enclosed and cavernous Art Expo and the open-air construction of Black Rock City. In the case of the former, works of art are sequestered and mystified in a way so as to render them accessible only to an initiated cognoscenti, while in the latter instance, they are almost always physically and symbolically available to a populist public who are encouraged to freely interact with the works as they see fit. Even in this aspect, the art of Black Rock City comes closer to the spirit of its surrealist forebears, for as art historian Lewis Kachur has noted:

> Surrealist exhibition installations created between 1938 and
> 1942 . . . took place at, and were conditioned by, diverse sites: a
> traditional Old Master Gallery, the amusement zone of the 1939
> New York World's Fair, and a private mansion that had been
> converted to a war relief agency. In each setting, the participants
> abandoned any attempt at neutrality of presentation in favor
> of a subjective environment that itself embodied a statement.
> Indeed, these exhibitions offered startled viewers an early version
> of installation art, before there was such a phrase for this form.[9]

Rather than recount here the long history of installation art and the tradition of Happenings that stemmed from that tradition, let us simply register the fact that Black Rock City is a temporary construction that rises, falls, and then disappears each year on a geographical site that is not only radically exoteric, but seemingly extraterrestrial as well. The distant vistas of its exaggerated horizontality conjure such things as the uninhabited piazzas of Giorgio De Chirico's metaphysical paintings, the infinite xyz space of virtual reality construction, or the vast featureless plains that were the sine qua non of 1950s-era science fiction illustration.

Black Rock City is the desiring machine created by and for Burning Man, making it an Art Expo for the proverbial rest of us. It temporarily manifests itself every Labor Day weekend as a massive camp-out that doubles as a sybarite's utopia ministering to a polyglot congregation of urban nomads, vacationing sex workers, amateur cross-dressers, and sun-starved toilers in

the information economy's still-proliferating webyards. The multiple implications of the term "camp" are not lost on any of the inhabitants of this posturban hallucination. First, there is the obvious survivalist sense of the word, which is amplified by the harsh desert environment. Then there is the implication of adherence to a group belief system, which reminds us of how silly such adherences can be. This is why the citizens of Black Rock City organize themselves into theme camps, so that they can be the camp followers of their own silliness rather than regular, everyday normal silliness. And let's not forget Susan Sontag! In 1964 she postulated the existence of a "camp" aesthetic, which was supposed to be a good kind of bad taste in the way that it parodied the irrelevance of good taste. Of course, we all know now that camp has become a kind of official form of good taste ever since Andy Warhol took the folks from the Art Expo on his own brand of (over-branded) camping trip, but Sontag alluded to something much less cynical when she ended her fifty-eight mini-essays on the subject with this important reminder that is near and dear to the hearts of the citizenry of Black Rock City, even as it seems to have been forgotten by almost everyone at the Art Expo.

André, would you like to read it now?

"*Number 55.* Camp taste is, above all, a mode of enjoyment, of appreciation—not judgment. Camp is generous. It wants to enjoy. It only seems like malice, cynicism. (Or, if it is cynicism, it's not a ruthless but a sweet cynicism.) Camp taste doesn't propose that it is in bad taste to be serious; it doesn't sneer at someone who succeeds in being seriously dramatic. What it does is to find the success in certain passionate failures.

Number 56. Camp taste is a kind of love, love for human nature. It relishes, rather than judges, the little triumphs and awkward intensities of "character.". . . Camp taste identifies with what it is enjoying. People who share this sensibility are not laughing at the thing they label as "a camp," they're enjoying it. Camp is a tender feeling."[10]

That's great André! That certainly applies to Black Rock City, which is full of the nicest folks you would ever want to meet. They all bring lots of extra stuff just to share, and they always try to make new friends. Nobody sequesters anything here! And over the course of a few days, the city appears out of nowhere like a big mushroom that playfully lives and then dies a

cathartic death in vigorous celebration of what George once called "the notion of expenditure" as a way of describing an economy of libidinal affirmation arrayed against "the hoarding hypocrisies of honor and duty." As an antidote to those hypocrisies, George advanced a principle of "non-productive expenditure," which was "not guided by servile father-son relations," but instead opted for "the construction of sumptuary monuments, games, cults, spectacles, arts, perverse sexual activity," as forms of "creation by loss, which is a form of sacrifice."[11] For the sake of embracing its own omni-kaleidoscopic experience of "creation-by-loss," Black Rock City temporarily appears and then disappears without a trace, residing in the mind's eye as memory, hallucination, and Web site. After an arduous three-week cleanup effort, there is literally no residue of the event left behind. Harry Houdini was never so good at disappearing!

Look at how all the theme camps form a three-quarter circle around a great big empty space that can be entered and exited from almost any direction. The inner part of that circle is where some people make great big sculpture, and some of it is real good. Not all of it, because at Black Rock City anybody can make a sculpture if they want to and that means that there is a lot of amateur work that gets made. But you know what? The word amateur really means something done by someone out of the love of doing it! That's right, you can look it up! And if that is true, doesn't that mean that there might be a lack of love in the professional work at the Art Expo? I think that George and André might agree with us on that point.

But there is another way to look at the monumentally scaled sculpture at Black Rock City. Remember back in 1947 when André Malraux wrote that there would someday be "a museum without walls"? He meant that we would soon come to the point where a photograph of a work of art would be just as good as a work of art, and that anybody could have one. He wrote, "it is the same with figures that in reproduction lose all both their original significance as objects and their function (religious or other); we might almost call them not 'works' but 'moments' of art . . . thanks to a specious unity imposed by photographic reproduction on a multiplicity of objects . . . a 'Babylonian style' seems to emerge as a real entity."[12] Of course, that was before photographs became accepted at the Art Expo, but now we have the Internet, which creates a newer and much larger museum without walls! Maybe this newer and much larger museum without walls is part of the reason why the center part of Black Rock City makes such a point of showin' a

bunch of art in its own museum without walls, which is like a big playground sandbox in the middle of an endless horizon, just like the Internet!

Anyway, the term "Babylonian style" is a good way to describe many of the works of art exhibited at Black Rock City. Many of them sport obsessively applied additive assemblage techniques that teem with detailed ornament and arcane complexity. Quite a few are robust and even cheeky in their aggressive extroversion of an *aesthetics of the marvelous* in a way that vividly contrasts with the earlier Surrealists' inclination toward poetic introversion; and almost all of them guilelessly bespeak and codify the localized values of many different microcommunities of desire. Or, failing that, they function as gregarious send-ups of conventional modernist-derived ideas of public sculpture, seeming in some ways to be theater props that function as pidgin misrepresentations of obscure or outlandish art. Or perhaps they are outlandish artworks that are witty dissemblances of such imaginary theater props, each an aggressive misconstrual of commonplace absurdities-heaped-upon-absurdity. Either way, a do-it-yourself aesthetic is featured, and materials tend to be selected in large part upon the basis of availability and affordability.

The pragmatist dictum stating that art is a form of vernacular expression redeemed by the codes of high style is fully in play at Black Rock City, and if some of those codes can be measured by Art Expo lights as being insufficiently mastered, than we can also turn tables on that judgment by highlighting the vernacular vitality embraced by the city's public artworks, their unpretentious conviviality offering a much-needed breath of fresh air to the Art Expo's over-coded stylistics that fail to speak to the lived experience of its bemused audience. To support this claim, we can here proffer a rather selective account of Burning Man (mis)understood(?) as an outdoor sculpture festival. Always stationed at the center point of Black Rock City's circular ground plan is the eponymous figure from which Burning Man takes its name. In addition to being at the event's symbolic and geographical center, it is also the tallest object to be seen there—the representation and embodiment of a phallic verticality that waits to be sacrificed by and to the "vaginal" city that horizontally encircles it. An initial examination of the figure will conclude that it is a magnificent sculpture, and it is all the more so when the night sky gathers around its bright internal illumination. In fact, night is calculated to be the optimal viewing time for a great many of the city's works of public art, the blinding daytime light is too inhospitable for

such a physically demanding task. And since ceremonial burning is the intended destiny for many of these installations, darkness best accentuates the dramatic effect of large fires, making nighttime the right time for art at Black Rock City. This was certainly the case when, in 1996, an installation entitled *HelCo Towers* was incinerated before a wildly cheering crowd. The towers were built by a San Francisco–based performance group called the Seemen, led by sculptor Kal Spelletich. Standing about thirty feet tall and covering well over an acre of space, these bright red towers were surrounded by other structures that appeared to be the carnivalized mock-ups of well-known fast-food franchises, complete with signage reading STARFUCKS and CACABELL. The inspiration for this tableau was the idea that a satanic corporate strip mall had been built in Black Rock City, replete with crude simulations of franchise "brandings" that flagrantly disobeyed the city's "no corporate advertising" ordinance. The Seemen saw to it that the towers paid the price for this sin, and the systematic destruction of the installation was enacted as a memorable Roman circus that was characterized by Religious Fundamentalist commentator George Otis Jr. as "the darkest thing that I have ever experienced."[13] Soon thereafter, crowds gathered around another work entitled *The City of Dis* by San Francisco sculptor Pepe Ozan, a three-story structure featuring a clutch of gothic vaults and spires made of dried mud affixed to a skin of reinforced wire. The spires doubled as fluted chimneys, and they were decorated with an assortment of tortured faces, all of which seemed utterly demonic when backlit by firelight as the structure was burned in the finale of a four-act opera composed and directed by Ozan entitled *The Arrival of Empress Zoe*, featuring a cast of several dozen performers. Ozan also created similar works for the 1997–2000, and 2002 events, the majority of these pulling double-duty as stage-set for his Dionysian operas.

The year 1997 was particularly good for large-scale sculpture at Burning Man. Perhaps the single most memorable work from that year was Tim Kaulen's *Sta-Puft Lady*, a giant helium-filled balloon tethered to the ground made from the stitched-together fragments of many different billboard advertisements. Almost all of these fragments featured images of over-idealized "Barbie doll"–type women—thin, alluring, and glamorous—and in this context, all seeming to be eerily dead, all the better for being recycled into a Frankenstein's monster of resurrected femininity configured around the full-figured silhouette of a rather terrifying earth goddess that dwarfed

and infantilized the viewer. In Jim Mason's *Temporal Decomposition*, time literally stood still. Here, we witnessed a monumental ice ball suffused with broken clocks, illuminated at night by the flame of a propane torch implanted at its crown. Add to this description the fact that the piece was completely constructed in the desert's arid environment, and that it took almost a full week to melt, aided by Burning Man participants who were encouraged to use the work's surface as a convenient aid for the cooling of overheated skin.

That same year, located in the deep desert was Shelly Hodes-Vaca's photomural entitled *Mirrorage*, beautifully counterpoising the stark horizontality of the vast desert with a fifty-six-foot-long sequence of images of the endless horizon of the ocean. Not far away was a twenty-foot-tall Trojan horse constructed by Bill Walker. Aside from exhibiting an impressive feat of carpentry undertaken in harsh surroundings, the work also revealed a keen respect for how a historical Trojan horse might have looked. Positioned nearer to the central camping area was Michael Christian's twenty-five-foot-tall *Bone Tower*, a stupendous memorial to the harshness of the desert and the stoic sense of mortality bred by it. Made of hundreds of bleached cattle bones affixed to a steel frame, the tower itself took on the form of a giant bone, resembling a monumental vertebra, perhaps alluding to the drought-stricken area's failed cattle ranches, complete with their multitude of failed cattle. Another of Christian's works (titled *Flock*), made an impressive showing at the 2001 incarnation of Burning Man. *Flock* was a surreal figure stretching thirty-five feet up from the desert floor. Made of intermingled vines of twisted metal rods, this stunningly ambitious work featured a subtle morphological transformation from plant to animal shapes about two-thirds of the way up from the ground, gradually articulating a sinister-looking gargoyle perched at the work's crown. Underlit by lurid green lights, *Flock* swayed in the wind, seeming to be a giant stalk of surreal kelp affixed to the bottom of some postapocalyptic lake.[14]

In 1998, there were several works that stood out. Finley Fryer's *Chapel* was an elaborate three-story theatrical stage made of over 27,000 recycled plastic toys, many of which were brightly colored and translucent. At night, internal illumination made the *Chapel* glow as if it were made of stained glass, creating a magical apparition set against the darkness. During the week, the *Chapel* played host to many performances ranging from the somber to the silly. One memorable example was Michael Peppe's enactment of a segment of his Behaviourmusik entitled *Information White-Out*, featuring the artist precisely mimicking a barrage of media messages at the

exaggerated pace of an epileptic seizure. That same year, Fryer also constructed a giant Rubic's cube, and the year after, a tall sentinel figure capped with a deep-sea diver's helmet, also created from discarded plastic.

Stationed far away from the 1998 event's most populated area was Michael Light's *Full Moon*, which consisted of a sequence of 115 fifteen-by-fifteen-inch photographs mounted under plexiglas, installed directly on the desert floor. Illuminated at night by two strands of white lights, the installation suggested a forlorn landing strip, even as it also revealed the story of another journey. The photos were culled from a collection of thousands of NASA documentary pictures, and, running from one end to the other they indicated the story of a mission to and from the surface of the moon, with the middle portion of the sequence revealing how a close-up picturing of the lunar surface bore an uncanny resemblance to the actual desert floor just inches away, itself seeming to be an extraterrestrial environment as it was displayed under the eerie light of the last lunar eclipse of the twentieth century. In 2002, Light used the same exhibition strategy to present a similar collection of one hundred photographs of nuclear explosions entitled *100 Suns*.

An abundance of wit and sophistication was revealed in Steven Raspa's *Sacred Grove & Wheel of Faith*. Almost a quarter acre of empty desert was bisected into four quadrants by this work, marked by corridors of artificial ficus trees inserted into the ground—the same kind of generic trees that are more commonly encountered in hospital waiting rooms, the offices of bail bondsmen, and the galleries in the Art Expo. Large banner-style signs were placed at each end of the ficus corridors, sporting the words "Hope," "Pray," "Wish," and "Dream." The color and typeface of these words bore an unmistakable resemblance to the officiously upbeat design of California State Lottery graphics (a good joke in casino-friendly Nevada), and the association of these banners with the typical prayers uttered by gamblers was emphasized by the devotional altar-in-the-form-of-a-roulette-wheel at the center point of the installation. In fact, the whole installation seemed like an elaborate prayer altar that was reconfigured as a cosmic observatory *a la* Stonehenge, galvanizing the statistical associations of "hitting the Lotto" and being struck by lightening.

In 1999, Steve Hecht created a *Piano Boat* out of discarded pianos and television sets, looking very much like a surreal tramp steamer sailing away from the city out to the desert horizon. Closer to the city was another boat of sorts, Andy Hill's *H.M.S. Love*, constructed out of painted plywood and

appearing to be the bow and conning tower of a surfacing submarine. Like Fryer's *Chapel* the *Love* doubled as a performance platform for skateboarders, musicians, and DJs alike, providing a good example of how an artwork can function as a multitasking object.

In 2000, the construction of the semicircular layout of Black Rock City was spectacularly enhanced by an installation entitled *Beaming Man* created by a team led by Russell Wilcox, which used lasers positioned on twenty-foot-tall towers to articulate the vitruvian Burning Man logo stretching two miles across the diameter of the whole city, viewable in its entirety only from a high altitude. Located near the center of the city were two monumental works that addressed themselves to that year's theme of "the body," one being a work entitled *Body of Knowledge* by Dana Albany and the other *The Faces of Man* by Dan Das Mann. The former was a monumentally scaled figure comprised of hundreds of books glued together, poetically suggesting how we are all the sum of the wisdom that we acquire. *Faces* was a trio of twenty-foot-tall masks that surrounded a central core, each made from a different material, with one actually crying nighttime tears of fire to produce an eerie effect. Farther out into the deep desert was an installation Aaron Muzalski and Todd D'Amerio entitled *AD2K*, which was an impressive stack of five-by-ten-foot-tall dominoes made from painted plywood. Looking like an ambitious spoof on the monolith from *2001: A Space Odyssey*, *AD2K* engaged the vast desert space perfectly, reminding us of the true infinity of that metaphorical sandbox in which we play out our game of life. For their 2001 project, Muzalski and D'Amerio created a pair of red dice that were the size of suburban houses, complete with "fuzzy" surface attributes. Located inside the dice was a cocktail bar that kept irregular hours. For the nautically themed 2002 event, Muzalski created a work entitled *Anus Volcanus*, which was a giant yellow duck made of painted wood. Contained within it was a two-story casino, where would-be gamblers had to barter for gaming chips.

The 2001 event hosted a work by David Best and Jack Haye's entitled *The Temple of Tears*, which was arguably the best single artwork to have ever been constructed at Burning Man, in large part due to the communal aspect of its construction and subsequent ritual use.[15] The Temple was created out of thousands of plywood remnants retrieved from a factory that makes toy dinosaurs, and these were cobbled together to create an intricate three-story structure that amalgamated Balinese, Tibetan, and Gothic influences. Throughout the week of the event, hundreds of Burning Man participants

were encouraged to contribute written statements and memorabilia attesting to grief and the loss of comrades inside the temple. By week's end, it was filled with scores of eulogies and heartfelt confessions. The Temple was ceremonially burned amidst a nocturnal sandstorm on the last night of the event, inspiring a long moment of reverential introspection that proved to be prophetic given that it took place a little over a week before the September 11 terrorist attacks. The following year, Best and Haye directed the construction of *The Temple of Joy*, a structure that was equally impressive, but was devoted to expressions of gratitude. In 2003, their effort was entitled *The Temple of Honor*, taking on the very different look of an onion-domed Byzantine basilica, while in 2004, they created the *Temple of the Stars*, which was perched atop a ceremonial causeway almost half a mile long. In 2003, three other works made a vivid impression. One was entitled *The Temple of Gravity* by Zach Coffin, which consisted of four granite boulders suspended on a double-arched frame, inviting participants to tempt fate by climbing up on them. Located at the opposite end of the city was Rosanne Scimica's *Cleavage in Space*, which was an ornate chandelier of gigantic proportions that seemed to have crashed from some Olympian sky, its bright red internal illumination visible for miles around. And finally, a San Francisco collective called the Flaming Lotus Girls responded to the *Beyond Belief* theme of that year's event by constructing *The Hand of God*, a sixteen-foot-tall hand made out of welded metal that was capable of shooting pillars of flame one hundred feet up in the air. In 2004, the Flaming Lotus Girls returned to address the event's *Vault of Heaven* theme with an even more ambitious project entitled *The Seven Sisters*, that being an installation of seven elaborate metal sculptures that represented each of their eponymous celestial bodies by breathing and/or spewing fire in different ways.

Black Rock City came alive with electronic art during the 2002 event, making the whole city pulsate like one grand twenty-five-square-mile hallucination. But, amid the noisy cacophony of all of this activity, there were some impressive works that emphasized a meditative moment, such as the black-lit *Lily Pond* by Jeremy Lutes. This work's subdued lighting and soothing sonic component were activated when people came near its computer sensors. Much larger lily pads were featured in a garden of welded steel by Paul Cesewski and Jeanne Giles entitled *Lotus Land*, which had the added bonus of also functioning as a propane cannon that could periodically direct plumes of fire high overhead. Stationed in a deeper sector of the uninhabited desert

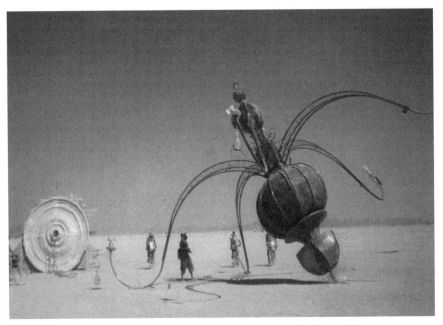

Cleavage in Space, *by Rosanna Scimica (2003), steel, glass, lights,*
21' x 60' x 35' (approx.). Photograph by Mark Van Proyen.

was Dierdre DeFranceaux's *Sirens*, which were monumental female figures
made from cast fiberglass, their electronic sound components inviting
passersby to play the part of a curious Odysseus via a close examination of
their irresistible charms. Another impressive work was entitled *Sisyphish* by
Peter Hudson. This featured a rotating sixteen-foot turntable of cast plaster
heads and arms that was illuminated by a flashing strobe light to create the
zoetrope effect of an animated figure swimming in a circle through the sur-
face of the desert. Nearby was a structure by Dardara entitled *The Fool's Ark*,
a two-story gazebo structure that resembled the ornate boat pictured in
Hieronymus Bosch's *Ship of Fools*. The task of manning the Ark was left
to passersby, who were invited to climb aboard and misbehave in medieval
fashion. In addition to hosting these memorable works, Burning Man
2002 also proved to be the best year for art cars, especially those that were
in keeping with that year's nautical theme of *The Floating World*. Particularly
impressive was a sixteenth-century Spanish galleon, entitled *La Contessa*,

by Simon Cheffin, also mounted on a bus chassis, which allowed it to go on periodic voyages out into the deep desert. There were hundreds of others, and these would regularly converge at indeterminate points in the nighttime darkness for the sake of creating makeshift celebrations of their own improvised device.[16]

This last observation is more than an aside, because it reminds us that the art presented at Burning Man is not the kind of thing that one merely stands back from, waiting to be beheld as a candidate for the status of "historical masterpiece." Rather, such works challenge their viewers to enter into a very different kind of perceptual contract. Oftentimes, they invite viewers to physically and interactively participate in activating and completing the experience that they offer by way of enlarging and transforming everyday activities and materials—deploying them in unpredictable combinations enacted at heroic and even colossal scale. For example, in a work created for the 2000 event by Jeanne Giles and Philip Bonham entitled *Ribcage/Birdcage*, the viewer could sit on a swinging seat suspended within a twenty-foot-tall rib cage. Swinging to and fro, viewers could feel themselves to be the heart that beats at the center of a larger body, the body in question being the city itself. Many other works feature populist wit and a prankster's idea of good fun. A memorable example of this kind of redemption was found in an anonymously authored object called *The Bill Clinton Suntan Lotion Dispenser* that was exhibited at the 1998 event. It was constructed out of a simple sheet of painted plywood cut into the silhouette of a figure, and its visual association with the president from which it took its name was simply made by gluing a photocopy of his face onto the cut-out's head. The *piece de resistance* was a commercial soap dispenser filled with liquid sun block, an essential item for desert survival that was freely provided to passersby. This was affixed to the figure, and upon that was attached a realistic dildo that could be made to squirt the sun block through interactive manual operation, allowing participants to gain tangible testament to the priapic tendencies of our forty-second Commander-in-Chief. Another memorable anonymous work was presented at the 1996 event. It consisted of a sink full of dirty dishes that was sunk into the desert floor, going so far as to include a dripping faucet complete with hidden plumbing. When the artist responsible for the work was asked about her effort, she simply responded by saying that it was "a metaphor for her life."

Manny Farber once coined the term "termite art" to differentiate certain inductive artistic practices from a more convention-bound "white

elephant art," which gained its impetus from the etiquettes of prepackaged logics.[17] For Farber, termite art "feels its way through walls of particularization, with no sign that the artist has any object in mind other than eating away the immediate boundaries of his art, and turning these boundaries for the conditions of the next achievement." The applicability of this definition to the art exhibited at Burning Man cannot be understated, especially if we read its open-air exhibition space as being the final and absolute destination existing beyond any and all walls of particularization. If there is one thing that can be confidently stated about all of the art presented at Burning Man, it is that it is motivated by a guileless celebration of eccentricity as it stems from the diversely "particularized" life experiences of artists working with diverse skill-sets and hailing from many different backgrounds. Despite an unevenness of traditional production values, the perfervid eccentricity of Burning Man artworks always shows through, insisting on its own vitality in a way that we might superficially associate with so-called "outsider" or "folk art."

As Burning Man's week-long celebration of imaginative possibilities builds to its pyrotechnic finale, there is a sense that the sheer abundance of its many apparitions and activities are both multiplying and speeding up, that the participants are starting to swarm as if they were being governed by a single mind. It becomes clear that the event itself has created a special place in the imagination, one of catharsis and redemption, and for postmodern urbanites lost in a world of manipulative illusions, it is both tonic and occasion for sacrifice (of false-self-images). In short, Burning Man provides for the enactment of collective delirium on a mass scale, its famous pyrotechnics serving as an injunction to eroticize intelligence in stark contrast to the cowardice of the world of the Art Expo that can be seen to be quick and smug in its intellectualization of the erotic.

This is perhaps the most important point, and to help us flesh it out, we need to ask George to read the description of sacrifice from his 1948 essay entitled *The Theory of Religion.*

> George: "Sacrifice is the antithesis of production, which is
> accomplished with a view to the future; it is a consumption
> that is concerned only with the moment. This is the sense
> in which it is gift and relinquishment; but what is given
> cannot be an object of preservation for the receiver: the
> gift of an offering makes it pass precisely into the world

of abrupt consumption. . . . This is the meaning of 'sacrificing to a deity,' whose sacred essence is comparable to fire."[18]

And this is related to your idea about the festival?

George: "The Festival assembles men whom the consumption of the contagious offering (communion) opens up to a conflagration, but one that is limited by a counterveiling prudence: there is an aspiration for destruction that breaks out in the festival, but there is a conservative prudence that regulates and limits it. On the one hand, all the possibilities of consumption are brought together: dance and poetry, music and the different arts contribute to making the festival the place and time of a spectacular letting loose."[19]

Is there more?

George: "The constant problem posed by the impossibility of being human without being a thing and of escaping the limits of things without returning to animal slumber receives the limited solution of the festival."[20]

And?

George: "The festival is the fusion of human life."[21]

Because?

George: "The divine world is contagious, and contagion is dangerous."[22]

André, you can have the last word.

"Everything suggests the belief that there is a certain point of the mind where life and death, the real and the imaginary, the past and the future, the communicable and the incommunicable, the high and the low are no longer perceived as contradictions. It would be vain to look for any motive in surrealist activity other than the hope of determining that point."[23]

NOTES

The opening quote is from Marcel Raymond, *From Baudelaire to Surrealism* (New York: Wittenborn and Schultz, 1950 [1947]), 294.

1. Arthur Rimbaud, "Letter to Paul Demeny: 15 May 1871," in *Complete Works, Selected Letters*, trans. and ed. Wallace Fowlie (University of Chicago Press, 1966), 307.

2. André Breton, "Manifesto of Surrealism (1924)," in *Manifestoes of Surrealism*, trans. Richard Seaver and Helen R. Lane (Ann Arbor: University of Michigan Press, 1972), 26. Breton's famous claim that "only the marvelous is beautiful" is on page 14. It should be noted here that Breton was characterized by Victor Crastreas as being "the Pope of Surrealism!" in *Les Temps Modernes* 34 (July 1949): 54 (trans. Donald Kuspit).

3. Quoted in Tamar Manor-Friedman, ed., *Dreaming with Open Eyes: The Vera, Silvia and Arturo Schwartz Collection in the Israel Museum* (Jerusalem: Israel Museum, 2000), 60.

4. Donald Kuspit, "From Critical Consciousness to Perverse Desublimation: The Deterioration of the Avant-Garde," in *Art and Aesthetics in the 90s*, ed. Bergit Baroe (Oslo: Spartacus Forlag, 2000), 48.

5. Gilles Deleuze and Félix Guattari, *Anti-Oedipus: Capitalism and Schizophrenia*, trans. Robert Hurley, Mark Seem, and Helen R. Lane (New York: Viking Press 1977 [1972]), 36–37.

6. Felix Guattari, *Chaosmosis: An Ethico-Aesthetic Paradigm*, trans. Paul Bains and Julian Pefanis (Bloomington: Indiana University Press, 1995 [1992]), 8–9.

7. Stephen L. Post, "Surrealism, Psychoanalysis and Centrality of Metaphor," in *Psychoanalytic Perspectives on Art, Volume II*, ed. Mary Mathews Gedo (Hillside, N.J.: Analytic Press, 1988), 192. Responding to the "linguistic imperialism" implicit in structuralist readings of Surrealism, Jack Spector writes, "How can one write history in the context of a postmodernism that ... insists that discourse replace mimetic description? ... Surrealism, which embodies a labile mixture of the visual and the verbal or the syntactic and the semantic ... made the centering on single texts or issues a controversial matter." Jack J. Spector, *Surrealist Art and Writing 1919–1939* (London: Cambridge University Press, 1997), 6.

8. For documentation of Heizer's early works in the Black Rock Desert, see Germano Celant, *Michael Heizer* (Milan: Fondazione Prada, 1997). *Dissipate #2* (1968) is pictured on page 100, *Isolated Mass/Circumflex I* (1968) on page 106, and *Primitive Dye Painting* (1969) is on page 109.

9. Lewis Kachur, *Displaying the Marvelous: Marcel Duchamp, Salvador Dali, and Surrealist Exhibition Installations* (Cambridge, Mass.: M.I.T. Press, 2001), xiii.

10. Susan Sontag, "Notes on Camp," in *Against Interpretation* (New York: Farrar Strauss and Giroux, 1965 [1964]), 291–92. It is interesting to note that Sontag's influential notion of "camp" aesthetics was formulated very shortly after she published a long and controversial review of Jack Smith's film entitled *Flaming Creatures*. Her initial description of the 1963 film sounds like a prescient précis of typical Burning Man hi-jinks: "In Flaming Creatures, a couple of women and a much larger number of men, most of them clad in flamboyant thrift-shop clothes, frolic about, pose and posture, dance with one another, enact various scenes of voluptuousness, sexual frenzy, romance and vampirism—to the accompaniment of a soundtrack which includes Latin pop favorites, rock-'n'-roll, scratchy violin playing (and) bullfight music," Sontag, "Jack Smith's *Flaming Creatures*," in *Against Interpretation*, 229–34.

11. George Bataille, "The Notion of Expenditure," in *Visions of Excess: Selected Writings 1927–1939*, ed. and trans. Allan Stoekl (Minneapolis: University of Minnesota Press, 1985 [1933]), 118–19. Bataille's text enthusiastically cites Marcel Mauss's 1925 study of potlatch ceremonies entitled *The Gift* as an inspiration. See Marcel Mauss, *The Gift*, trans. W. D. Halls (New York: W. W. Norton, 1990). Burning Man has been frequently described as being devoted to "a gift economy."

12. Quoted in Douglas Crimp, *On the Museum's Ruins* (Cambridge, Mass.: M.I.T./October Books, 1993), 55.

13. Otis's statement was made on the May 18, 1998 broadcast of Pat Robertson's *700 Club* television program.

14. Christian explained his title in the following terms: "Flock, despite its name, was a sculpture of a single creature that appeared to be wandering about as if separated from a herd of similar creatures and seeking a return to its 'flock.' As people came to check it out, they tended to 'flock' around the sculpture as they viewed it from various angles and distances." Michael Christian, artist's statement in "Special Section: The Art of Burning Man," *Leonardo* 36, no. 5 (2003): 354. This special issue of a journal devoted to "art, science and technology" had an extensive section devoted to the art of Burning Man (pages 341–69), including essays by guest editors Louis Brill and Burning Man curator Christine Kristen as well as explanatory statements written by Burning Man artists Dana Albany, Aaron Wolf Baum, Lisa Nigro, Steven Raspa, Austin Richards, Michael Christian, Cassidy Curtis and Chris Whitney, Dierdre DeFranceaux and Jann Nunn, Hendrick Hackl, Cynthia Petit,

Kal Spelletich, Jenne Giles and Phillip Bonham, Dan Das Mann, Susan Robb, Finley Fryer, David Abel, Tim Black, Jeremy Lutes, Christopher Schardt, and Russell Wilcox. See also http://www.burningman.com/ for an extensive photo archive of works of art that have been presented at Burning Man since 1995.

15. See Pike's essay in this volume for more on the Temples.

16. For more on art cars at Burning Man, see Northrup's essay in this volume.

17. Manny Farber, "White Elephant Art vs. Termite Art," in *Negative Space* (New York: Praeger Books, 1971 [1962]), 135–36.

18. George Bataille, *Theory of Religion*, trans. Robert Hurley (New York: Zone Books, 1992 [1948]), 49.

19. Ibid., 54.

20. Ibid., 53.

21. Ibid., 54.

22. Ibid., 53.

23. André Breton, "Second Manifesto of Surrealism (1930)," in *Manifestoes*, 123–24.

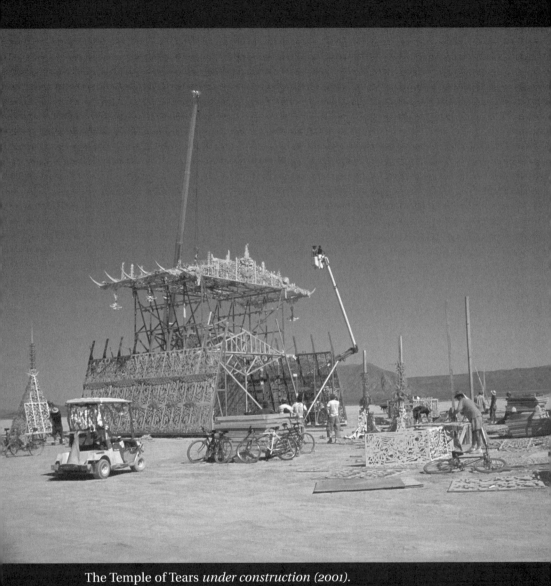

The Temple of Tears *under construction (2001).*
Photograph by Holly Kreuter.

No Novenas for the Dead

Ritual Action and Communal Memory at the Temple of Tears

Sarah M. Pike

"Mom, you need no novenas to be in my heart," read one of the hundreds of messages penciled on the *Temple of Tears* or "Mausoleum" (as it became popularly known) at Burning Man 2001.[1] Robert Collier, a *San Francisco Chronicle* writer who helped assemble the Mausoleum, described it as "part Balinese temple, part Angkor Wat, part Viking fantasy. The overall effect was transparent, full of light and life, uplifting and magical."[2] The term "no novenas" suggests festival-goers' dissatisfaction with the available religious options for mourning their beloved dead. Losses that could not be named in other religious and social contexts—suicides, estranged parents, parents who sexually abused their children—were inscribed on the walls of the Mausoleum. For instance, one woman addressed the father who had abused her: "It was the most difficult thing. But I still love you."[3] Other messages described lost love and a dear friend dying by his own hand: "artist extraordinaire, lover, piano player, struggled with mental illness for many years, hung himself in the garage. I was not there. I'm sorry. I miss you my friend." The Mausoleum became a ritualized sounding board, a bridge between the living and dead and a site of interchange between private and public mourning. Participants wrote down confessions, grief, hopes, and promises with pencils on wood and paper and placed tokens of remembrance on makeshift altars. After the Mausoleum was set aflame and reduced to ashes and festival

participants returned home, they remembered it as a beautiful and meaning-ful site where their grief and losses were transformed and released.

When I first arrived in Black Rock City in 2001, I asked two neighbors which art installations they had found powerful, and both immediately described the Mausoleum and urged me to see it. I soon rode my bicycle out onto the open area reserved for sculptures and large art installations, where I easily located the Mausoleum behind a cloud of dust. At three or four stories high it was larger than I expected and even more stunning than my neighbors' descriptions suggested—"like something you'd come across in a jungle in Thailand" observed my friend Jason. As I drew nearer, I noticed a large wood-en box that held hundreds of small blocks of wood upon which people had inscribed names and messages. Beyond this box was a pile of blank blocks and a few crouching people, busily writing on their blocks and then dropping them into the box. Costumed and half-nude men and women were swarming around and inside the structure or sitting in its shady niches. Inside a man was playing a soft and somber song on his guitar while those who weren't sitting and resting were intently writing messages on every surface of the structure with pencils provided by the artist, David Best. According to Best, the previous year he and a good friend had planned to set up a chapel (*The Temple of the Mind*), but the friend died right before Burning Man. Best came anyway and turned the *Temple of the Mind* into a memorial. Hundreds of people sponta-neously wrote messages on it before it was burnt. Because of the obvious com-munity interest in this kind of participatory art, the Burning Man organization approached Best and asked him to construct something larger for the 2001 event. Best erected a similar temple structure in 2002, *The Temple of Joy*, a trib-ute to the gifts everyone has been given in their lives, as well as *The Temple of Honor* in 2003, dedicated to the passage of spirits, and *The Temple of Stars* in 2004, also devoted to remembrance and reflection. Although the 2003 installa-tion was structurally very different, collective memorializing continued to be central for each subsequent version.[4]

I wandered inside and around the Mausoleum reading some of the thousands of messages people had written on the pieces of filigreed plywood that comprised the temple structure. Some messages were quotes from famous people, including philosopher Søren Kierkegaard and Doors singer-songwriter Jim Morrison, but most were intensely personal and addressed loss, sacrifice, mourning, fear, guilt, forgiveness, lost friends and lovers, or the disappointment of failed relationships. I visited the Mausoleum five or six

times during my four days at Burning Man that year. Whenever I wandered into it, I was moved by the ritual work taking place: people scribbling small, personal messages and reading those left by others, playing music, praying, and crying. Although I may have been the only person taking notes on the messages, everyone was reading them. Many messages were to dead relatives and a few to dead children: "5–26–88/11–25–94, I love you baby, Mommy." Other messages were plaintive cries of loss: "Billy, Billy, Billy, come back." Some asked for support and guidance, while others urged certain attitudes in keeping with Burning Man's philosophy of radical self-expression: "Live free or die," "the fear of death is the beginning of slavery," "Let go of fear."

Burning Man participants constructed an alternative space where they said they felt safe to be themselves, to express beliefs unacceptable to the broader society, and to speak in public about topics that are usually silenced, such as suicide. Following an explicit invitation from Best to use the *Temple of Tears* as a space to honor suicide victims, many of the messages included on the Mausoleum addressed this: "You left us by your own hand. We love and forgive you." The central altar, dedicated to suicides, was covered with flowers, a teddy bear, photos, notes, a mask, a bracelet, and a Buddha head. Several times throughout the day Best asked Mausoleum visitors to put up their right hands: "That's the person who committed suicide, alone and ago-nized. Put your left hand close to you. That's the child who died of leukemia, surrounded by love and support. Now move the two hands together and lift them."[5] Best's point was that "those who died amid love will help liberate those who died in anguish."[6] At this site, Burning Man participants made suicides visible, sought their forgiveness, and grieved for their loss as they also grieved for the deaths and loss of family members, personal ideals, rela-tionships, and parts of the self.

The Burning Man community was intimately brought together at this memorial site, but multiple desires and contentious issues were also re-vealed here. Because the Mausoleum invited festival-goers to invest it with their own meanings and to construct their own mourning rituals, it attract-ed discordant as well as harmonious voices. Yet it became a powerful site that seemed to offer participants an experience that they did not receive elsewhere. The ritual action and communal memory focused around the Mausoleum, made possible in this temporary community set apart from the rest of the world in the middle of the desert, point to the current impover-ishment of available death rites for many Americans.

Private and Public Rites for the Dead

Death rites at the Mausoleum transformed private grief and loss into pub-
lic expression in ways that are generally unavailable to most contemporary
Americans. Rather than departing from more traditional ways of memorial-
izing, visitors to the Mausoleum in fact reached back to the past in order to
revive important ways that human communities made sense of death and
moved on with life. Peter Homans has argued that industrialized cultures
have lost traditional avenues for mourning the dead, where "most of the
world's cultures have linked together...the painful experience of collective
loss; mourning, or the healing response to that loss; and the building of mon-
uments or the construction of cultural symbols to re-present the loss over
time and render it memorable, meaningful, and thereby bearable."[7] Drawing
on French historian Philippe Ariès's groundbreaking work on the history of
death in the West, Homans identified the ways in which mourning was tra-
ditionally a shared, community-wide, and "tamed" experience: "the tame
death tames...the dying person, making not only bearable but even mean-
ingful what might otherwise have been chaotic and intolerable agony."[8]
Death became tamed because the "commonly shared community took upon
itself, in the form of its rituals, much of the burden of mourning that would
otherwise have been overwhelming."[9] Tame death required communal rit-
uals and visibility; it was a public spectacle instead of a private rite.

In contrast, industrialized, secularized societies have privatized and
individualized death, placing "the burden of mourning" on the shoulders of
the individual, such that the shared experience of mourning declined in the
West where the loss of sources of authority and consolation characterized
many communities.[10] Mourning practices moved from churches to psychol-
ogists' offices and shifted from the community to the individual: "the dying
often meet their fate alone, tethered to medical rigs in impersonal hospitals,
in poignant contrast to the medieval tableau of tamed death at home in the
presence of one's family."[11] Instead of shared communal rites most Western-
ers are left with "the invisible death: a biological transition without signifi-
cance, pain, suffering, or fear."[12] This invisibility is especially problematic for
those who are not regular participants in religious communities, which was
probably the case for most of the men and women who visited the Mauso-
leum. If many modern Westerners can no longer access traditional religious
and communal means of mourning the dead, Burning Man participants
have created new ways to deal with their grief. Many of the messages

inscribed on the surface of the Mausoleum, the rituals conducted within its walls, and the final incineration that carried it up into the desert wind point to levels of meaning beyond grief and loss, meaning that transcended the facts of death.

In marked contrast to the broader historical current of mourning in the West, Burning Man participants worked to make death and loss both vocal and visible. The Mausoleum represented an attempt to recognize their suffering, share stories, admit loss, and heal pain through collective expression of personal grief. The testimony of many Burning Man participants indicates that grief over unmourned and unritualized loss is overwhelming for many who can no longer turn to traditional ways of mourning the dead. Burning Man participants witnessed each other's stories of death and suffering at the Mausoleum, and sought to restore vocal, physical, as well as personally and collectively meaningful rites of mourning. The Mausoleum became a site for speaking out loud, describing the dead and their stories, sharing photos of them, and bringing out silenced memories and suppressed grief. Letting go was possible because of Burning Man's emphasis on self-expression within community. Just as costumes and body art allowed Burning Man participants to externalize repressed aspects of the self and play with alternate ways of presenting and expressing themselves, so rituals at the Mausoleum encouraged the expression of pent-up grief and the healing of untended wounds.

Many monuments are either personal—such as the grave of a family member—or public—like the Lincoln Memorial, but there are some, like Maya Lin's Vietnam War memorial in Washington, D.C., which people have personalized by leaving messages and mementos as a way to communicate with the dead. The Mausoleum, too, was both a public monument for the dead, and a memorial for personal loss. It provided an environment to ground more abstract modes of mourning, and in this it functioned like many other monuments. Participants returned to their memories through messages and poems inscribed on its surfaces as well as with trinkets and photos left on its shelves and in its corners. Surrendering their loss to the Mausoleum, and thus in turn to the broader Burning Man community, helped to disperse their grief. The process of release was accomplished both by the expression of personal loss through writing messages and in the Mausoleum's final public burning, when grief ascended with the dust and smoke of the windy desert bonfire.

One example in particular highlights the different ways that memorializing at the Mausoleum was deeply personal and publicly witnessed. Death was brought nearer when the evening the Mausoleum was set to burn news spread through Black Rock City that a participant had died in a collision on his way home. His brother wrote an account of his experience at the Mausoleum soon after learning of the accident:

> My mood was already heavy as earlier that day I had spent an
> hour or more crying and writing names of loved ones that had
> died on little wooden blocks that would later burn in the
> mausoleum. Without knowing what was to come, I had already
> begun to make peace with the dead. At around 10 P.M. Sandra
> [his brother's fiancée], myself, and the remaining members of
> Hookahdome [their theme camp] walked slowly out to the
> mausoleum. Hundreds of you encircled the mausoleum as
> we were escorted in to write our prayers on the altar inside. . . .
> As we silently looked on the mausoleum was set ablaze.[13]

Here again the private and the collective came together. Many festivalgoers who attended the Mausoleum burn were unaware of this private meaning and yet contributed the intensity of their own mourning to the recent grief of a brother and friends who were left behind. Comments about the fatal auto accident appeared on Internet bulletin boards and Web sites, in this way expanding the community of mourners to include the broader public.

Remembering the Dead

Like other mourning rituals, the Mausoleum "tamed" death by providing participants with a process by which they could release grief over a variety of past losses, return to the present, and move on with their lives after temporarily taking time out to remember the dead. Memory and mourning were inextricably connected at this site.[14] Images of the past—how a parent played with you, what you shared with your closest sibling, and other deeply embedded memories—were related by writing on the Mausoleum. These scenes from memory keep the dead "alive" and present to the living.

People found solace at the Mausoleum through the shared act of remembering loss, of placing one's own personal message among the hundreds of

others about death and loss. Loss of relationship to the living was a common theme: "Dad, I'm sorry you think I'm not the same little girl you twirled all over the world. I am. I don't want to lose your love." The majority of messages were to the dead, especially to parents and grandparents: "Ancestors, guide me in the river of life until I join you." There were also messages of gratitude. Many took this opportunity to honor important people in their past and present lives: "To the lineage of men who have shown me the way. . . and the way not. I learn from you all. Grandfathers, Brothers and Fathers. We burn in the same fire." Alongside these messages were a few to children: "We lost them, the two angels with eyes of blue, the day after Christmas. Mom will never forget nor will she be the same. Beckie (age 5) and Laurie (age 6), you were loved and will never be forgotten." By allowing participants to share stories of their dead, the Mausoleum helped them overcome the isolation that many contemporary Westerners feel in the face of loss by engaging them in "a rhythmic project of loss and retrieval....The lost object is permitted to go its way...and thus the joy in having suffered love is sustained."[15]

The remembering that occurred at the Mausoleum made use of the dead to ease the minds of the living. Those left behind when their loved ones died were able to do something for them at the Mausoleum site in the presence of others. Intensely personal mementos and messages were left at the Mausoleum to be seen and appreciated by the entire Burning Man community. The thousands who visited the Mausoleum typically participated in the memorial by reading the messages inscribed on its surfaces and then allowing those messages to evoke their own ghost memories via the trace of a stranger's memory.[16] Reading the testimonies of estranged daughters, heartbroken fathers, bereft lovers, and wounded children, they recalled their own losses. The process of reading the messages of others was as much a part of the ritualizing that took place at the Mausoleum as writing one's own words on its surfaces.

For many visitors to the Mausoleum the notion of forgiveness was important in giving meaning to memories and coming to terms with the past: "To the death of a part of myself, a death I've tried to mourn so many times. But I haven't been able to let go, to move on. Let this fire break the chains that hold me to my past. I forgive myself, I forgive myself." Many people shared memories of fragmentation and separation and called on forgiveness to heal them and make them whole: "To my Dad—Alive but without life. I wish I could have seen you 'happy.' I'll forgive you." Participants expressed

their desire to forgive and be forgiven on the Mausoleum's surfaces. They made it clear in their messages that they came there looking for closure to their mourning process and support for their grief.

Although the Mausoleum's rituals for the dead were all marked by the absence of a body or corpse, the flesh of the dead was present through memories embedded in the bodies of men and women who visited and used their bodies in the process of remembering. In writing on the Mausoleum's surface, the living connected bodily with the dead and in the act of reading messages, that connection was shared with all of the Mausoleum's visitors. Physical expressions of grief were encouraged at least in part by the Burning Man community's celebration of the body through body art, nudity, dance, gender play, and other forms of embodiment that are not widely accepted in the world outside of Black Rock City. While the Mausoleum had a somber and peaceful atmosphere, it was rarely still. People moved through and around it, knelt to read messages, climbed on benches to write in blank spaces, meditated, wept, chanted, and prayed. In these ways they reclaimed the participatory aspect of funeral rites.

Participants' bodily experience of the Mausoleum's ritual burning was one aspect of the mourning process that they remembered after returning home. This ritual process was not only emotionally demanding but often physically arduous because of the dust storms that regularly visit the Black Rock desert. Participants were enveloped in an intense dust storm as we struggled against the wind to make our way out to the middle of the open playa where the Mausoleum was set to burn. In the dark of night and through the thick clouds of dust we could see nothing before or behind us. Our isolation was interrupted here and there when jeeps carrying couches full of revelers careened past, or bicycles covered with colorful luminescent tubes suddenly appeared out of a cloud and then vanished again. As one participant later described it,

> Occasionally you would catch sight of a shadowy figure in the distance, and it was not hard to imagine that it was a ghostly presence. Then the dust would lift slightly, and the ornate detail of the mausoleum would fade into view, torches flickering in the wind. Then it would disappear again. It truly felt like being in the land of the dead, that for a brief time was connected to that of the living.[17]

Before the dust closed in, the moon had risen heavy and bright over the

mountains to the southeast. But now there was no moon or stars by which to navigate, only the art deco lampposts that lined the boulevard out to the site where the Man had burnt the previous night, in front of the Mausoleum. Their lanterns gave a faint and hopeful light, our only landmarks in the dust storm.

For the first time all week I felt ill at ease, concerned for my safety as trucks, golf carts, and bikes rushed around the desert in near-zero visibility. I could easily imagine being mangled beneath them without anyone noticing. And even though my face was covered with a small shop mask, my lungs were filled with dust and my unprotected eyes stung. I thought of my vulnerability and my children at home and finally decided to turn back toward Center Camp. The near total whiteout brought on feelings of vertigo, confusion, fear, and the humbling of oneself before a great and unrelenting force. For those who made it out to the Mausoleum, the dust added to the ritual's power and mystique. Some even used the dust to deepen their ritual experience: "the Mausoleum burn was for the living to mourn and honor their dead. And having to wait due to the dust storm gave us time to focus on our grief, to call up those painful, comforting memories of those who have gone, to really get deep inside the ritual."[18] Getting deep inside the ritual is where Burning Man's mourning rites intersected with the traditions of other cultures that mourn their dead in intensely physical and public ways.

I never reached the Mausoleum to participate in the final rite of communal mourning that I had been looking forward to since I first heard of it. But others reported on this community-wide ritual: "The inferno, the Gregorian chant, the blinding dust storm, and the hundreds of people surrounding us were at once, somehow serene and terribly severe. The tomb before us was consumed, freeing both the souls within and our suffering."[19] The ritual burning finalized the mourning process that had been taking place at the Mausoleum all week, providing a ritual passage for both the dead and the living. Another participant, Janna, reported that "it looked like burning lace," and while Oxeon watched, "the structure ignited and great red clouds enveloped it. Somewhere from out on the playa some camp was playing a gentle house track that had a wistful sax as its hook. People began to slowly walk away from the burn, their faces full of longing, resignation, eyes wet with tears."[20] Much of the Mausoleum ritual's power came from a connection between body and fire, as fire symbolized the final release of death that the living and the dead will both ultimately participate in. One man reflected on this continuity in his message for the Mausoleum: "For my Mum

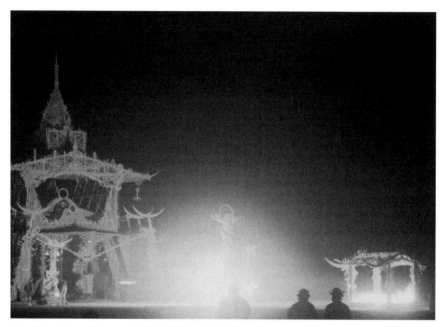

The Temple of Tears *by David Best (with Jack Haye), (2001).*
Photograph by Holly Kreuter.

and Dad who have burnt, for my wife and I who are burning, for my son who
will burn soon. Together in ash soon." Through the long trek from their
campsites to the Mausoleum, the ritual acts of mourning performed there,
and the physical experience of dust, wind, and fire at the Temple's burning,
the bodies of the living came together with the absent bodies of the dead.

Lamentation and the Ongoing Conversation between the Living and the Dead

Mourning rites serve a dual purpose; they take care of both the living and
the dead. In so doing they provide assurance that the bond between dead
and living is eternal, while also enabling them to part ways. Mourning teach-
es us how "to bury the dead, which is to say how to come after them, how to

live in the aftermath of their loss. . . . The loss always shadows, but it does not swallow, the mourner's love."[21] Burning Man participants who left their messages on the Mausoleum wanted to send messages to dead loved ones, but also to move on with their own lives by coming to terms with their grief. The ancient Greek tradition of lamentation makes clear the parallel functions of mourning rites, especially the oppositional qualities that render them effective. Lamentation is described in Greek literary epics, philosophical writings, and histories and its traces remain in some twentieth-century Greek communities. Mourners reflected on the dead person, "the hopes cherished then, the despair he has now caused, the journey he is now making to Hades, and the desolation of those left behind."[22] Mourners' words and actions released their sorrow and expressed their ongoing commitment to love and care for their dead. Burning Man's rites for the dead suggest that many kinds of loss have been unwept and unburied in the lives of contemporary Americans and that the Mausoleum enabled participants to reflect on loss and seek comfort from despair. Many participants felt this was the only site where they could fully attest to their love and care for the dead.

Ancient Greek laments and inscriptions on tombs often included dialogue between the living and the dead as part of the ongoing mourning process.[23] At Burning Man the Mausoleum also became a medium for conversations with the dead. Some messages directly connected dead loved ones to the Burning Man festival: "You would have loved this place, maybe it's the only place you would have fit in," and: "Paul, if only I could tell you about Burning Man." Many messages expressed the longing to set things right, to remedy the ostracism or loneliness of a friend who had died, somehow to be able to assure them and oneself that all was well. The Mausoleum also facilitated conversations that never happened when the dead person was alive. Participants sent their regrets to the dead and spoke what was left unsaid between the dead and living: "Dear Grandpa, I love you and miss you and the childhood that goes with that. Thank you for your trips to the toy store and your showing me how a transistor radio worked. I am sorry that I did not truly understand when you died and I hope that my tears now mean something. You are a great man in the minds of all who remember you." The Mausoleum structure opened a channel to the dead for the men and women who ritualized there: "Dad—I hope all is well in the spirit world."

Mourning rites allow the living and the dead to come together one last time before separating forever and in this way provide closure. But they also

establish an ongoing link between living and dead every time they are reen-
acted and may sustain the mourning process for longer periods of time.
According to ritual theorists Arnold van Gennep and Victor Turner, rites of
passage facilitate movement from one stage of life or status to another,
through separation from a previous stage of life, to the transitional or liminal
phase where mourning happens, and finally through reincorporation as the
dead remain with the dead and the living return to their community and get
on with their lives.[24] At Burning Man's Mausoleum all kinds of losses were
articulated, but the living were not reunited with relatives gathered around
the dead person's grave. Instead they came together as a community of
strangers made intimate by their experiences at the Mausoleum. Many of the
writings on the Mausoleum expressed the desire of the living to choose life,
similar to Greek mourning rites where "the living must be persuaded to
choose life and the living community rather than succumb to the powerful-
ly detrimental emotions of loss, anguish, and sorrow."[25] One message prom-
ised, "If only I could tell you about Burning Man. Your life was too short. I will
strive at 100% pace in life. Thank you for being you." Mourning at Burning
Man was a substitute for failed rites of passage in the outside world, healing
emotions left behind after more traditional death rites were completed.

Conclusions

Unlike many other monuments and memorials, the Mausoleum was radical-
ly inclusive and mobile. Suicides, lost loves, dead parents and children, parts
of the self, and fallen World Trade Center rescue workers were all mourned at
multiple incarnations of the Temple and beyond. Participants then brought
home pieces of the Mausoleum discarded in the construction process and
reassembled them into something new. Private memories were transformed
into photographs and public stories that participants took away with them
and later circulated on the Internet and in the news media. If shrine-making,
drumming, chanting, praying, and other rituals that took place at the Mauso-
leum seemed ancient, mourning was also facilitated by twenty-first-century
technologies when the media ran video clips and participants shared their
experiences on Web sites, bulletin boards, and list-servs. Like other memori-
als, contests over the Mausoleum's meaning accompanied it everywhere.
Debates that took place on the burningman.com "e-playa" message boards

after participants returned home from the 2001 event indicated that radical inclusivity could divide the community as well as unify it around rites of mourning. People who wanted to drum loudly and celebrate the bonfire came into conflict with those who wanted to weep in silent fellowship with other mourners.

While I was packing to return home, a festival neighbor named Maria came to say good-bye and told me she had watched the Mausoleum burn, explaining that she had been awed by the beauty and solemnity of the burning temple just as she was deeply moved when she had visited the Mausoleum earlier, and had written messages for her many friends who had died drug-related deaths. Maria approached the Mausoleum burn to grieve in a peaceful and supportive environment with other mourners, but to her dismay not everyone there had come with similar intentions. A group of "spectators" were standing behind her, making fun of the emotion and the spectacle. There was also a dispute as the ritual started between a crowd in front who did not want to sit down, and those behind who complained because they could not see. Before the emergence of the Temple rites, the main model for collective ritual was the burning of the Man, a festive and exuberant occasion. Some participants responded to the Temple burning as they would have to the burning Man, while others sought a quieter, more solemn ritual experience.[26] In the charged atmosphere of that evening dust storm on the last day of Burning Man 2001, the fluidity of meaning-making and the freedom of individual expression around the Mausoleum felt disruptive to some mourners.

In their messages to the "e-playa" after returning home, participants complained about, praised, and debated their final experience at the Mausoleum as it went up in smoke and flame. Most messages echoed Janna's: "It was beautiful, cathartic, and deeply meaningful." But Janna also registered her dismay at the

> disrespect those people showed to all of us there, to the creator
> of the Mausoleum, and most importantly, to the hundreds
> (thousands?) of the deceased whose names were written inside—
> including the man who was killed in the collision just hours before,
> to whom the Mausoleum had a special dedication. . . . If you are at
> a memorial service that's about to begin, would you go up in front
> of the representation of the dead, and the group of mourners, and
> holler 'Hey, everybody, let's make some noise! Whoo!'[27]

Caution Girl added, "my friend and I abandoned the mausoleum before it burned . . . the vibe was ugly, the crowd was ugly. . . ."[28] Messages in this exchange were long and heartfelt. They also revealed the extent to which Burning Man experiences, particularly those around the emotionally charged Mausoleum, extend Black Rock City into the Internet's virtual world.

If the Mausoleum facilitated the grieving process and created community by making the private public, as I have suggested, then it also worked in the other direction to make the public private. Just as mourning at the Mausoleum was put out for public consumption in the news media and on the Internet, national events like the destruction of the World Trade Center on September 11, 2001, were taken into the Burning Man community and given personal meaning. Burning Man participants across the country organize regional Burning Man-esque events at other times throughout the year in order to stay connected to the community and experience during the "off season." The "East Coast Burning Man Contingent" had planned their annual "beach burn" on a stretch of Delaware coastline a month after September 11.[29] Several hundred people gathered there, many of them from New York City, and built their own mausoleum out of remnants brought home from the *Temple of Tears*, adding to it four panels of news stories about 9/11. Some of the New York participants were EMTs who had been on duty during the World Trade Center attacks. The East Coast Contingent intended their own mausoleum to be cathartic for these people as well as a memorial for the dead. By taking a form from the Burning Man event—the Mausoleum— and then using actual remnants from its construction, the "beach burners" shared in national mourning for those who died in the World Trade Center tragedy, but did so in their own way.

At the event in 2002, the Burning Man community recast national mourning rites involving the flag with its own elements. They memorialized September 11 with a parade of flags and a "Tribute to the Fallen" that included firefighters in uniforms followed by "goggled unicyclists and gigantic fuzzy catmobiles."[30] In addition, "a chest containing the names of all the World Trade Center [fallen] rescue workers perched atop the main altar" of the 2002 *Temple of Joy*, which was very similar to the 2001 *Temple of Tears*.[31] The tragedy of September 11 occurred less than two weeks after Burning Man and some participants connected it to their experiences at the Mausoleum. In these ways the Burning Man event, which is billed as an alternative vision of society and is seen by many outsiders as bizarre and marginal, connected

directly to a national event with memorial rites similar to those observed by other Americans.

Although I heard many people rave about the Mausoleum or tell me that they were moved by it, not everyone at the festival had good things to say about it. One of my festival neighbors told me later that he was "creeped out" by all the people crying in the Mausoleum. He also told me that he had been surprised to see two men intimately embracing against the side of the Mausoleum, one nude and with a visible erection. The juxtaposition of sex and death was a powerful aphrodisiac for some participants and had the opposite effect on others. The peaceful and sorrowful mood of the Mausoleum affected everyone differently. For me, the atmosphere of the Mausoleum made it a compelling place that affirmed love and life: a man bowing before it and praying, a small group who gathered to meditate in front of the Mausoleum at dusk, the gratitude and generosity toward others, the acceptance of death and anger over loss, a woman dressed in green standing and weeping in front of the Mausoleum entrance, a couple holding and comforting each other as one of them cried, a young man embracing the graying and weathered artist. For some Burning Man participants sexual arousal could serve as a sign of the continuity of life and love in the face of so much loss. In their cross-cultural study of mortuary rituals, Richard Huntington and Peter Metcalf describe examples of the celebration of life in the face of death and conclude that "Life continues generation after generation, and in many societies it is this continuity that is focused upon and enhanced during rituals surrounding a death."[32] The continuity of the living is a more palpable reality than the continuity of the dead, and for this reason "it is common for life values of sexuality and fertility to dominate the symbolism of funerals."[33] Although the feeling of the Mausoleum was sad and meditative, it was also uplifting and profoundly life-affirming. Celebration of life coexisted with the recognition of death's impact on people's lives.

In response to the desire of participants to celebrate as well as mourn, at Burning Man 2002 David Best and his crew constructed a near replica of the *Temple of Tears*, called the *Temple of Joy*. The Burning Man Web site described the new Temple's purpose:

> Like last year's Mausoleum, known as the Temple of Tears, the
> Temple of Joy will be a place to commune with the passage of
> spirit . . . we invite visitors to take time here to reflect upon the
> gifts we have received from those we love, both living and dead,

and to consider how these gifts have changed our lives. Pilgrims to the temple may bring tributes to the givers of these gifts, and they may inscribe messages that memorialize this passage of gifts upon its many-storied walls.[34]

When I visited the 2002 Temple, Best gathered visitors around him and told them that the Temple was about two things this year: to reflect on the gifts you have been given and to claim the gifts that were given you that you refused to accept. "Get rid of remorse," he instructed, and "don't go to the end of your life with regrets." I asked him what was different this year, and he suggested that "this time it's about celebration." But I was struck at how similar the messages were to those at the previous year's Mausoleum. Forms of expression were somewhat different, but the memorializing that took place at the *Temple of Joy* in 2002 was just like activity at the Mausoleum the year before. Burning Man organizers may emphasize the fluidity of meanings and symbols, but in this case participants refused to let the Temple be anything else but the memorial site they had so loved the previous year. Though some put more emphasis on giving thanks for what people had given them, many of the messages were of sorrow and loss. In the center of the Temple was a large hand-written letter with photos pasted on it from the youngest daughter in a large family, who wrote that her older sister had killed herself by jumping off a tall building in Los Angeles. This was an expression of grief and shock like many of the Mausoleum's messages, but the letter's emphasis was on the gift that came out of this tragedy, relating that because of one sister's death the writer became closer to another sister she had previously grown apart from.

On the last day of Burning Man 2002 dusk had fallen on the *Temple of Joy*, which was scheduled to burn in a couple of hours. The sun had sunk behind the gray silhouettes of mountains to the west and pink-tinted clouds in the east reflected its setting. The burn organizers had not yet established the perimeter around the Temple that would keep us all at a safe distance. People were still placing messages and mementos in the Temple's nooks and crannies and milling around expectantly as lamplighters hung lanterns from its corners. On one side of the Temple a small group of people had gathered together and was chanting while a man played a slow tune on his violin. Photographers snapped away and videographers recorded the scene. An hour or two later thousands waited at the perimeter of a circle about a hundred

yards across. Art cars and art buses lined up behind the rows of people. The sky was full of stars and a small airplane flew low over us as a fire dancer twirled balls of fire and a couple of people on stilts wandered around. An operatic singer began the ritual with a rendition of "Amazing Grace," although I could not hear this clearly at first because of a group of drummers drumming loudly next to me. Fireworks exploded and the Temple was finally lit. Soon spirals of flame, ash, dust, and wind flew from the Temple, taking with them wishes, promises, grief, and joy. Everyone watched quietly and when the entire structure finally collapsed they walked slowly toward the burning pile of wood, dark shapes silhouetted against the fire. Participants said later that the *Temple of Joy* provided an experience of cleansing and release, of celebration and letting go, just like the Mausoleum before it.

The Mausoleum, like shrines and memorials everywhere, took on a life of its own, and in so doing, asked the men and women who visited there to reach inside themselves and find something unexpected—buried emotions, unsent messages, a thanks saved up too long. But the diversity of responses to it created multiple meanings and attracted different desires. Desire was everywhere at the Mausoleum: desire to speak what had never been heard, desire to live a better, fuller, more honest life, desire for the pleasures of life. The proximity to death was an opportunity to reflect on the meaning of life. Here was a place to write in all honesty what had never before been told, to rise to the occasion of this memorial, to seek in the self for something profound to say, for something that others could take with them, or that the fire could take to the spirits, heaven, and the otherworld.

NOTES

1. This installation was created by artists David Best and Jack Haye in connection with the 2001 theme, *The Seven Ages*, in which the Mausoleum represented the final stage of life—death. The other "Ages" (modeled on a passage from Shakespeare's *As You Like It*) were: the infant, the child, the lover, the soldier, the temple of wisdom (which was the Burning Man itself), and the justice.
2. Robert Collier, "Building a Community for Grieving at Burning Man," *San Francisco Chronicle*, September 9, 2001, B3.

3. Ibid.

4. The essays by Davis, Gilmore, and Van Proyen in this volume also offer brief descriptions and analyses of these Temples.

5. David Best, overheard by the author at the Mausoleum, August 30, 2001.

6. Collier, "Building a Community," B3.

7. Peter Homans, ed., *Symbolic Loss: The Ambiguity of Mourning and Memory at Century's End* (Charlottesville and London: University Press of Virginia, 2000), ix.

8. Ibid., 5.

9. Ibid., 6.

10. Ibid., 5.

11. Patrick H. Hutton in "Of Death and Destiny: The Ariès-Vovelle Debate about the History of Mourning," in *Symbolic Loss*, 148.

12. Ibid., 153–54.

13. AC, Burning Man e-playa bulletin board, September 7, 2001.

14. Homans suggests that memory and mourning should be studied together, though scholars have not tended to do so (*Symbolic Loss*, 31).

15. Gregg M. Horowitz, *Sustaining Loss: Art and Mournful Life* (Stanford, Calif.: Stanford University Press, 2001), 142.

16. See Richard Morris, *Sinners, Lovers, and Heroes: An Essay on Memorializing in Three American Cultures* (Albany: SUNY Press, 1997) for a discussion of the relationship between memory and memorializing.

17. JD, Burning Man e-playa bulletin board, September 5, 2001.

18. JD, Burning Man e-playa bulletin board, September 5, 2001.

19. AC, Burning Man e-playa bulletin board, September 7, 2001.

20. Lace and Oxeon, Burning Man e-playa bulletin board, September 5, 2001.

21. Horowitz, *Sustaining Loss*, 153.

22. Margaret Alexiou, *The Ritual Lament in Greek Tradition* (Cambridge: Cambridge University Press, 1974), 165.

23. Ibid., 139.

24. See Arnold van Gennep, *The Rites of Passage* (Chicago: University of Chicago Press, 1960) and Victor Turner, *The Ritual Process* (Chicago: Aldine, 1969).

25. Donovan J. Ochs, *Consolatory Rhetoric: Grief, Symbol, and Ritual in the Greco-Roman Era* (Columbia, S.C.: University of South Carolina Press, 1993), 122.

26. Thanks to Lee Gilmore for this point about the expectations set by the burning of the Man.

27. Janna, Burning Man e-playa bulletin board, September 5, 2001.

28. Caution Girl, Burning Man e-playa bulletin board, September 7, 2001.

29. See http://burning-wheel.org/pdfpics.html (accessed August 25, 2003).

30. Adrienne Sanders, "Burning Patriotism," *The San Francisco Examiner,* September 3, 2002.

31. Ibid.

32. Richard Huntington and Peter Metcalf, *Celebrations of Death: The Anthropology of Mortuary Ritual* (Cambridge: Cambridge University Press, 1979), 93.

33. Ibid., 93.

34. Available from http://www.burningman.com/themecamps _installations/installations/02_art_theme.html#joy (accessed August 25, 2003).

CONTRIBUTORS

Katherine K. Chen recently completed her doctorate in Sociology at Harvard University and currently is a postdoctoral fellow at Harvard University. She also is a fellow in the Social Science Research Council's "Corporation as a Social Institution." She has attended the 1998 through 2002 and 2004 Burning Man events.

Erik Davis lives and writes in San Francisco. He is the author of *TechGnosis* and *The Visionary State*, a forthcoming book about California spirituality. He also published a critical study of *Led Zeppelin IV*. Davis stumbled into Burning Man in 1994, and wrote the first national article about the event.

Allegra Fortunati holds graduate degrees in Political Science and Art History. Currently, she serves on the Curatorial Committee and Board of The LAB in San Francisco. She has attended Burning Man four times since 1999.

Lee Gilmore completed her Ph.D. in Religious Studies at the Graduate Theological Union in Berkeley in 2005, and currently teaches at Chabot College in Hayward, California. She has been a participant in the Burning Man festival since 1996.

Jeremy Hockett received his Ph.D. from the Department of American Studies at the University of New Mexico. His dissertation on the Burning Man community, in which he has been participating since 1997, was completed in May 2004.

Robert V. Kozinets is Associate Professor of Marketing at York University's Schulich School of Business. Aside from his forays into consumer emancipation at Burning Man, his research interests include entertainment marketing, virtual communities, technology consumption, and subcultures. He has attended Burning Man four times since 1999.

JoAnne Northrup is senior curator at the San Jose Museum of Art in San Jose, California. She is currently organizing a major traveling exhibition and publication featuring the work of Southern California–based digital/video artist Jennifer Steinkamp, scheduled to open in 2006. She has attended Burning Man since 1995.

Sarah M. Pike is Associate Professor of Religious Studies at California State University, Chico. She is the author of *Earthly Bodies, Magical Selves: Contemporary Pagans and the Search for Community* (University of California Press 2001). She has attended Burning Man since 1997.

John Sherry, an anthropologist at the Mendoza School of the University of Notre Dame, is a Fellow of the American Anthropological Association and the Society for Applied Anthropology, as well as past President of the Association for Consumer Research. He was a newbie in 2000.

Mark Van Proyen is Associate Professor of Art History, Painting, and Digital Media at the San Francisco Art Institute. He has attended Burning Man since 1996.

INDEX